Oxford University Press
Digital Course Materials
for

Directions for accessing
Oxford University

Art and Design Fundamentals
2D and Color
STEVEN BLEICHER

Carefully scratch off the silver coating to see your personal redemption code.

This code can be redeemed only once.

Once the code has been revealed, this access card cannot be returned to the publisher.

Access can also be purchased online during the registration process.

The code on this card is valid for two years from the date of first purchase. Complete terms and conditions are available at learninglink.oup.com

Access Length: 6 months from redemption of the code.

OXFORD
UNIVERSITY PRESS

Your OUP digital course materials can be delivered several different ways, depending on how your instructor has elected to incorporate them into his or her course.

BEFORE REGISTERING FOR ACCESS, be sure to check with your instructor to ensure that you register using the proper method.

VIA YOUR SCHOOL'S LEARNING MANAGEMENT SYSTEM

Use this method if your instructor has integrated these resources into your school's Learning Management System (LMS)—Blackboard, Canvas, Brightspace, Moodle, or other.

Log in to your instructor's course within your school's LMS.

When you click a link to a resource that is access-protected, you will be prompted to register for access.

Follow the on-screen instructions.

Enter your personal redemption code (or purchase access) when prompted.

VIA OXFORD learning link

Use this method if you are using the resources for self-study only. **NOTE:** *Scores for any quizzes you take on the OUP site will not report to your instructor's gradebook.*

Visit oup.com/he/bleicher1e-2d-color-student-resources

Select the edition you are using, then select student resources for that edition.

Click the link to upgrade your access to the student resources.

Follow the on-screen instructions.

Enter your personal redemption code (or purchase access) when prompted.

VIA OXFORD learning cloud

Use this method only if your instructor has specifically instructed you to enroll in an Oxford Learning Cloud course. **NOTE:** *If your instructor is using these resources within your school's LMS, use the Learning Management System instructions.*

Visit the course invitation URL provided by your instructor.

If you already have an oup.instructure.com account you will be added to the course automatically; if not, create an account by providing your name and email.

When you click a link to a resource in the course that is access-protected, you will be prompted to register.

Follow the on-screen instructions, entering your personal redemption code where prompted.

For assistance with code redemption, Oxford Learning Cloud registration, or if you redeemed your code using the wrong method for your course, please contact our customer support team at **learninglinkdirect.support@oup.com** or 855-281-8749.

Art and Design
Fundamentals

Art&
Design

Art& Design

FUNDAMENTALS

2D AND COLOR

Steven Bleicher

New York Oxford

OXFORD UNIVERSITY PRESS

Oxford University Press is a department of the University of Oxford. It furthers the University's objective of excellence in research, scholarship, and education by publishing worldwide. Oxford is a registered trade mark of Oxford University Press in the UK and certain other countries.

Published in the United States of America by Oxford University Press
198 Madison Avenue, New York, NY 10016, United States of America.

© 2022 by Oxford University Press

For titles covered by Section 112 of the US Higher Education Opportunity Act, please visit www.oup.com/us/he for the latest information about pricing and alternate formats.

Library of Congress Cataloging-in-Publication Data

Names: Bleicher, Steven, author.
Title: Art and design fundamentals : 2D and color / Steven Bleicher.
Other titles: Art and design fundamentals (2022)
Description: New York, NY, United States of America : Oxford University
 Press, 2022. | Includes bibliographical references and index.
Identifiers: LCCN 2020022100 (print) | LCCN 2020022101 (ebook) | ISBN
 9780190632687 (paperback) | ISBN 9780197537114 (epub)
Subjects: LCSH: Design.
Classification: LCC NC703 .B582 2022 (print) | LCC NC703 (ebook) | DDC
 745.4—dc23
LC record available at https://lccn.loc.gov/2020022100
LC ebook record available at https://lccn.loc.gov/2020022101

9 8 7 6 5 4 3 2 1
Printed by Sheridan Books, Inc., United States of America

To my mother, Myra.

She always supported my art endeavors,

encouraged my being an artist,

and believed in me and my work.

Thanks Mom.

Brief Contents

Contents

Part 1 Process and Principles 2

Part 2 The Elements of Two-Dimensional Design 64

Chapter 4 Line 66

Chapter 5 Shape 82

Preface

In colleges, universities, and art schools today, students enrolled in art foundation courses often have diverse art and design backgrounds and varied levels of preparedness. Some students have had few art and design classes in high school, while others have had more extensive art education, either in school or as part of extracurricular activities. The challenge for the instructor—and for this textbook author—is to strike a balance between offering a suitable level of instruction and meeting the varying needs of a diverse student population.

Art and Design Fundamentals is designed to appeal to all students. It engages them through its equal emphasis on traditional and cutting-edge technologies, its equal representation of male and female artists and designers, and its concise chapters that feature rich visual examples. In addition to covering Western art traditions, each chapter of *Art and Design Fundamentals* has non-Western art examples and analysis to fully round out students' understanding of contemporary art and design. In short, this book enables students to gain the knowledge they need to succeed in their future endeavors, whether a career in studio art or one of the many design disciplines.

Art and Design Fundamentals is a contemporary introduction to art and design that emphasizes problem solving through building conceptual thinking skills. It emphasizes the principles of art and design by addressing them up front, establishing a framework through which students can learn about the elements of art and design. It offers an in-depth focus on color—one of the more nuanced elements—and, unique to this textbook, a complete chapter on digital color, which will prepare students for art and design in an increasingly digital world. The complete volume explores all aspects of three-dimensional and four-dimensional design, introducing dimensional design disciplines, composition, materials and methods, and conceptual art and installation.

An Approach That Puts Conceptual Thinking First

The most important aspect of any art and design education is learning how to think like an artist or designer. The meaning of an artwork or design is referred to as the *conceptual basis* of the work; it is the message, whether deeply personal or directed at a specific audience to sell a product or tell a story. *Art and Design Fundamentals* emphasizes the importance of clearly articulating a message. While the message may change or be dependent on the artist or designer's intention, expressing it in a strong visual style that imparts its meaning to the viewer is essential.

This textbook addresses three basic fundamentals:

- the concept or meaning (the message);
- the formal elements (use of space, line value, color, etc.); and
- the execution, or craftsmanship, of the work.

Art and Design Fundamentals brings these essential components together and integrates conceptual thinking throughout every chapter, enabling students to create meaningful and fully realized artworks or designs.

The materials or media selected must work *with* the message to express a cohesive statement. Understanding *why* something is created and what the piece is trying to convey is at the heart of everything we do as artists and designers. Otherwise, we are just making pretty pictures.

Pedagogy That Supports Student Learning

Every facet of *Art and Design Fundamentals* was designed with student learning in mind. Rich pedagogical features aim to enhance conceptual thinking skills, provide material for projects, pose thought-provoking questions, and allow students to take a step back and really think about what they are reading and seeing. The pedagogical features work together to support students as they (1) grasp the basic principles and elements of art and design, (2) consider rich examples, (3) understand what makes an artwork or design successful, and (4) begin conceptualizing and generating their own work.

Art and Design Fundamentals supports students as they learn about the basic principles and elements of art and design.

Written for Visual Learners. The elements of art and design have been covered so often in so many texts over the years, it would seem impossible to present this content in a new way. To do just that, however, this textbook presents diverse examples, perspectives, and descriptions to illustrate key concepts. Rather than having lengthy discourses on various topics, the text was written directly to the student in consumable "chunks." At the end of each chapter in the enhanced e-book, students will find *Visual Vocabulary* flashcards that help them understand art terms and concepts.

Looking Ahead and Think About It. Each chapter begins with a list of questions that act as a preview of the chapter. *Looking Ahead* questions help students to approach and reflect upon chapter content as they read. *Think About It* questions at the end of each chapter help students think conceptually and creatively about the content in each chapter. These questions can be assigned via a campus learning management system. Questions do not ask students to merely search and find answers; they require students to deeply consider the content, and they provide a framework that encourages critical analysis and understanding of the content, rather than focusing on terminology.

While learning the basics, students are exposed to exceptional examples of art and design.

New Perspectives. Artist and designer profiles in each chapter further a focus on contemporary artists in diverse genres and how they develop the ability to see with fresh eyes, because new perspectives are at the heart of successful art and design. *New Perspectives* are designed to offer students a better understanding of the conceptual development of the work and provide insight into why an artist or designer chose particular elements and design principles to communicate his or her ideas. This feature humanizes and personalizes the creative process for the reader. *New Perspectives* boxes are accompanied by *Contemporary Voices* online features that allow students to dive deeper into the repertoire of a contemporary artist or design.

Global Connections. The attention to looking in new ways extends to an emphasis on multicultural and global diversity. This textbook was designed to better represent the world's art and design diversity. Special box features on *Global Connections* reinforce the textbook's attention to cultural diversity. This feature invites students to approach their own work from a different perspective and consider their own cultural identity.

Gender Parity. No other basic design text has an art program that represents parity between male and female artists. This not only brings in fresh perspectives, but it also more genuinely reflects the current and future face of the creative and visual arts.

As students read, the text encourages them to think critically about what makes an artwork or design successful.

Interactive Image Walkthroughs. Each chapter features online *Interactive Image Walkthroughs* that guide students to the most important features of the figures discussed in the text. Image walkthroughs are all followed by assessment, making them easily assignable and giving students instant feedback on their understanding.

Conceptual Connections. To enable students to start thinking about principles and elements in tandem, instead of separately, each chapter has three *Conceptual Connections* that pose questions about the principles and elements appearing in a particular artwork or design. After responding to a *Conceptual Connections* prompt in the enhanced e-book, students can compare their answer to a model response.

Conceptual Thinking Activity. These activities are conceptually oriented and challenge students' preconceptions. The activities further explore a specific topic that is being discussed and are designed to enhance the student's understanding of the conceptual nature of art and design. Each chapter has two activities that could be used as in-class projects or homework.

Finally, activity prompts allow students to apply key concepts to their own work.

In the Studio. Time and again, students express frustration around idea generation, even when the design problem is clearly stated. This is why *In the Studio* presents both a project and a wide scope of examples from real students. These examples illustrate that there is no single answer to a studio assignment. In addition to helping students better understand the concepts in each chapter, these assignments encourage students to think creatively, conceptually, and critically. With online GoReact exercises, students are invited to present and discuss their own work.

All of these features and more are best experienced through the enhanced e-book. Integrating online resources into classes is easier than ever; your Oxford representative can help you integrate the resources into your campus learning management system with Oxford Learning Link Direct, or if you prefer, resources are accessible via Oxford's Learning Cloud platform. A full set of instructor resources on Oxford Learning Link makes course prep easier. Resources include a computerized test bank, PowerPoint lecture outlines, and a detailed Instructor's Manual.

An Organization That Emphasizes Creativity

Art and Design Fundamentals is organized into four parts: (1) Process and Principles, (2) The Elements of Two-Dimensional Design, (3) Color, and (4) Three-Dimensional Design and Beyond. For courses in two-dimensional design, a brief version is available. *Art and Design Fundamentals: 2D and Color* includes three parts: (1) Process and Principles, (2) The Elements of Two-Dimensional Design, and (3) Color.

Part 1: Process and Principles

While process and principles are often presented as secondary to the elements of art and design, ideas *do* matter. *Art and Design Fundamentals* focuses on process and conceptual

development in Part 1. The aim is to enable students to explore and enhance their imaginations so that they can practice thinking like an artist or a designer before they begin to work with the elements.

- **An emphasis on creativity from day one**. Chapter 1 introduces students to the conceptual methodologies and sources of inspiration used by artists and designers. Successful artists and designers come up with new ideas and novel ways of looking at the world and create a visual way to communicate that message.
- **A guide to the creative process**. Chapter 2 takes students from invention to evaluation and is studded with further strategies for discovery, problem solving, and generating ideas—challenging areas for most students—as well as practical ground rules for both providing and receiving critiques.
- **A foundation for effectively presenting visual information**. Chapter 3 begins with psychology—perception—and girds the discussion on how to communicate ideas in a visual age with new technologies that shape our existence, from a renewed interest in traditional arts and crafts to gaming animations.

Part 2: The Elements of Two-Dimensional Design

Chapters 4 through 9 introduce students to the elements of art and design: line, shape, texture, value, space, and motion as it is presented on a two-dimensional page or surface. Each chapter provides a clear definition of the element, outlines its characteristics, and explores a variety of uses.

Part 3: Color

Color may be the most complex and enigmatic of all of the elements of design. Differing from the other design elements, color elicits an unconscious, immediate response from the viewer. Due to the complexity of working with color both traditionally and digitally, *Art and Design Fundamentals* puts an emphasis on color, ensuring complete and thorough coverage of the topic.

- **Complete color coverage.** Chapter 10 covers the traditional aspects of color, such as color harmonies, color use, and color psychology. The chapter also covers multicultural and global color; with today's students entering an international arena, it is important for them to understand how the audience views, and is influenced by, color.
- **A unique chapter on digital color.** Technology has opened up new areas for artists and designers. Chapter 11 is dedicated to using color digitally, such as in websites or animations. Working in a media that has few borders, students' net-based creations can be viewed worldwide, adding to the complexity of using color.

Part 4: Three-Dimensional Design and Beyond

As students move from creating illusionistic or pictorial representations of space into the realm where art and design objects exist in actual space, they will discover that each method of construction and each material used has its own set of complexities. Part 4 addresses these exciting methods for creative expression and new conceptual challenges.

- **Contemporary coverage of three-dimensional space.** Chapter 12 introduces students to the basic concept of moving from the two-dimensional image to working in three-dimensional space, while Chapter 13 covers the principles and elements of dimensional design. These topics include color, colorants, scale, proportion, texture, contrast, and value. Principles of emphasis and unity and variety are also covered.

- **Methods of construction.** Chapter 14 highlights how media and materials form the conceptual underpinnings of the work. There are four main categories of dimensional construction: methods of subtraction and addition, and hybrid or digitally constructed designs. Casting and mold making are part of the additive process. The chapter addresses material and method selection so that students can achieve a desired outcome and message

- **Nontraditional forms of art and design.** Chapter 15 explores how dimensional creations have advanced. Postmodernism and its elements, which may include sound, scent, and taste, are explained and explored. This chapter also includes detailed coverage of installation, conceptual art, and earthworks. In these new artforms, the artist's body itself can become the subject of art and design creation.

- **Contemporary coverage of four-dimensional art and design.** Chapter 16 addresses integral elements of four-dimensional design, such as duration, tempo, intensity, and transition. Using exciting examples of performance, film, and video games, the use of linear, nonlinear, and real-time formats are examined.

About the Author

Steven Bleicher is a tenured professor in the visual arts department at Coastal Carolina University. He has been the department chair and associate dean of Thomas W. and Robin W. Edwards College of Humanities and Fine Arts. Bleicher received his BFA and MFA from Pratt Institute. He has worked and taught at the New York Studio School of Drawing, Painting and Sculpture, the State University of New York, Brooklyn College, and Marian College. In addition, he has served as the assistant dean of the School of Art and Design at the Fashion Institute of Technology.

Bleicher is an accomplished artist. His artwork is included in many major collections and is widely exhibited both nationally and internationally in numerous solo and group exhibitions. Bleicher collaborated as the color specialist with fellow artist and Pratt alumna, Jennifer Wen Ma, on *Man and Nature in Rhapsody of Light*, a permanent public art installation at the Water Cube in Beijing. The work combines traditional Chinese philosophy with contemporary aesthetics and digital technology. The lighting installation opened in June 2013.

In October 2004, Bleicher's book, *Contemporary Color: Theory and Use,* was published by Cengage Press and Thomson Learning. It is a comprehensive text on color, and focuses on digital color and its relationship to other new technologies as well as traditional color theory. Other chapters include color psychology, perception, and dimensional aspects of color. The second edition, published in April 2012, is updated and contains a new chapter with a focus on global color and multiculturalism.

Bleicher often provides interdisciplinary lectures on color psychology and has spoken to marketing and anthropology classes at Coastal Carolina University. Additionally, he was a lecturer for the Nancy Smith Endowed Speaker Series and Celebration of Inquiry events at the University. He has also been invited to other colleges and universities to speak and was a visiting professor and artist at the Nanjing Art Institute.

As a result of his expertise on color, Bleicher is often interviewed and has been quoted by notable publications such as the *New York Times* and *El Español*, as well as other local, national, and international publications. Bleicher has been a contributor to numerous podcasts, including *Sports Illustrated's The Narrative.*

He was a guest contributor to a local television program, *Today in South Florida,* for a series of segments about using color effectively. Bleicher is also a consultant on color psychology and has been an expert witness on color and design for many major corporations, including Tilson Communications and Staples, Inc. Most recently, he has been an expert witness in a case regarding color and copyright infringement.

Bleicher is a member of the College Art Association, Foundations in Art: Theory and Education, the International Council of Fine Arts Deans, the Southeastern College Art Conference, and the Mid-America College Art Association.

Acknowledgments

In the course of writing this textbook, I have had considerable assistance and input. It is my pleasure to acknowledge all of those who have assisted in this endeavor. First, to my editors at Oxford University Press I owe my heartfelt thanks—to Justin Hoffman and Richard Carlin for their vision of and support for this book, and to Kerry O'Neill for her editing skills, her many suggestions that improved it considerably, and her patience in this project.

List of Reviewers

Numerous reviewers and focus group participants have shared their thoughts, offered advice, and provided expertise. Oxford and the author are indebted to them for their feedback:

Scott Aigner (Pierce College)
Charles Basham (Kent State University)
Todd Brainard (Cypress College)
Derrick Burbul (University of Nebraska at Kearney)
Mary Alice Casto (University of Nebraska–Lincoln)
William Cavill (University of Nebraska Kearney)
Daniel Crocco (Central Piedmont Community College)
Anna Divinsky (Penn State University)
Matthew Forrest (Georgia College)
Rosanne Gibel (Art Institute of Fort Lauderdale)
Jerry R. Johnson (Troy University)
Lisa LaJevic (The College of New Jersey)
Leo Morrissey (Georgian Court University)
William Morse (Campbellsville University)
Jane Allen Nodine (University of South Carolina Upstate)
Kelly O'Briant (University of Dallas)
Bobby Osborne (Augusta University)
Paul Paiement (Cypress College)

Bryan Park (Benedictine College)
Vicky Randall (Ringling College of Art and Design)
Sandra Reed (Marshall University)
Daniel Rioz (University of Northern Colorado)
Christine L. Satory (Ball State University)
Jessica Simorte (Sam Houston State University)
Anita Stewart (Jacksonville State University)
Michael Stone (Art Institute of Houston; Houston Community College; Lone Star College)
James Alan Thurman (University of North Texas)
Jason Travers (Lehigh University)
Karen Ward (Mitchell College)
Tracy Wascom (Northern Michigan University)
Ian Welch (Bowling Green State University; Owens Community College)
Michele Wirt (College of Central Florida)
Jenchi Wu (Ventura College)
Karen Zeilman (Illinois Valley Community College)
Rebecca Zeiss (University of Michigan—Flint)
Six anonymous reviewers

Introduction: Art and Design Today

Art and design have endless opportunities.

This may be the most exciting time to be starting a career in art and design. Art and design have become pervasive in our living, working, and virtual spaces, and new technologies combined with traditional media are creating ever greater possibilities for discovery and invention. As new technologies shape our lives, so too do they shape the ways in which students are taught and trained, and the ways in which artists and designers practice their craft. While the principles and elements of art and design have been passed down from generation to generation, art and design practice and education are continually evolving and being reinvented. As an emerging artist or designer, you face a future full of possibilities as vast as your own imagination.

Opportunities in Design

Italian designer Massimo Vignelli famously said, *"If you can design one thing, you can design everything."* Throughout his wide-ranging career, Vignelli lived this credo. He created an assortment of products, furniture, packaging, graphic designs, posters, and corporate identities (fig. I.1). Today, many designers work in multiple areas at once; for example, a designer might design consumer products or packaging, logos, two- and three-dimensional graphics, animations, online ads and promotional materials, or entire websites. Indeed, the areas in which an artist or a designer can choose to work are vast and growing rapidly.

Design is an ever-evolving discipline—or more accurately, a series of related disciplines—and the lines separating one from another have become blurred. Today, designers can combine new technologies with traditional methods and approaches to produce creative designs. April Greiman, for example, combines a contemporary style with a familiar object (the postage stamp) (fig. I.2), while Max-o-matic fuses digital imaging with traditional drawing techniques (fig. I.3).

Opportunities in design are growing, as the field expands to include product design, industrial design, accessory design, and even textile and surface design. Take product design, for instance, which has flourished into an exciting area of creative exploration. Product design involves developing not only the functionality of the product, but also new design innovations and sleek styling, such as the vertical turntable designed by Louis Berger (fig. I.4). The need for fully realized, three-dimensional designs, such as Philippe Starck's *Lama Scooter* (fig. I.5), opens up many new avenues of expression for designers.

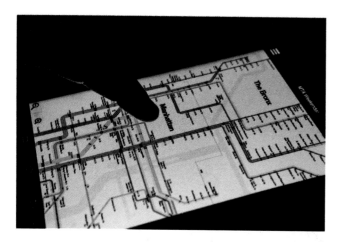

I.1 Massimo Vignelli, *New York Subway Map,* **2011.**
Vignelli created the iconic subway map. This reinterpretation of New York City improves readability and makes sense visually.

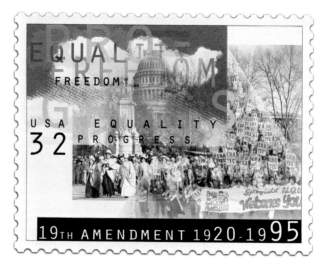

I.2 April Greiman, *19th Amendment Stamp,* **1995.**
The stamp—a decidedly antiquated instrument—takes on a contemporary look. The composition looks more like a splash page for a website than a postage stamp.

I.3 Max-o-matic, Cover for *Typex,* **2001.**
Max-o-matic, aka Máximo Tuja, combines digital imaging with traditional drawing in his cover art for the book *Typex.* Many contemporary artists and designers are intermixing new technology and old in a variety of styles and formats.

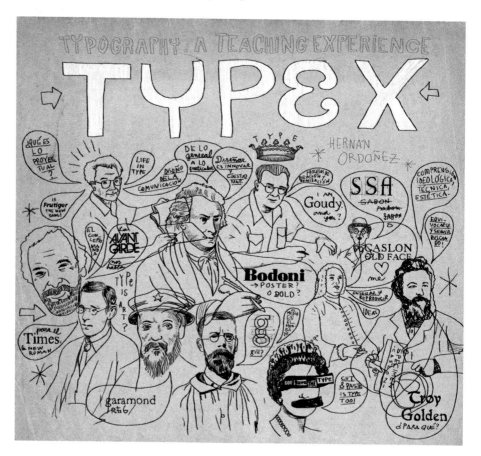

Opportunities in Studio Art

Studio art, or fine art as it is sometimes referred to, has also broken the bonds of convention and categorization. Artist Julian Schnabel, for example, breaks more traditional conventions in his groundbreaking, monumental canvases (fig. I.6).

Other artists have experimented with new techniques while using traditional two-dimensional methods, such as painting, drawing, printmaking, collage, or hot wax. Deborah Rockman, for example, developed her own method of layering charcoal on paper to produce a smooth surface without any lines or strokes (fig I.7). Many artists, especially photographers,

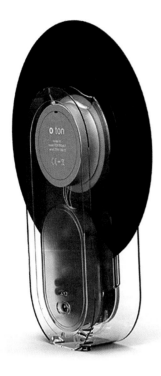

I.4 Louis Berger, *Vertical Turntable*, 2017.
The unusual shape and clear housing make the product stand out in the crowded audio electronics arena. Berger's minimal styling echoes the "form follows function" mantra of the Bauhaus.

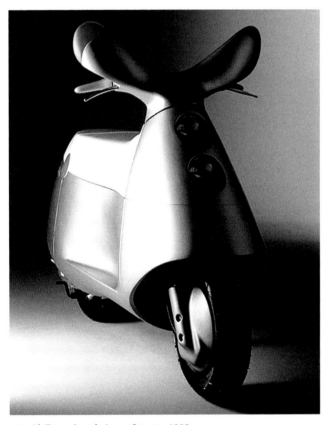

I.5 Philippe Starck, *Lama Scooter*, 1992.
This is a prototype for a motor scooter for Aprilia. Its sleek design gives the viewer the illusion of movement, even when the scooter is standing still.

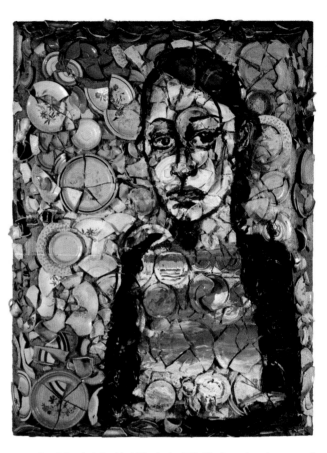

I.6 Julian Schnabel, *Untitled (Martine)*, 1987. Oil, plates, bondo on wood.
Schnabel's large-scale paintings using broken plates are an amalgam of painting, mixed media, and mosaics.

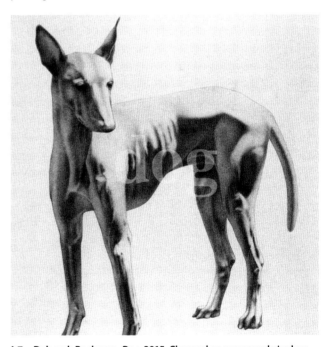

I.7 Deborah Rockman, *Dog*, 2015. Charcoal on paper and vinyl on glass, 29 × 23 in.
Rockman developed her own method of working with charcoal to produce a smooth, uniform surface, free of lines and marks. She creates transparent text by using vinyl letters on glass.

I.8 Ljubodrag Andric, Photograph for Amnesty International, 2011.
This editorial photograph for an Amnesty International poster campaign is a dynamic image that captures the audience's attention.

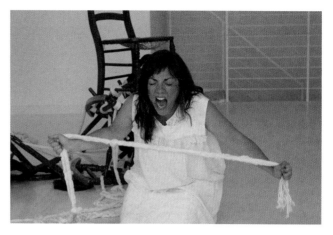

I.9 Rae Goodwin, *at her feet*, 6 hour performance at Glasshouse Art-LifeLab, during Neo Domestic Performance Art Festival, Brooklyn, NY, 2017.
In performance art, the act is important. In this way, the artwork pushes new boundaries both in terms of media and presentation, as well as subject matter.

have also blurred the line between fine art and commercial photography (fig. I.8). The results, and the methods used to achieve those results, all depend on the artist's intention.

Fine art, while traditionally showcasing three-dimensional works such as sculpture—fully dimensional, freestanding works—and ceramics, has more recently come to include conceptual art, such as performance art, earthworks, site-specific installations, and so on. Conceptual art, which prioritizes the development of the idea over the physical end product or object, has brought about new innovations by questioning the boundaries of traditional art forms. Rae Goodwin's, *at her feet*, is an example of performance art (fig. I.9). Photographs are used to document the live event, but the dramatic performance is the central focus of the piece. While conceptual art has often been categorized as sculpture, it is sometimes taught within sculpture departments under the term *new forms*. Whether it is referred to as sculpture or new forms, all conceptual art is classified as fine art.

New Technologies

Technological advances, including the internet, have opened up many new areas for artists and designers. Web-based design can include websites, such as Fred Davis's site (fig. I.10), animations, and online games. Composed of media that has few limitations, web-based creations can be viewed worldwide.

Since they often involve both imagery and text, web-based creations are complex and challenging.

Moving, four-dimensional images are vital to design today. Time is the key element in these works. They are durational in nature and can last from seconds to hours, or from months to years. Four-dimensional design includes film, video, digital video, and cinematics (fig. I.11). These works may be viewed on a movie screen, on a television screen or a computer monitor, or on any other digital device. The action is as mobile as your smartphone or tablet.

New technology has also influenced fine art. The internet, including social media, provides artists with a nonfiltered format for displaying their artwork directly to the public. Annette Weintraub almost exclusively uses the internet as her preferred medium (fig. I.12). Working in this manner frees her from the restrictions of time and allows her to work in a virtual environment with limitless possibilities. The key to working in a virtual environment is knowing how to use the elements and principles of art and design to plan, think, and create with the addition of the fourth dimension—time—as an integral component.

New technologies, along with innovative conceptual idioms for art and design, are dissolving the traditional boundaries between the two disciplines. Today, artists and designers feel free to mix mediums and genres. Graphic designers create earthworks to promote their products, and artists create works that are solely intended to be viewed online. Students studying art and design today will be the ones who forge new paths in art and design.

It all comes down to doing what you love—what Joseph Campbell called "following your bliss." If you do what you love—what is meaningful to you—you will work harder, longer, and with passion and dedication.

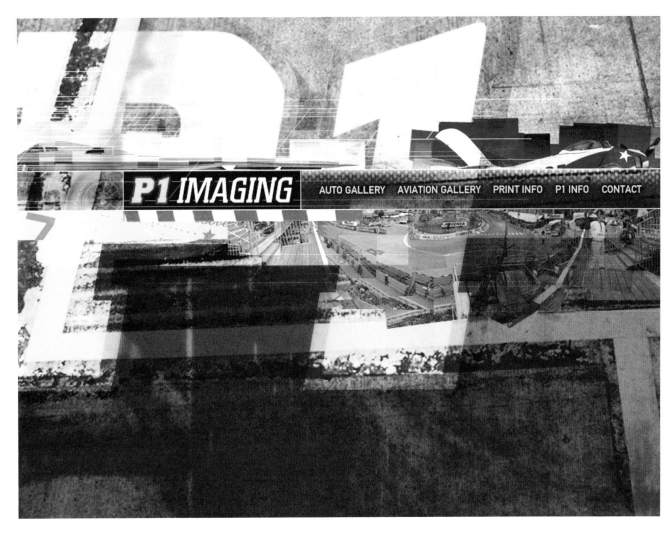

I.10 Fred Davis, *P1 IMAGING website*, 2007.
The website depicts the feeling of movement. The dynamics of the graphics, along with the racing car moving off the page, convey to the viewer that this is a company on the move. The use of complementary orange and blue hues adds to the vibrancy of the imagery.

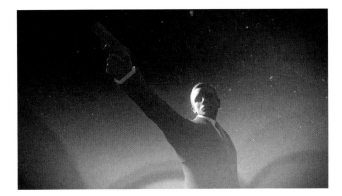

I.11 Alex Donne Johnson (aka Victor Meldrew). Animation for Activision.
The main thrust of the image, the man's arm, is placed on a diagonal to convey the feeling of movement, even in the still frame of this animation. The extreme foreshortened image of the man holding the gun also increases the feeling of excitement in this fast-paced video game.

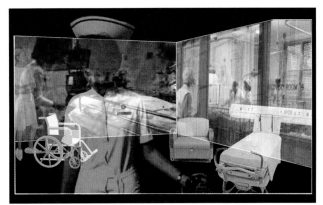

I.12 Annette Weintraub, *Life Support*, 2003.
Weintraub creates a series of spaces based on typical hospital rooms: a waiting room, patient room, etc. Each of these locations is associated thematically with a particular psychological state explored in moving images paired with short fictional stories. The multilayered images create an evocative experience.

Art and Design Fundamentals

One

Process and Principles

As an emerging artist or designer, you are about to encounter possibilities and opportunities as vast as your own imagination. To help you along the way, this textbook will begin by showing you how to thoughtfully approach your artworks and designs. All too often, art textbooks begin with an explanation of the basic elements of design, but cover the creative and conceptual thought process almost as an afterthought. In this book, we will reverse that approach by first exploring how to think creatively and how the design process works. The aim is to enable you to explore and enhance your imagination so that you think like an artist or a designer before you begin to work with the elements. To create a compelling artwork or design, you need to be able to think creatively and develop a solid sense of the concept behind your work. With this concept in place, you can begin to use the elements of design more meaningfully. Otherwise, you may end up moving elements around the page without understanding why.

To support this approach, Part 1 gives you the means of tackling an artwork or design with creativity and thought, so you can then use the elements in a more cohesive, effective, and thoughtful manner. Chapter 1 prepares you to think creatively, conceptually, and critically. Chapter 2 introduces you to the design process, offering insightful techniques for solving problems, generating ideas, and revising and evaluating works. Finally, Chapter 3 examines the role of visual perception and the principles of composition. With this foundation in place, you will be well prepared to dive more deeply into the elements of art and design—first in Part 2, which covers line, shape, texture, value, space, and the illusion of motion, and then in Part 3, which explores the meaning and use of color.

P1.1 Paula Scher, Poster for CBS Records, 1979.

Thinking, Meaning, and Creativity

LOOKING AHEAD

- How do you foster creative thinking?
- In what ways are conceptual and lateral thinking useful?
- What is inspiration, and what role does it play in art and design creation?
- What is the difference between a subjective and an objective rendering?
- What is semiotics and how has it shaped contemporary art and design?
- How can form help to establish meaning in an artwork or design?
- How do form and function work together?
- How are the subject and content interrelated?

A VAST KNOWLEDGE OF ALL OF THE DESIGN ELEMENTS AND PRINCIPLES will not take you very far or mean very much if the concept or idea behind your work is underdeveloped. All you may end up with is a well-crafted array of lines or shapes. If you are lucky, you may end up with a pretty picture. But an artwork or design is more than just a collection of lines and shapes. It is more than just something that is pretty or nice to look at. A **design** is the concept or message that provides the underlying **aesthetic** of a work—the look of the work and the manner in which visual elements are used to communicate a message. Design is purposeful, even when it incorporates the qualities of random chance. After all, "by design" means "on purpose," and "to design" means "to plan." Design matters because at its core is the desire to communicate.

Communication is a fundamental human impulse, and it is one of the fundamental drives within art and design. The message may be a personal statement

1.1 Lambie-Nairn, BBC News Motion Graphic Logo.
The designers at Lambie-Nairn created the BBC News logo as a spinning symbol to convey their client's timely global news coverage. The red hue was retained from an earlier static logo so that viewers would associate the color with the company.

expressed through fine art, or it may be a statement about an organization's identity presented through advertising and graphic design (fig. 1.1). The method and means of communication change as society and technology evolve. But an artwork or a design is created intentionally by the artist or designer to elicit a specific response from the viewer. This process is highly personal, but also transcends the individual, because at its heart, design is a mode or form of communication. Communicating visually, in a way that grabs and holds the viewer's attention, requires thinking creatively and in new ways.

Thinking Creatively

How do you define *creativity*? For a design or work of art to be creative, it must be original or show the audience something in a new and innovative way. Creativity is as much about the thought process behind the work as it is about the work itself.

An excellent example of innovation can be seen in the work of Jonathan Ive and his design team in their design for the iMac (fig. 1.2). The initial two-tone design was a revelation in personal computing and product design that helped save Apple from near bankruptcy. The notion that computers could be made in a color other than the standard institutional grey or office putty transformed the personal computer from an office tool to a home furnishing accessory. The computer became something to be displayed and shown off. The initial iMac colors—first "Bondi Blue," then grape, lime, strawberry, tangerine, and blueberry—were an instant success. Even though the iMac's price point was higher than that of a traditional PC, the iMac outsold the competition. In the years that followed, Ive's team continued to push the bounds of design by changing the shape of the computer and then streamlining it to its essence.

Figure 1.2 shows the progression of their design, from the original two-tone design; to the '60s retro look of the early 2000s; to the sleek, minimalist design of the contemporary iMac.

Creative thinking is about opening your mind to limitless possibilities. Successful artists and designers come up with new ideas and novel ways of looking at objects you have seen thousands and thousands of times before; they encourage you to look at the world with fresh eyes. Ive's design team took something unconventional—the idea that the computer was for the home and for fun—and created a visual way to communicate their message. For Ive and his team, this message was "personal," "playful," "toy," and "home," which contrasted with their main competitors' messages of "business," "work," "machine," and "office." Successful artists and designers use their creative thinking skills to create a context that enables viewers to see things anew.

Seven Principles of Creative Thinking

One method of developing your own ability to think creatively is to look at how others have developed their creative, conceptual, and critical reasoning skills. A prime example of a creative thinker is Leonardo da Vinci. He was a true *Renaissance*

(a) (b) (c)

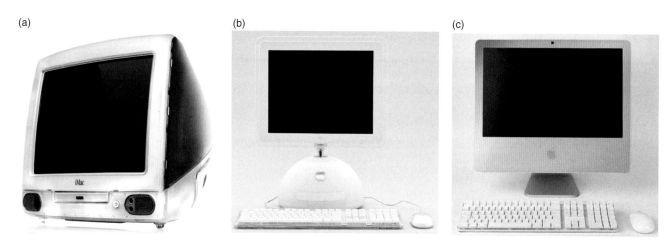

1.2 Jonathan Ive, iMac Computers, 1998–2004.
Pictured is the evolution of Ive's design for the iMac. Left: the original iMac. Center: the 2002 version of the iMac. Right: the 2004 version of the iMac. iMac computers changed shape and color to convey the message that the computer wasn't just for the office anymore.

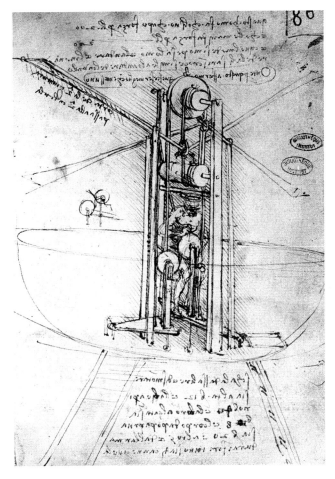

1.3 Leonardo da Vinci, Sketchbook, c. 1490.
This page from Leonardo da Vinci's sketchbooks reveals the artist's fascination with flying. He watched birds, sketched them, and made endless models to try to unlock the secrets of flight. This approach is a visual form of thinking and exploring a subject. Many of da Vinci's flying inventions look very similar to modern aircraft.

man, excelling in myriad areas, not just art. He was a painter, a sculptor, an architect, a scientist, and a military general, just to name a few of his many accomplishments. He invented or designed precursors to the parachute, the helicopter, and other modern inventions (fig. 1.3).

Leonardo da Vinci's ideas regarding cultivating creativity are still studied today. He believed that creativity revolved around keeping an open mind and believing in endless possibilities. His approach to creativity has been the subject of numerous books, perhaps most notably Michael J. Gelb's *How to Think Like Leonardo da Vinci*. Gelb and others have crystallized da Vinci's approach into seven principles for creative thought:

- *Be curious.* Da Vinci's thirst for knowledge was unquenchable. To follow this principle, be sure to keep an open mind and investigate things you don't understand. Keep a notebook, sketchbook, or journal, and write in it daily. Jot down everything that you see, think, and feel. A comprehensive sketchbook should include both written and visual notes and thoughts.
- *Dramatize.* Stage it; bring your ideas to life. Test out your ideas, making them visible. Da Vinci believed in testing one's knowledge through experience—this means not only sketching out ideas but also making models. An artist or designer should be able to work in both two and three dimensions.
- *Refine your senses.* Refine and become aware of all of your five senses. While da Vinci prized sight most highly, he was also keenly aware of his other senses. Play games with yourself to explore your senses: put on a blindfold and examine an object; feel it, smell it, maybe even taste it. See how your other senses can help you to achieve a new awareness of the object.
- *Embrace uncertainty.* It is said that da Vinci never met a contradiction he didn't like. He believed the idea of uncertainty was a motivating factor and a driving force. The lesson here is not to shy away from uncertainty, but to embrace it as a potential source of inspiration.
- *Establish equilibrium.* Don't focus on only one thing. While da Vinci was primarily interested in having a balance in his life between art and science, he was also deeply interested in religion. He felt there should be a balance between reason and imagination.
- *Nurture the body.* Da Vinci believed in keeping the body as fit as the mind. He believed in balance by maintaining a good diet, working, and getting a good night's sleep. He also exercised regularly by walking, riding, and fencing. It's important to keep in shape both physically and mentally.
- *Make connections.* Use your knowledge. Put two and two together. Use what you know. It's not enough just to acquire knowledge—you must put that information to work.

As these principles suggest, an important first step in becoming an artist or designer is to develop your own ideas and begin to record them. Many creative thinkers, from architects to filmmakers, like to use sketchbooks to record their ideas (figs. 1.4–1.7). Sketching quickly generates broad ideas and visual notes for compositional ideas and representations. Many designers also keep what's known as a *rough book*. This book contains drawings and sketches like a sketchbook, but it may also contain pasted-in copies of images, layouts, typeface examples, and even texture or material samples from other sources. Consider your sketchbook as your visual diary or journal.

1.4 Krzysztof Wodiczko, *Tijuana Projection Sketch*, 2001.
Wodiczko worked out the mechanics for his projection installation in his sketchbook. It allowed him to work on variations on a theme prior to production. The notations and personal comments show his creative and thought processes.

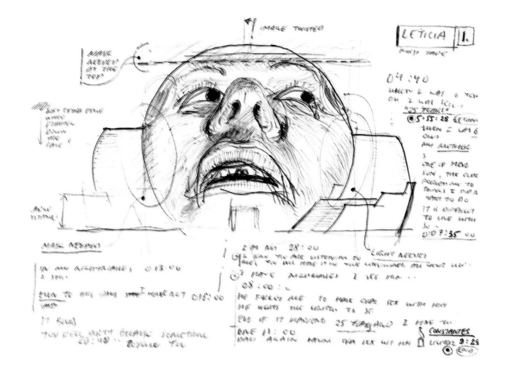

1.5 Graphic Designer, Rosanne Gibel, *Rough Book*, 2011. Pencil, ballpoint pen, and laser prints, 8.5 × 11 in.
A page taken from Gibel's rough book contains notes and quick sketches for a poster for the play *Our Town*. The facing page shows a collection of typefaces the designer was considering for the poster.

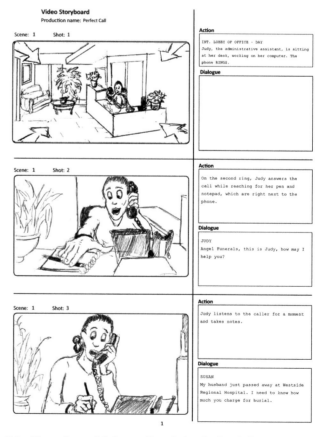

Approaches to Thinking Creatively

There are many methods or modes of thinking. We are probably most familiar with linear thinking, which is orderly and logical. This type of thinking can be very useful if you need to get from one idea to another in a fairly predictable way, or if you need to learn an established process or memorize information. Think back to how you learned to ride a bike or recite the multiplication tables. This type of learning and thinking may work well with some subjects, but not in the

1.6 Filmmaker and Animator, Brett Baker, *Perfect Call*, 2020. Sketched storyboard.
Filmmakers from Guillermo del Toro to Brett Baker keep sketchbooks and storyboards sketching out each scene as visual language to hone and refine their ideas and map out scenes. Baker's loose drawing and notes enable him to fully develop characters and scenery for *Perfect Call*.

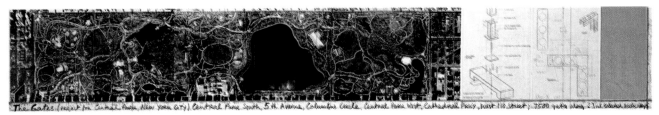

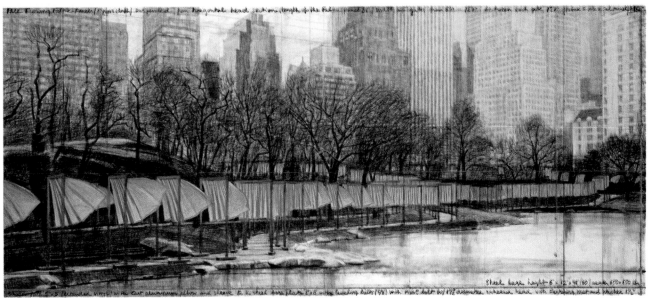

1.7 Christo, *The Gates (Project for Central Park, New York City)*. Drawing 2003 in two parts. Pencil, charcoal, pastel, wax crayon, fabric sample, aerial photograph, and hand-drawn technical data, 15 x 96 in. and 42 x 96 in.
While most sketches are meant to be a private means of working out an idea or recording thoughts, Christo produced refined drawings of his proposed projects. Later, he would sell these drawings to raise funds for complex, site-specific installations. Also included in the rendering is a plan view of the prospective work.

creative fields of art, design, or music. Opening your mind to possibilities requires more than just learning and doing what has been done successfully in the past. Rather, it requires you to make unconventional connections to create new perspectives—just as Ive did when he visualized a computer that was playful rather than purely professional, or as Leonardo da Vinci did when he thought about making machines that fly. The question becomes, how can I keep my thinking from being confined by what is familiar and expected? How can I make new connections that break traditional associations?

Conceptual Thinking

One approach to thinking creatively is to engage in **conceptual thinking**, which involves taking a broad look at a situation to find patterns and links between seemingly unrelated elements and discover their relationships. Conceptual thinking involves opening your mind and developing ideas that challenge traditional modes of thought and result in the creation of new perspectives. Often, thinking metaphorically can lead to conceptual thinking. Metaphors are visual and lend themselves to the creative process. Examples include *feeling*

blue or *a burning passion*. Playing around with this sort of visual language can lead to unexpected insight and stimulate the imagination. For example, try turning a metaphor on its ear, so to speak, by changing one or more of its elements. What does *feeling orange* mean? What would it mean to have *a frozen passion*?

Lateral Thinking

Edward de Bono—a physician, philosopher, inventor, filmmaker, and writer who founded the Cognitive Research Trust—first coined the term **lateral thinking**. Unlike linear thinking, lateral thinking wanders, free-associates, and is intuitive. This type of thinking reveals connections that may not be immediately apparent or obvious. In lateral thinking, the object is to move from accepted ideas to innovative ideas in ways not obtainable by using only traditional, step-by-step logic. For example, the nineteenth-century Impressionists used lateral thinking when they decided to allow their brushstrokes to be visible in their painting. Prior to that time, the surface of a finished painting was completely smooth. The surface quality of the Impressionist paintings was a part of the conceptual basis of their work.

Questioning Assumptions

A common method of promoting conceptual and lateral thinking is to ask questions designed to fracture traditional thinking patterns. For example, you might ask the question "Why?" in a nonthreatening way: "Why does something exist?" or "Why is it done the way it is?" The result is a very clear understanding of "Why?" that naturally leads to fresh new ideas.

To make a concept for an art or design piece clearer, you can set up a problem and ask some questions. Developing different solutions to the problem will hone your conceptual and lateral thinking skills. Questioning is a valid way to generate ideas. Remember to keep questioning what you see and what you know to be true. Practicing this will allow you to find new ways to communicate a message.

The goal is not just to produce something novel, however. There must be a deeper significance or concept behind the work. Consider photographer Laura Swanson's exploration of the question, "What is your point of view?" In asking this question, Swanson plays with the double meaning of "point of view"—as a particular attitude toward a subject, and as a physical vantage point from which we view the world. Common conceptions about one's physical point of view take for granted the idea that an eye-level vantage point is between five and a half and six feet from the ground, but Swanson takes as her starting point the concept that eye level is relative. Laura Swanson's exceptional point of view is both actual and aesthetic—she has dwarfism and stands just under four feet tall.

Swanson's height and her lifetime of experience looking at things from this distinctive vantage point have made her photographs unique. Swanson takes the traditional conventions of composition and manipulates them to create a personal aesthetic. She creates a strong underlying concept in her compositions when she cuts off parts of the figures in the photographs (fig. 1.8). Her works are a visual interpretation and representation of the world as seen from this vantage point.

This example illustrates one artist's unique voice or vision. Now the question is, "What do *you* want to say?" Each one of us has his or her own voice. It's important to reflect on why you want to make a visual statement. Many people have an innate fear of expressing their own ideas. Don't succumb to this fear. Make a statement. Be true to yourself. Keep asking questions. As you try to push yourself further when thinking about a visual solution to a problem, keep the following advice in mind:

- Be open to new ways of seeing the world, and be willing to explore.
- Don't worry about the end result; enjoy the journey.
- Put aside commonly accepted beliefs or constraints. What is true today may change tomorrow.
- Find a way to understand a visual problem by identifying patterns, similarities, or connections.

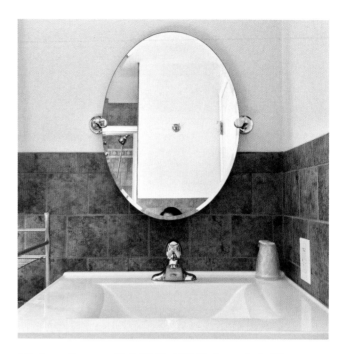

1.8 Laura Swanson, *Digital Selfie*, 2011. Photograph, 5 x 5 in.
At first glance, someone might miss the forehead of the person's reflection in the mirror. Swanson's method of framing the subject, in this case a series of self-portraits or "selfies," results in the figure barely being visible. The vast empty space of the photograph reinforces her vantage point at eye level and shows the issues she faces in daily life.

CONCEPTUAL CONNECTIONS

How can changing the point of view alter the sense of balance in a composition? How does your eye level influence or affect your work?

- Use your technical training, experience, creativity, reasoning, and intuitive processes to identify potential solutions or viable alternatives that may not be obvious.

Finding Inspiration

Inspiration refers to the initial germ or concept behind a creative or innovative idea. Making use of a moment of inspiration involves taking the germ of an idea and going forward, using it as a starting point for your creative endeavor, whether it's creating an artwork or a design. One of the most traditional methods of sparking creative thinking is to take your first idea or inspiration and see where it leads. Thinking conceptually, you could ask yourself questions about how you might use your sources of inspiration to see patterns, make connections, and explore issues. Inspiration is not copying. There is a difference. Copying is just that—even if it's copying a color or a texture. There is a fine line between borrowing

David Hammons's *Basketball Drawings*

Charcoal? Pencil? Or dirt? How can media make the message?

When you think about drawing, the first things that come to mind are probably the most traditional means of media application: a brush, a pencil, a pen, a stick of charcoal, and so forth. But what other tools could you use to make drawings? What would happen, for example, if you applied powdered charcoal to a rock, a ball, a rolling pin, or a car tire? This sort of thought experiment is not just about finding a new means of applying the media. For the result to be meaningful, you must make a connection to your content and what you are trying to say with your work.

David Hammons's drawings are rooted in the African American, inner city experience. Hammons created the series *Basketball Drawings* by bouncing or dribbling a basketball on pieces of paper (fig. 1.9). The marks on the paper are not composed of any traditional drawing media such as graphite or charcoal, but of dirt. On the paper, the soft gray dirt looks similar to graphite. Using a basketball to apply graphite, charcoal, or dirt can be considered an anti-art technique, and the process can be seen as pushing the bounds of materials and media to create a new form of drawing.

The drawings—most of which measure 10 feet in length—are framed and propped up against the gallery wall. Behind each drawing rests an old suitcase. This found object may speak to the artist's own feelings of disenfranchisement. The luggage can also be viewed as a metaphor for the distance from the inner city to the world of the art museum. Further, it represents the emotional baggage we all carry with us. The gilded frames add an additional element of preciousness and have a direct relationship to the museum world and high culture.

Visit the online resource center to view the Contemporary Voices feature.

1.9 David Hammons, *Out of Bounds*, 2000–10.

or sampling and plagiarism. Push yourself to make the concept your own. It has been said that success is 1 percent inspiration and 99 percent perspiration. There is no substitute for hard work.

Artists and designers find inspiration everywhere. The following list explores some of the most common sources.

- **Nature.** The entire range of flora and fauna can provide inspiration. Components of natural organisms are also valid avenues of exploration, from the elemental structure of an atom to the building blocks of the human body, including bones and muscles. One way of using nature as a source of inspiration can be found in the work of Georgia O'Keeffe. O'Keeffe is well known for her paintings of flowers, but she was also very interested in the form and structure of bones. She used bones in her drawings and paintings, developing ideas from their natural shape and structure (fig. 1.10).
- **Culture.** Culture—the beliefs, customs, and practices of a people, nation, or class—can generate interesting

1.10 Georgia O'Keeffe, *Pelvis Series—Red with Yellow*, 1944. Oil on canvas, 36 1/8 × 48 1/8 in.
O'Keeffe drew inspiration from nature (in this case, bones) to produce works that do more than copy the original forms—they convey her personal aesthetic statements about the essence and flow of the natural forms.

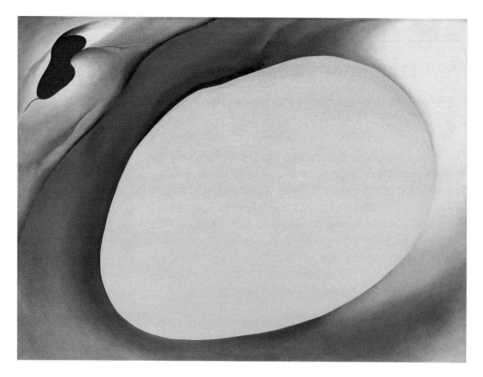

1.11 Jonathan Green, *Lowcountry Blue House*, 2013. Acrylic on archival paper.
Green often draws on his Gullah heritage for inspiration. The painting shown here portrays a female figure winnowing rice using a traditional sweetgrass basket.

CONCEPTUAL THINKING ACTIVITY

Artists and designers often use their cultural or religious heritage to develop their work. Using your background heritage and life experiences, develop a work of art or design that reveals something of your personal history and how it shapes your worldview. Think about who you are as an individual and interpret this through your voice, personality, or individual sensibilities. Write a paragraph explaining your concept and why/how you created the artwork or design.

avenues of exploration. An artist or designer may comment on his or her own culture and traditions or on a new culture experienced as a tourist or visitor. Artist Jonathan Green uses his Gullah cultural heritage as the basis for much of his work. In many of his paintings, he explores traditional cultural themes such as the historical significance of rice cultivation in South Carolina, where he was raised (fig. 1.11).

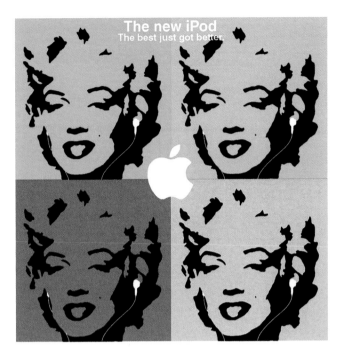

1.12 Laleh, *Imagined iPod ad*, 2015.
This imagined ad for Apple's iPod uses the Pop Art style of Andy Warhol and his silk-screened images, referring back to pop culture icons. The images of Marilyn Monroe are familiar to everyone today, even though she died in 1962.

1.13 Gary Tepper, *Mauser*, 2005.
Tepper's choice of subject was inspired by his Jewish heritage. In *Mauser*, which is part of the series titled *Yid Du Partizaner (Jewish Partisan)*, the viewer is confronted with a landscape devoid of people, evoking the devastation experienced by Jewish people during World War II. The drawings in the series show only traces of someone having been there—a jacket, a cup, the tip of a gun barrel, and so on.

CONCEPTUAL THINKING ACTIVITY

Artists and designers often rework one another's creations (see also figs. 1.19 and 1.20). Choose a famous artwork or design and interpret it in your voice. How would you remake the work to bring it into a contemporary time and setting? Alternatively, how might you remake it to incorporate your personality, sensibilities, philosophy, or outlook? Write a paragraph explaining your concept and how you might recreate this artwork or design.

- **Pop culture and mass media.** Popular culture, which includes the mass media, is a subset of culture. It provides a fertile ground for social and political commentary. The artists of the Pop Art movement, which arose in the 1950s, were influenced by and reacted to what they viewed as contemporary, mass-produced culture. More recent commentaries on mass-produced culture surfaced through a design contest organized by DesignCrowd, a crowdsourcing marketplace for freelance designers. In 2015, DesignCrowd challenged designers to Photoshop famous pop culture icons into modern advertisements (fig. 1.12). The contest demonstrates how advertising capitalizes on elements of pop culture to sell products. Today, consumer commercialism has become a staple concept for artists and designers to observe and investigate. These observations can take the form of satire or a political, social, or personal commentary.
- **Personal experience and heritage.** Artists and designers often reflect on their own experiences and express their own biographies and heritages in their work. An example can be found in Gary Tepper's drawing series *Yid Du Partizaner (Jewish Partisan)*, which is an homage to the Jewish resistance during World War II (fig. 1.13). While every work has some part of the artist or designer imbued within it, the reason or context in which it was produced is part of the work and can never be separated from it.
- **Art history.** Artists and designers also look back into the history of art for ideas. For example, in his later years, Picasso reworked the most famous paintings of the Old Masters, painting them the way—as he put it—"they should have been done" (figs. 1.14 and 1.15). Picasso is not plagiarizing the original; he is internalizing it and reinterpreting it in his artistic voice. It is not "sampling," since he is not taking pieces of the original but is, instead, completely reinventing it.

Keep these examples in mind as you seek out and explore different sources of inspiration that speak to you, and as you draw on these sources to generate meaningful ideas for your own artwork or designs.

Creating Meaning

Making art or creating designs is a way to express ideas and emotions that go beyond words or that may be difficult to define. Meaning can be conveyed either subjectively or objectively. A **subjective** view provides a personal or emotional interpretation of the subject matter (fig. 1.16). Conversely, an

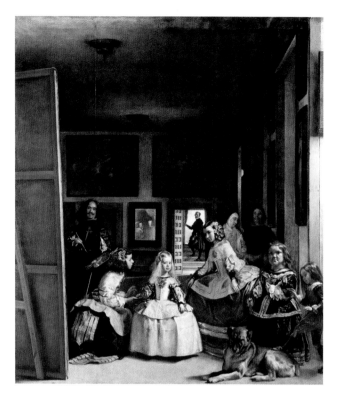

1.14 Diego Velázquez, *Las Meninas*, 1656. Oil on canvas, 125 × 109 in.
Velásquez depicts the members of the Spanish imperial family preparing to sit for their portrait. He portrays this as a pictorial event, in full detail, and even includes himself in the royal portrait, raising his status as their equal.

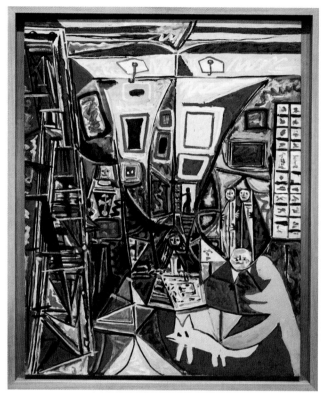

1.15 Pablo Picasso, *Las Meninas (after Velázquez)*, 1957. Oil on canvas, 64 × 51 in.
In his later life, Picasso often reworked the paintings of great master artists, such as Velásquez. He felt they were the only ones whose work was on par with his own. He also believed his works bettered the work of his predecessors.

objective rendering is unembellished and straightforward, not influenced by personal feelings or opinions (fig. 1.17). In either case, it is not really a matter of what to say, but how to say it, that creates a context for meaning. Context is a critical component of how we understand and perceive art and design.

Perception and Meaning

When you look at any depiction or illustration, it's important to understand that you are not looking at the thing itself but a representation, a **symbol**—a shape or other visual representation that is commonly understood to stand in for something else. Each culture or group of people may have differing meanings for similar objects. The term *iconography* refers to the visual symbols and icons used in a work of art, and also to the study of their cultural usage and meaning. Understanding the use of these pictorial elements is known as *visual literacy*.

Comprehending the meaning of any symbol or collection of symbols is vital to the creative process. The study of these underlying or intrinsic messages is known as **semiotics**. Literary theorist and semiotician Roland Barthes, along with other pioneers in semiotics, argued that a symbol or "sign" has two components: the signifier and the signified. The **signifier** is

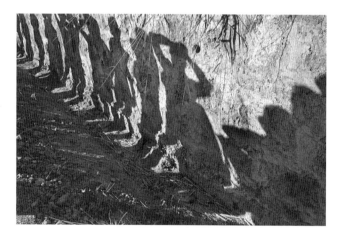

1.16 Susan Meiselas, *Soldiers Searching Bus Passengers*, 1980. Photograph.
Long cast shadows portray the bus passengers lined up, hands on their heads, being interrogated. The faceless figures seen only in shadow create a sense of foreboding and danger. Meiselas does not merely record the incident; she gives us her interpretation of the events as they unfolded.

the visual form that the sign takes, while the **signified** is the object or concept that the sign represents. In other words, the signifier refers to the sign's physical shape, while the signified is

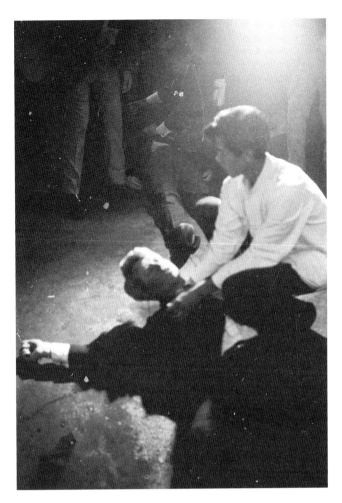

1.17 Bill Eppridge, *Robert F. Kennedy Shot*, 1968. Photograph.
This photograph documents the moments after Robert Kennedy was gunned down. Eppridge dispassionately records the occurrence without trying to editorialize or comment on this tragic event.

CONCEPTUAL CONNECTIONS

If everyone has a personal view of the world, how can an artist or designer create an objective composition? Is there such a thing as true objectivity?

the meaning associated with that sign. Consider, for example, the symbol of the American flag. The flag itself, in its physical form, is the signifier. The *meaning* of the flag—the American people, along with their beliefs and ideals—is the signified.

René Magritte explores the relationship between the signifier and the signified in his painting *Treason of Images* (fig. 1.18). He depicts the image of a man's pipe. The text or caption proclaims, "This is not a pipe." This is true; it is not a pipe. It's an image or painting of a pipe. Magritte knew that words and names, like symbols, could misrepresent the true meaning of an object. In this work, he challenges the notion of what we have been brought up to accept on face value and asks us to look more closely at the images we see.

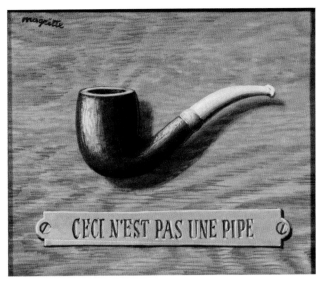

1.18 René Magritte, *Treason of Images*, 1910. Oil on canvas, 24 × 31 in.
If we take Magritte's message a step further, what you are viewing here, on this page, is not a Magritte painting, but the scanned image of a photograph of the actual work.

The meaning of an artwork or design is not always obvious. Viewers' interpretations of artworks and design are often influenced by their personal experiences and heritage. While these experiences can inform a viewer's interpretation of a piece, conversely, a viewer might misinterpret an image if he or she is missing a piece of the puzzle—cultural context. Take, for instance, the varied ways in which different cultures think about color. Let's take the practice of funerals as an example. In the West, black has been the customary color for funerals. In much of Asia, however, white is the traditional funeral color (Bleicher, 2012). To apply Barthes's terms, white is the signifier, while its associations—the purity of the soul at death—are the signified. Red is the color for mourning in many parts of West Africa and in South Africa, while yellow is the color used in traditional Egyptian funerals. The signifier, or visual form, therefore, can reveal a multitude of different meanings depending on the viewer and his or her unique interpretations.

Modernism and Postmodernism

Modern art can be defined as art created or produced from around 1870 to about 1970. The term encompasses the philosophy and aesthetic styles of the art produced during that time period. In the modern era, artists and designers moved past tradition and focused on experimentation and personal expression. In some ways, the modernist approach can be thought of as moving beyond painting what one sees, to being able to create anything one's mind can conceive. Modern art movements include Impressionism, Cubism, Surrealism, Abstraction, Minimalism, and the beginning of Conceptual art.

We refer to the *postmodern era* as a reaction against modernism. It is a paradigm shift and philosophical split from the formalism of modern art to antiformalism. For instance, while the modernists were interested in the physical properties of a piece—what it looks like and the method used to create it—the postmodernists were less concerned with form. In postmodern art, the role of the artist or designer is more about conception than production. Postmodern movements are different and disparate yet connected by a number of characteristics, in particular the satirical and playful treatment of fragmented subjects and the breakdown of cultural hierarchies or classes. Postmodern artists often subverted the traditional concepts of authenticity and originality while emphasizing text, image, grandeur, and spectacle.

Postmodernism and Contemporary Contexts

In today's **postmodern** world, the meaning or concept behind a work is often ironic and fractured. To convey such messages, postmodern artworks and designs typically make use of one or more of the following elements:

- **appropriation**—taking or borrowing something, often from popular culture or art history, to create a different context for its use. This can also be referred to as "sampling."
- **hybridity**—mixing two different or incongruent elements together, often achieved through combining various disparate media or materials.
- **layering**—combining many items or elements on top of one another, including the expression of levels of meaning.
- **fragmentation**—showing elements in bits and pieces rather than portraying the entire image.
- **nonlinearity**—creating elements of a narrative that move in an unpredictable fashion.
- **recontextualization**—placing familiar words, images, or concepts in new or unexpected contexts.
- **juxtaposition**—placing contradictory words, images, or concepts close together to show a contrast.
- **deculturization**—shifting the focus away from concepts of high or low culture to create a democratization of cultural status.
- **spectacle**—the grand, glorious, and monumental is preferred to the banal and everyday.
- idea over technique—concept is more important than craftsmanship or style.
- instant meaning—images should be immediately recognizable to the audience.

In effect, postmodern works ask us to view things in a new way by questioning our assumptions and making the familiar unfamiliar. In this way, the conceptual and creative thinking behind postmodern works creates new perspectives.

Postmodern works often make use of cultural **icons**—images or works that have become so familiar that everyone recognizes them and shares an understanding of the concepts they represent. In a sense, an icon is something that has become part of the visual vernacular. Many well-known paintings and sculptures have become icons, taking on a life and meaning beyond their original context. Consider Edvard Munch's *The Scream*, which for many has become shorthand for an agonized howl of pain or fright (fig. 1.19). Photographer Jonathan Knowles appropriated this familiar image for an advertisement that he helped to create for an anti-obesity drug (fig. 1.20). In this case, the audience's immediate recognition of the reference to Munch's famous painting establishes a meaningful connection. In other cases, this sort of recognition and recontextualization works as a form of satire, using humor to comment on cultural obsessions. Using humor in this manner can be an effective design strategy.

1.19 Edvard Munch, *The Scream*, 1893. Oil, tempera, and pastel on cardboard, 35.8 × 28.9 in.
The iconic figure in the foreground has a gaping mouth and hands holding or caressing its face in distress. It is distanced from the other two figures in the background. Munch uses a contrasting palette of orange and blue, which adds further drama to the imagery.

1.20 Jonathan Knowles, *Xenical Scream*, c. 2006.
This advertisement for a drug aimed at treating obesity comments on contemporary society's obsession with weight loss and dieting. The reference to Munch's *The Scream* contributes to the image's strong visual impact.

Thinking Critically: A Framework

Critical thinking involves delving deep into the heart of a problem or an issue. It involves analyzing an issue from all sides, such as by taking a work apart to examine the individual elements in order to better understand how its message has been constructed. When a work of art or a design is discussed or analyzed, it is thought of as having two basic components: form and content. As you think critically about a work, consider the following questions:

- How does the form relate to the content or message?
- How does the form relate to the work's function?
- How are the subject and the content related?

In the next section, we define form and content, and we examine some of the major considerations raised by these questions.

Form and Content

Form can refer to the overall shape and appearance of a work, or it can refer to the makeup, structure, and collective elements that combine to create a work. When we talk about *formal elements*, we refer to the elements that contribute to a work's form—both the materials used (e.g., ink, paper, or clay) and the design elements (line, shape, color, etc.). These elements, which can be measured or categorized, can contribute to a work's content in a number of ways (e.g., see fig. 1.21):

1.21 Morten Løfberg, Cover for *Journalist* Magazine, 2017.
Løfberg's choice of materials and his use of organizational elements contribute to the overall effect and meaning of the work.

- *Materials.* The materials an artist or designer selects when creating a new work can greatly affect the look, feel, and inherent message of the artwork or design. If an artist selects watercolor, the look and feel of the work will be different than if the artist had used oils or acrylics. Løfberg's use of ballpoint pen and digital technology creates an interesting mixture of surfaces, including the buildup or layering of pen marks. The right material and media need to be selected to impart specific meaning and context to the work.
- *Line.* Line can lead the viewer through a work. It can be used as a physical element, or it can be implied or suggested through such things as the gaze of one person looking at another. In Løfberg's image, the man looks directly at the audience, confronting it. Lines may also be used to form shapes or to create texture or value, such as Løfberg's use of hatching in the beard and cross-hatching in the coat jacket.
- *Shape.* When a line connects and encloses a space, a shape is formed. Shapes can be geometric, organic, or realistically rendered, as in the man depicted in Løfberg's magazine cover.

- *Texture and Pattern.* Texture is the physical, tangible quality of an artwork or design. Textures imbue the work with a visceral tactile quality. Pattern is the visual repetition of a shape or color. In Løfberg's image, the pen work gives an overall texture to the drawing.
- *Value.* Value adds depth and volume to the shapes. Without value, all forms would be dimensionless and flat. It also can convey the quality and strength of the light or light source. Løfberg's use of different line techniques—hatching and cross-hatching—adds value to the work.
- *Space.* Space can be portrayed as shallow, deep, or even flat. There is a shallow sense of space in Løfberg's magazine cover, with no distinct foreground and background.
- *Motion.* Creating the illusions of motion on a flat page or canvas can give the viewer a sense of the speed and movement of the images portrayed. Placing elements or object on a diagonal within the composition is one method of conveying a sense of movement: the greater the angle of the diagonal, the faster the movement will appear. When working in three dimensions, the artist or designer can work with actual or kinetic motion.
- *Color.* Color can create mood, suggest light, show the time of day or season, or be used purely as a design element. In Løfberg's cover art, the palette is directly related to Google's use of color in their logo.

More broadly, *form* refers to the style of a work. There are a few main styles within the field of art and design:

- **Naturalism.** Created from direct observation, naturalistic art is a realistic or factual representation of a person, object, or landscape. Also known as *realism*, naturalism might be thought of as an honest portrayal of the subject, "warts and all" so to speak. There is no attempt to romanticize or manicure the image. A strict, sometimes even photographic, representation is fundamental in these works (fig. 1.22).
- **Idealism.** Related to the concept of naturalism is idealism. Both concepts are tied to a visually realistic representation of the subject, with one major difference: in idealism, the goal is to make the object appear better than it may actually be in life. The idealization of the human form dates back far into human history. For example, the Ancient Greeks and Romans were renowned for their idealization of physical beauty (fig. 1.23).

- **Abstract.** Abstract art is derived or synthesized from nature. This may possibly be the most misunderstood style of art. Abstract art does not, as many people believe, encompass all nonrealistic or highly imaginative works; there are limitations to what can be considered abstract. In abstract art, the elements are altered to fit the composition and the *artist's* intent by being elongated, streamlined, or trimmed down to their bare essence. Whatever the visual treatment of the form, *abstract* implies that the design, images, or forms have their roots in the natural world (fig. 1.24).
- **Non-objective.** The elements in non-objective art have no relation to and do not reference the shapes or forms in the natural world. A good example of non-objective work can be seen in Jackson Pollock's

1.22 Kadir Nelson, *Harlem on My Mind*, cover for *The New Yorker*, 2016. The cover realistically portrays important figures in Afro-American history, including Zora Neale Hurston, Malcolm X, Billie Holiday, and Duke Ellington. Accurate and detailed representations, like the representations on this cover, characterize naturalism.

drip paintings (fig 1.25). Often people refer to non-objective works as abstract, which is inaccurate. When communicating with other art professionals, it is important to use the correct terminology in order to ensure clear communication and understanding.

Content refers to the meaning of the artwork or design. It is the message of the subject, that which the artist or designer is trying to communicate. That message can be very literal, as in the case of an advertisement, or it can be more abstract and open to speculation and interpretation, as in the case of an artwork. The message can be personal, religious, political, or formal. All artworks and designs have a message or meaning. Sometimes, it's important to pass over a work's title and examine the imagery for its true meaning. For example, the title of Salvador Dalí's painting *Composition with Boiled Beans* belies the artist's intended meaning and was meant to fool

1.23 *Aphrodite of Melos*, also called *Venus de Milo*, **Hellenistic, c. 130–120 BCE. Marble, 80 in.**
Considered the ideal of feminine beauty, Aphrodite (or Venus, the Roman equivalent) was the goddess of love and fertility. Here she is represented with idealized proportions, such as a smooth, simple curve to the nose, fixed proportions of height to weight, and even an index toe that is longer than the big toe.

1.24 **Nicola Golden,** *Eve 1,* **2004. Bronze, approx. 10 in.**
Golden uses a streamlined, smooth, organic form to express her concept of Eve, the first woman. The features have been pared down to their most elemental form. Golden maintains that the green patina gives the form the feeling of extreme aging, as if the object had been uncovered after hundreds of years.

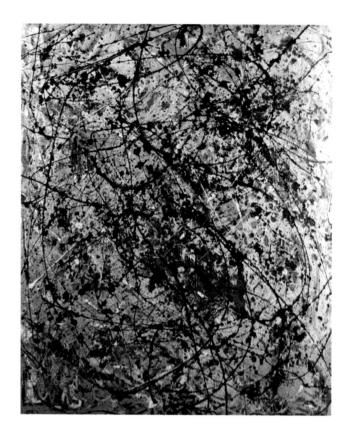

1.25 Jackson Pollock, *Reflection of the Big Dipper*, 1945. Oil on canvas, 43 1/2 × 36 in.
The spatters of paint in this drip painting do not represent streams or rivers or any other observable phenomena in the natural world. What the viewer sees is the movement and action of the paint as it hit the canvas.

the uninformed viewer (fig. 1.27). The imagery—in particular, the tormented face, abstracted sword, and skeletal parts against a desolate landscape—convey a message about the savage brutality of war.

Form and Function

An artwork or design may be created for its functional use. Many times the form and function of an object can go hand in hand (fig. 1.28). This was the underlying concept of the **Bauhaus**, a German art movement beginning in the early part of the twentieth century. The name *Bauhaus* is derived from the German words for *to build* and *house*. The movement was founded by Walter Gropius in 1919 and combined the aesthetic of crafts and fine art using radically simplified forms that stressed the functionality of the object. The credo of the German school was "**form follows function**." Bauhaus artists and

Global Connections
Benin Sculpture

Is naturalism a Western concept?

Naturalism is not solely a Western concept. While many non-Western traditions tend to have very formalized nonrepresentational imagery or depictions, the Edo people of the Benin Empire in Africa were known for their naturalistic representations, a rarity in early non-Western societies. Their sculptures of human forms are realistic and anatomically accurate. Consider, for example, the brass sculpture in fig. 1.26. Reflecting the conventions of the time, the sculptor depicts the "Oba," or high ruler, in an idealized manner. Portrayed at the prime of his life, the Oba's straightforward-gazing eyes, which originally would have included iron inlays, seem as though they are peering into another world; as such, the piece emphasizes the divine power of the ruler. Bronze castings such as this one are a hallmark of Benin art, reflecting the society's advancements in both art and technology.

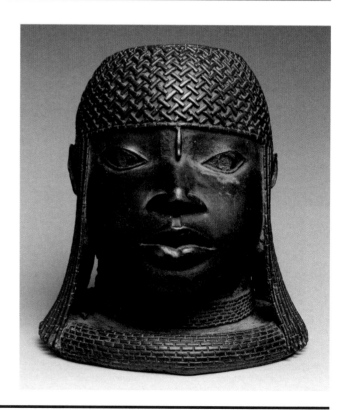

1.26 Head of an Oba, African, Nigeria, Edo; Court of Benin (ca. 1550). Brass, 9 1/4 × 8 5/8 × 9 in.

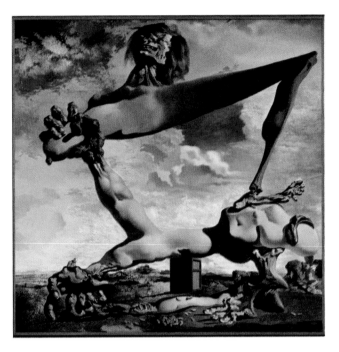

1.27 Salvador Dalí, *Composition with Boiled Beans*, 1936. Oil on canvas, 39 × 39 in.
This painting is a political antiwar statement, referring to the events of the civil war in Dalí's home country, Spain. The imagery of the beans represents a traditional Spanish offering to placate evil spirits. Dalí also contrasts the softness of the beans (the people) with the hardness of the sword-wielding arm, which represents the Franco dictatorship.

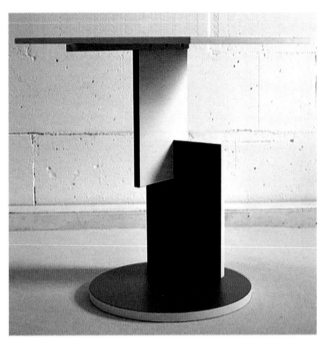

1.28 Gerrit Rietveld, *Table Schröder*, no date (reproduction).
Rietveld believed in the importance of front-end planning. His innovative, thoughtful design for a table stresses functionality first, which dictates the object's form.

CONCEPTUAL CONNECTIONS

How can the personal use of abstract images develop a sense of meaning in an artwork or design? How can that personal statement be made to communicate a more universal idea or concept?

designers believed that mass production could exist harmoniously with the individual artistic sprit. Their goal was to harness the potential of mass production and preserve Germany's economic competitiveness with England and other Western countries.

The philosophical outlook of the Bauhaus school profoundly influenced contemporary furniture, product, and graphic design. The movement was part of a growing trend toward German nationalism. By the mid-1930s, however, the Nazis had closed down the school, and many of the artists immigrated to the United States. The Art Deco movement of the same period stands in sharp contrast to the Bauhaus philosophy; for proponents of Art Deco, style and grace outweighed function and use.

Subject and Content

We may not always agree with the subject and content of a work of art or design. Yet this sort of disagreement does not necessarily mean that the art or design is not executed well or that it is a poor creation. When assessing a work, we need to be able to separate personal, subjective taste from objective analysis. A piece of work can be very well done and someone may dislike it for its message and content, the forms used, or even its color.

In her exhibition piece *Falling*, Sharon Paz placed silhouetted figures on glass windows to make it look as if the figures were falling through mid-air (figs 1.29 and fig. 1.30). The work was exhibited on the one-year anniversary of the World Trade Center attacks. It reminded people of the heart-rending sight of people jumping from the Twin Towers—a sight that is now engraved in our collective memory. The association with that unforgettable moment in time created a controversy in which many people, including some of the art center's staff and visitors, insisted that the work be removed. On September 23, 2002, after numerous complaints and much bad press, the work was taken down.

1.29 Sharon Paz, *Falling*, 2002.
This controversial piece consists of cutouts of human figures pasted to the exhibition venue's windows. The figures are all placed on an angle or diagonal to further create a feeling of motion.

1.30 Sharon Paz, *Falling*, 2002.
An exterior view of the installation at the Jamaica Center for the Arts & Learning in New York City.

Paz defended her work, explaining that her subject was the experience of falling. The fear of falling is one of the most basic human fears, but at the same time, people associate falling with the dream of flying. Paz said she wanted to represent this dichotomy in her work and explore the psychological side of the event. The content, however, includes the emotional resonance this work had with the horrific events of September 11, 2001.

The public reaction to a work of art or design brings out questions about art's role in our society. What one person finds acceptable, another person may find offensive. Questions every artist and designer must face are where do you draw the line, and what is your responsibility to yourself and to the public?

THINK ABOUT IT

- What is creativity?
- What creative traits or habits do you use in your daily life?
- Could a work of art or design be both objective and subjective at the same time? Or are the two concepts mutually exclusive? How would you sketch out an idea that showed both principles simultaneously?

- What is semiotics? How would you use the concepts of the sign, signifier, and the signified to analyze an advertisement or artwork?
- As an artist or designer, how concerned should you be with the impact of your work? What is the responsibility (if any) of the artist or designer to the audience?

IN THE STUDIO

A key to thinking conceptually and creatively is the ability to change your initial concepts and perceptions. Practicing this ability as you create new artworks and designs will help you to expand your language of visual forms. Taking a cue from

David Hammons (see fig. 1.9), create a drawing (11" × 14" or larger) that is either representational or nonrepresentational by using any non-art media. These media might include tape, mud, makeup (such as eye liner), coffee, or even rust. Think

about how your choice of media relates to your subject matter (figs. 1.31, 1.32, 1.33). Be bold with this project; don't be afraid to express your ideas and make a statement. Experiment with the media and see where it takes you.

1.31 Student Work: Skylar Delaney, *Alternative Media*, **2016.** Delaney used food coloring and glue to create this work as part of her disease series.

1.32 Student Work: Emily Beekman, *Alternative Media*, **2016.** Beekman used food coloring and tissue paper to develop this naturalistic portrait of an elephant. The tissue paper creates the tactile sensation of the elephant's hide.

1.33 Student Work: Morgan Hedgecock, *Alternative Media*, **2016.** Hedgecock produced this nonrepresentational color field work with wax. She was interested in the flow and blending of the wax as it hardens, freezing the moment at which the colors blend together.

VISUAL VOCABULARY

abstract
aesthetic
appropriation
Bauhaus
conceptual thinking
content
creative thinking
critical thinking
deculturization
design
form

form follows function
fragmentation
hybridity
icon
iconography
idealism
inspiration
juxtaposition
lateral thinking
layering
naturalism

nonlinearity
non-objective
objective
postmodern
recontextualization
semiotics
signified
signifier
spectacle
subjective
symbol

2

The Design Process

LOOKING AHEAD

- What are some art and design techniques for solving problems?
- How do I get started with the design process?
- What are some approaches to generating new ideas?
- Why is drawing and visual ideation important to the design process?
- Why is it important to revise and edit a work in progress?
- What are the different methods of evaluating an artwork or a design?

MOST PEOPLE PASS BY THE ITEMS THAT SURROUND THEM IN THEIR daily lives without giving them much thought. An important part of the creative process is to carefully observe your surroundings—to really look and see what's all around you. Taking the time to sensitize yourself to your environment raises your consciousness; it can lead you to discover new or unusual connections and combinations.

The first step in the creation or development of an artwork or a design is finding an initial idea or inspiration. As we saw in Chapter 1, this inspiration can come from many sources. The challenge for the artist or designer is to refine that first vision into an entity that will hold the viewer's attention and communicate the intended message (fig. 2.1).

The method of thinking, planning, and executing an artwork or design is known as the **design process**. The design process is more than just the physical act of

2.1 Pat Gorman of Manhattan Design, MTV Press Kit Cover, 1982.
The variety of colors and images in this promotional design for MTV holds the viewer's interest. The colors were randomly selected from a vibrant palette to convey the new network's hip and edgy personality.

producing or making an artwork or design; it encompasses the complete thought process an artist or designer needs to use in order to achieve an end result and communicate a desired message.

Problem Solving

Often, artists and designers work to solve a problem or answer a question that exists within themselves, based on an internal need, desire, or curiosity (fig. 2.2). At other times, they may work to solve a problem presented to them by an employer or a client, to meet an external goal (fig. 2.3). Whichever the case, the problem-solving task should be viewed as a holistic, imaginative process. Questioning and understanding how something works or how its components fit together can lead to new insights and ideas. Those ideas, in turn, can lead the way toward developing creative visual solutions.

In the initial stages of problem solving, writing can serve as a productive means to help clarify a problem and create new channels of thought. While this may sound strange, since we think of art and design as nonverbal methods of communication, many artists and designers find the following approaches useful for gaining a deeper understanding of a given problem:

- *State the problem.* The first step is to write down the problem. What are you being asked to do or accomplish? Think about the problem from several different points of view, and describe it in as many ways as possible. Stating the issue in a variety of new ways opens up the possibilities of what might be created or produced. The more open-ended the statements or

2.3 Adobe Inc., Promotional Adobe Creative Cloud Poster, 2015. This poster has been produced to fulfill the needs of the client, Adobe, by promoting their software package. The designer's intention is to capture the viewers' attention, make them want to know more about the product, and hopefully convince them to purchase it for themselves.

questions are, the greater depth they will have, and the more likely they are to lead to more complex creations.
- *Write out what you want to accomplish.* Another method of opening yourself up to new possibilities is to write out in a single sentence what you want to do or accomplish. Be as clear and precise as you can. Try

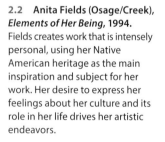

2.2 Anita Fields (Osage/Creek), *Elements of Her Being*, 1994. Fields creates work that is intensely personal, using her Native American heritage as the main inspiration and subject for her work. Her desire to express her feelings about her culture and its role in her life drives her artistic endeavors.

to write your goal in a strong, positive voice. When you have your sentence, cut it down to one word. That one word should be the heart or essence of your goal. It will become your mantra.

- *Take notes.* An adjunct to writing out the problem is to take notes. If you are working for a client, record the words she or he uses to describe the problem. Don't rely on your memory. Write down everything and don't be afraid to ask questions. If you don't understand a term—ask. There are no stupid questions. Don't assume. Also take notes to record your first thoughts and inspirations. Writing down your initial ideas can provide a valuable starting point as you begin to develop your concept, design, or work of art.

Always try to frame your problem statement as a positive action statement. Negative statements are closed and tend to lead to dead ends. They slow down the thinking process. Look at the two sentences below and see which one leads you in a more positive direction and opens your mind to new thoughts:

1. Should professional athletes be allowed to use steroids?
2. Should professional athletes be forbidden to use steroids?

Positive statements, like number 1, open up the mind. They can speed up the thinking process, encourage the flow of new ideas, and keep you moving forward.

When facing a problem, try to approach it without any preconceived notions of what the solution might be. Each problem is unique and should be treated as such. This may sound simple, as though it should go without saying, but it's not as easy as it sounds. Most people aren't born with an innate understanding of how to develop a concept, let alone how to create an effective design or work of art. We need to learn how to think and what steps to use when we are faced with a great challenge or are confronting a blank page, canvas, computer screen, slab of clay, block of stone, or even the vast emptiness of an exhibition space.

Getting Started

The *creative process* is the term for the way in which an innovative mind comes up with an idea and then executes it; it is the cognitive or conceptual component of the design process. It encompasses everything from the first glint of inspiration all the way through to the project's completion, whatever form that may take—from a finished painting to a market-ready product or design. Three steps can help you get started on the creative process:

1. *Identify* the criteria.
2. *Investigate* the person, object, or topic.
3. *Evaluate* the context.

You can use a simple abbreviation to remember these steps: IIE.

Identify the Criteria

Once you have a clear idea of the problem or assignment, your first question should be: *What are the project's* **criteria***?* Criteria are defined as the rules or specifications of the project:

- What is the time frame—is there a deadline by which the project must be completed?
- What materials may be used?
- Where will the project be exhibited or seen?
- Is there a specific size requirement?
- Can color or a specific range of colors be used, or must the work be achromatic?
- Who is the target audience?
- Is there a specific intended use?

If you are working on a project for yourself, you can likely decide the answers to these questions on your own. If you are working for a client, however, you should always discuss the criteria with that person. For instance, you may be expected to work within the parameters of a design language, or even create your own. A **design language** is a style developed by artists or designers that allows for a collection of works—whether products, ads, environmental graphics signage, or artworks—to have a consistent look and feel. Developing a design language early in the creative process provides guidelines that may be followed loosely, so that pieces within a series are connected conceptually and visually; or strictly, so that the artworks or designs produced have a strong thematic quality. Artists and designers create a design language to describe their choices for certain aspects of the work, including its materials, color schemes, shapes, patterns, textures, layouts, and so on. They can then follow this scheme throughout creation or development of the work.

Checking over the project's criteria and being aware of possible constraints are first steps that will save you time and fuel the creative process. Understanding what the audience or client expects is key to a successful art and design solution.

Investigate the Person, Object, or Topic

With your criteria in mind, you can develop a means of approaching or attacking the problem. Find out as much as you can about the person, object, or topic that is the focus of your project. By investigating a specific topic, you may discover new information and jog your memory about things you may have forgotten. If your focus is on a person, learning all you can about that person's history and personality can direct your creative design approach. If you are developing a design

for an object, like a smartphone, you need to know what the object can do and how it will be used.

A good place to start your search is the internet. Using Google and other search engines, you can likely find information about the person, object, or topic in question. Consider the following assignment:

Create a visual representation of tension.

First, it's important to understand the meaning of the word *tension*. Even if you think you know its meaning, looking up the word in an online dictionary can widen the possibilities. What does *tension* mean? Can it have *more than one* meaning? *Oxford Dictionaries* online gives us the following definitions:

> **tension: 1** The state of being stretched tight. **1.1** The state of having the muscles stretched tight, especially as causing strain or discomfort. **1.2** A strained state or condition resulting from forces acting in opposition to each other. **1.3** The degree of tightness of stitches in knitting and machine sewing. **1.4** Electromotive force. **2** Mental or emotional strain. **2.1** A strained political or social state or relationship. **2.2** A relationship between ideas or qualities with conflicting demands or implications.

In most cases, online search results will include not only written but also visual information. Our search for the word *tension* might return photographs and illustrations of such things as a woman with a headache, a man gripping a stress ball, children arguing, or a rope that is about to break. Both words and images can provide valuable insight and inspiration.

Clearly understanding the focus of your creative task can make all the difference in coming to a solution that not only fits the problem but also fits your personality as an artist or a designer. Figures 2.4 and 2.5 show how two different artists developed two very different works that respond to the example we've examined above—creating a visual representation of tension.

Evaluate the Context

Different situations make different solutions possible. Thus, each project must be considered in light of its **context**—the conditions that surround it and inform its meaning. Considering the context will help you find the most effective and appropriate way to communicate your message. When evaluating the context for a specific project, consider the following factors: audience, purpose, media and materials, and tone.

Audience

Who are you designing this for? Is there a target audience? Are you creating this piece as a personal statement, or do you have a client? Clients come in all shapes and sizes. They can be individuals, groups, corporations, or other designers. As a student, you might even consider your instructors or professors to be your clients—they may give you a set of criteria, ask

2.4 Andrea Moon, *One Foot Stomper,* **2008.**
This is a formal representation of the concept of tension. The body of the sculpture is balancing on one foot. It feels unsteady, as if it's about to fall. The anticipated movement generates a feeling of tension.

you to formulate a visually stimulating and pleasing response, and then review your work and assign a grade.

Purpose

It's important to think about what you are trying to do or say with the work. What problem are you trying to solve? What is your goal? What is the underlying concept or message in the work? What do you want or need to say to accomplish your personal goals or to meet the expectations of your client?

Media and Materials

There are two schools of thought on the nature of media. The first believes that the material has its own inherent qualities and life, and that all the artist is doing is revealing the final form. Early modernist sculptor Constantine Brancusi developed the concept of "**truth in materials**," which reflects this philosophy. Brancusi's concept asserts that the material used should display its inherent qualities—that stone should look

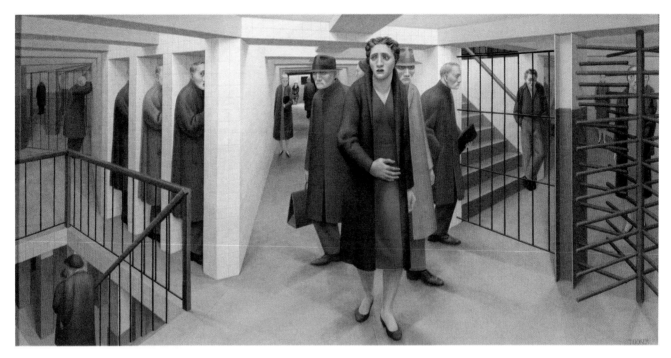

2.5 George Tooker, *The Subway,* **1950. Tempera on composition board, 18 1/2 × 36 1/2 in.**
Tooker uses a narrative format to convey tension in his painting. He represents the concept as an emotional and psychological state. The expression on the woman's face as she leaves the subway reveals her anxiety and fear of the lurking figures.

like stone, wood like wood, and so on. The second school sees the material as inert. According to this philosophy, a material may be selected for its ease of manipulation, strength, or availability. It may be painted, stained, or embellished as needed to suit the final product. Regardless of one's philosophy, it is important to select the right material for the desired

❱ new perspectives

Frank Gehry's Guggenheim Museum Bilbao

How can innovation change the face of architecture?

Sometimes the right medium is a new medium. Frank Gehry made a novel choice with the use of titanium for the skin of the Guggenheim Museum Bilbao, in Spain (fig. 2.6). This material had never before been used for the outer shell of a building. In Gehry's innovative design, the titanium reflects its surroundings and seems to change color at different times of day. The overall design also reflects the building's physical context—Bilbao is a seaport, and the form of the building has an organic, fish-like quality, with the titanium skin resembling scales. This use of a new medium combined with an organic curvilinear design has become a signature style for Gehry.

Since its completion in 1997, the Guggenheim Museum Bilbao has become a landmark tourist attraction, drawing more than a million visitors each year. This attention has helped to transform the once floundering city of Bilbao into a world destination.

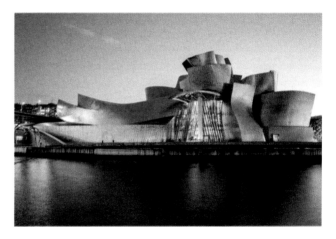

2.6 Frank Gehry, Guggenheim Museum Bilbao, Spain, 1997.

Visit the online resource center to view the Contemporary Voices feature.

end result (or the right medium for the job). This can be as simple as choosing bronze instead of wood for a monument that is intended to last for a very long time. Understanding how your genre and purpose affect your choice of materials is essential. Each material or medium has its own strengths and weaknesses.

Tone

All artworks and designs have a voice, and that voice can take on a variety of tones: literal, poetic, ironic, and so on. Every ad, for example, has a tone that can convey subtle content messages. Look at any ad on television or in a magazine and consider how each detail contributes to the overall tone. How are the people's gender, ethnicity, or religion portrayed in the ad? How are the people dressed? What is the setting? What colors and typeface styles are being used? If there is music, what kind is it? Each element is there to complement other components. It is the combination of these components that contributes to the tone of your work.

Generating Ideas

Once you have a solid understanding of the criteria, focus, and context of a new project, your next step will be to start generating ideas. At this stage, it's easy to become anxious about the prospect of going from nothing to something, but when you become tense, it's hard to open yourself up to new possibilities. Inspiration can provide the seed of an idea and be intellectually or emotionally stimulating. But inspiration is not an end in and of itself. It is merely a starting point—the birth of an idea. If spontaneous inspiration fails, there are numerous other approaches to help you generate ideas. Some of the most popular and productive methods are outlined below. While they are similar in nature, each one works in a slightly different manner and challenges you to think in a slightly different way. Try all of them on for size, and remember that each may have its place in your arsenal.

Free Association

Artists and designers have borrowed a method from psychotherapy to open their minds and spark the creative process. The psychoanalytic tool of **free association** (also known as stream of consciousness) allows you to explore new avenues and unlock your subconscious mind. In this mode of thinking, you try to bypass conscious thought by saying or writing down the first things that come to mind. For example, when you hear a word like *dog*, what is the first thought that comes to your mind? It could be "cat," "barking," "bite," or a name such as "Fido." Each answer will start to point you in a new and personal direction. This method opens you up to

2.7 Lee Krasner, *Night Creatures*, 1965. Acrylic on paper, 30 × 42 1/2 in. Krasner used a kind of "visual free association" in her paintings, as can be seen in the swirling, linear elements of her work. She felt that this spontaneous method of working allowed her greater creativity by enabling her to break through the conscious mind and release her intuitive nature.

CONCEPTUAL CONNECTIONS

How does "free association," or allowing the incorporation of the serendipitous event, affect the rhythm and repetition of the visual elements in the work? How might changing the page orientation affect or enhance the visuals?

new ways of thinking about the item or subject. Free association has long been a favorite of artists and designers because it opens up the wellspring of thoughts trapped within the subconscious (fig. 2.7).

Brainstorming

One of the problems with trying to generate new ideas is that many people think they must come up with the idea all by themselves. There is the notion that if anyone else has any input into the idea—no matter how small—the design might become tainted, less important, or not our own. But you don't always have to work alone. **Brainstorming** is a very productive method of generating ideas that involves working in a group, with members bouncing ideas off one another. Working in a group generates synergy. You can think of the process as a game of mental pinball, in which each group member is a bumper, and each initial idea is a ball being launched into the game. Every time the ball touches a bumper, a new idea springs to life. As the score increases, your collection of ideas expands.

Brainstorming makes use of free association, which is discussed above, but in this case many minds contribute to the process. Be sure to write down each person's responses, and don't try to control the direction of the ideas. Detailed below

is a list that a brainstorming session focused on Abraham Lincoln might generate:

Abraham Lincoln

President, Civil War, Union, black stovepipe hat, rail splitter, honest, shot, assassinated, tall, thin, lanky, piercing eyes, beard, no mustache, dark eyes, Illinois, lawyer, loner, brooding, dark, emancipator, slavery, prejudice, strife, log cabin, melancholy, father, husband, Republican

Once you have exhausted your list of possible associations, stop and look carefully at what you have written. Is there a common thread? What new areas, directions, or images have come out of your group's interaction? Where might these new ideas lead you?

In some contexts, brainstorming groups are referred to as "think tanks." Many large advertising agencies and design firms use think tanks to generate ideas. Often, these panels include people who are considered to be experts in an area of interest or who have extensive experience working on similar projects.

Mind Mapping

Mapping out your thoughts on paper or in a digital form is a good way to make them visible and visual. The process of creating a **mind map** typically begins with the placement of a primary thought in the center of the page, and then related thoughts are added, branching out in all directions (fig. 2.8). Lines show how the words are connected to one another. In this way, mind maps bridge the gap between written words and visual images.

Mind maps work much like free association by letting the mind wander, but they have one major advantage: they are

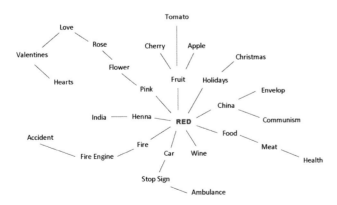

2.8 A mind map.
Notice how the thoughts spread out from a common center and flow in all directions. The map allows you to see the interrelated features of an idea.

not restricted to linear relationships. Thus, they are better able to show how various ideas fit together within a greater whole. In a sense, they tell a story that records your thought process. This story may reveal hidden connections among individual elements, thus leading to new ideas and directions.

Role Playing

Role playing involves exploring a concept or topic from someone else's point of view. For example, you might look at the problem from the point of view of a member of the opposite sex, and then think about how your feelings might change regarding the item in question. Or, you might imagine yourself as a child or an older adult, or as someone with a physical or mental disability (this can be especially helpful in product development). You could approach this task on your own, or you could work with a partner or a group as a variation on brainstorming. Often, looking at a problem from a new point of view reveals insights that would not otherwise appear.

What If?

The "What if?" game, as its name implies, involves imagining your item or idea from all different angles. The first questions are the most simple: What if I turn the item on its side? What if I turn it upside down? What if I look at it from a top view? Try making drawings of your item from as many different angles as possible: try at least twelve, and as many as fifty different angles or versions (fig. 2.9). This promotes new ways of looking at an object and can increase the visual interest of your work. The second part of the game entails asking more imaginative questions about your item: What if it were made out of cheese? What if it were on the moon? What if it were underwater? What if it could fly?

Talk to a Friend

Discussing a problem or idea with a friend can help you identify and correct weaknesses in your approach. If you find that you can't explain your ideas to that person clearly, you may not really have a firm grasp on the issue. Or, if you get a response like, "That's great, but what does it have to do with *x*?" you may find that you need to step back and reexamine how you may have strayed from your original task. Use others as a sounding board. Seek their opinions. You can always reject their opinions if you feel strongly about your own ideas, but the input of others can be valuable in making sure you are moving in the right direction.

Jump Right In

When all else fails, just start. Take the blank page, and begin by making marks or shapes. Many artists and designers can become frozen at the sight of a blank page—the pure

2.9 Ursula Hockman, _"What If" Drawing_, 2004.
The "What if?" exercise forces an artist or designer to look at an object from many different angles. In this work, a student artist has drawn a Swiss Army knife from 15 distinct vantage points.

..

CONCEPTUAL THINKING ACTIVITY

Develop your own "what if" drawing. Using a large sheet of paper or illustration board, divide it into 12 or 16 rectangles. Select an object that can fit in the palm of your hand and draw it from all imaginable sides. Each small rendering should be able to stand on its own as a fully finished piece. Use any media you desire.

..

emptiness may seem like a vast, impenetrable ocean or desert. It can feel as though there is too much to deal with. As soon as you make a mark, however, you have marred the surface and dirtied the page (fig. 2.10). It's no longer pristine and sacred. It's just a page. By diving in, you can break through the roadblocks and release many trapped or hidden ideas. Remember, as an artist or designer, you are a visual person. Seeing something—anything—on the page may help you to move forward.

2.10 Katie Holten working in her studio in Paris, 2006.
Holten is working directly on the blank wall of her studio. For some artists and designers, marking up a blank, unconventional space allows for a more immediate and deliberate means of beginning a new piece.

Drawing and Visual Ideation

Once you have an idea or inspiration, it's important to get it on paper. Many of the world's most creative thinkers have worked through their ideas in a visual way. For instance, Galileo Galilei brought his ideas to life by sketching them in detail (fig. 2.11). Albert Einstein frequently made diagrams rather than writing out multiple lines of mathematical algorithms; he believed these diagrams helped him develop his concepts by thinking in spatial terms. Most artists and designers likewise find **visual ideation**—the process of forming ideas or concepts through visual means—to be more productive than exploring new ideas in writing.

Drawing is at the heart of everything we do as artists and designers. It is our common language. Drawings can be understood by every artist, regardless of their nationality or language. Your renderings allow you to review, reflect on, and revise your ideas. No matter how rudimentary the marks on the page may be, they are a visual form of notation or information that can be universally comprehended. Virtually every work of art or design begins as a sketch or a drawing. This is partly because in the act of drawing, the artist is able to envision the possibilities and to investigate design alternatives. Mary Colter, for example, drew several sketches of her proposed buildings for the Grand Canyon National Park to see how she could incorporate these structures into the landscape (fig. 2.12). Her goal was to have them work in harmony with their soundings.

At first, just making doodles or rough sketches may be fine—anything to get the idea down in some tangible form. There are three common forms of sketching: roughs,

2.11 Galileo Galilei, *Drawings of the Phases of the Moon*, circa 1660.
By sketching his ideas in a visible form, Galileo was better able to understand the complexities of the problems he was dealing with, and to communicate his ideas to others.

thumbnails, and comps. Each takes a different form and has a different purpose:

- **Roughs** are quick drawings that may or may not be to scale. They are important because they help to convey an idea in a visual form. A great idea in your mind may look completely different once it's down on paper.
- **Thumbnails** are also loose, quick studies. They are typically relatively small, showing a single detail or component of the entire work. The most important aspect of a thumbnail is that it is drawn in proportion to the final product. This allows the artist or designer to more easily increase the scale and then transfer the sketch to the final work.
- **Comps** or **comprehensives** are much more detailed, and could be considered the final drawing stage. They are usually produced in a "client ready" fashion, meaning they are prepared to present to your client or patron.

Sketching is a more intense experience than merely viewing an object. When you draw, you are actively involved in the cognitive analytical process. Drawing forces you to translate your thoughts or perceptions of an object into something that

2.12 Mary Colter, *Guest House Drawing*, c. 1905.
Colter, a student of Frank Lloyd Wright, was one of the chief architects for the buildings at the Grand Canyon National Park. Sketching her concept and vision allowed Colter to create buildings that worked with the natural landscape.

2.13 Genevieve Astrelli, Sketches for *CMYK* Magazine Cover.
Astrelli, *CMYK*'s art director, made numerous sketches to explore new forms and work out her ideas for a magazine cover. Sketching allowed Astrelli to develop her ideas into complete designs.

can be seen (fig. 2.13). In the process, it helps you build an understanding of forms and structure, which increases your visual vocabulary as an artist or designer.

Art and design, especially drawing, can be seen as a means of understanding an object or objects in ways that language cannot express. For example, if you write the word *chair*, your readers will have a general sense of what you mean—an object on which a person can sit. But each reader will likely have a different mental image of the chair, and those mental images will likely differ from your own. Looking at the two words pictured below— one in English, the other in Spanish—the word *chair* tells us only that it is a piece of furniture:

2.14 Photograph of a chair.
Simply taking a photo of a chair may or may not enable the viewer to understand the chair. Similarly, the photographer may or may not contribute to the viewer's understanding of the chair.

Chair Silla

If you are not familiar with the language, these words may seem like little more than a random hodgepodge of letters, symbols, or marks. The words themselves do not convey the material, style, or position of the chair. Taking a simple photograph of a chair can overcome language barriers and provide more information, but it doesn't necessarily help us *understand* the chair (fig. 2.14). By *creating* the object, however, whether as a drawing, a painting, or a design, we develop a more complex level of understanding. As we render it, we build it from the inside out, with a completeness that one word cannot express. By depicting the chair, we come to understand its structure, surface quality, material, relative value, and more (fig. 2.15).

2.15 Helaine L. Cohn, *Chair*, 1988.
This is not a straightforward rendering of a wooden-backed piano stool; Cohn imbues it with emotion and pathos. The artist revealed her feelings about the chair and the act of drawing to the audience.

CONCEPTUAL THINKING ACTIVITY

Create a representation of a chair. What kind of chair will you select and why? Use any drawing media or collage to develop your emotional response to the chair you select. How will your choice of media affect the represented image?

When working in three dimensions, the equivalent of a thumbnail is the **model** or **maquette** (fig. 2.16). A model is a small-scale representation of the item to be produced. The mock-up can be made from any material, including cardboard, metal, wax, or clay. Producing a model helps the artist or designer understand the object from all sides and in its totality.

A **prototype**, on the other hand, is an original, full-scale model after which the final work is copied or patterned. Like a model, it can be made out of a variety of materials. The relatively recent and popular method for creating a scaled prototype is using three-dimensional modeling software. Programs, such as AutoCAD and Maya, allow the artist or designer to configure a model in virtual space. These types of digital mock-ups can be imported to other software programs to test their construction and durability (fig. 2.17).

Planning a work of art or design can take many forms. As you have seen, some artists make thumbnail sketches, while others create models or make detailed prototypes. What all of these approaches have in common is that they enable artists and designers to explore their initial idea or inspiration, and they provide a starting point for creating the final work (fig. 2.18). This allows artists and designers to make subtle

2.17　A designer uses VR technology and CAD software for industrial design, development, and prototyping.
Creating a three-dimensional model with computer software allows the model to be tested and modified with ease. Prototypes for vehicles, for example, are often tested in computerized wind tunnels to measure their durability and aerodynamics.

2.18　Marcia Cohen's studio.
Cohen hangs her color sketches and maquettes on the walls of her studio, allowing her to examine and inspect several works simultaneously.

changes or iterations refining their work. This planning and invention stage may be the most important part of the act of creation. It is where the concept is honed and refined, marrying the concept, message, and materials together as one unified entity.

Creating and Revising Your Work

After you've produced all of the drawings, models, and prototypes you need, it's time to start working. Creating the actual entity is known as **execution**: the production or construction of the final artwork or design. During this stage, there is still time for experimentation and investigation. Accidents and difficulties may arise while the work is being constructed. For

2.16　Louise Nevelson, Maquette for
Monumental Sculpture III, 1977.
A maquette is a three-dimensional realization of a sketch or drawing. The model can be constructed from a variety of materials. Nevelson constructed this maquette from steel.

example, if you are carving marble, a piece may fracture off in a way that you had not intended. These sorts of challenges are not always disastrous; most often, they can be overcome through a bit of revision to the original plan. To solve the problem of the fractured marble, you could adjust the design to work with the new shape of the stone. In some cases, unexpected difficulties may even be beneficial to the final outcome of the project. When a mistake or a misfortune leads to an improvement, it is referred to as a *serendipitous accident*—some problem arises while the item is being produced, the artist or designer works to overcome the challenge, and the result is even better than the original plan. Within the construction process, there is always room for revision, correction, and addition. Many artists will produce several works on a common theme, varying a small element or color to see how this change will affect the overall work.

Evaluating Your Work: The Critique

The last step in creating an artwork or design is to evaluate what you have done. How successful was the end product? Did it meet the desired criteria? Was it well received? When reflecting on your own work, be honest with yourself. Most artists and designers are their own worst critics. They can see weaknesses in their work that may not be apparent to others. If you are able to do this, it is actually a good thing—it means you are self-critical and seeking to improve your skills. It is part of a learning process that will help you develop as an artist or designer.

An analysis of a work of art, with assessment of how effectively the form and content work together, is often referred to as a **critique**. By focusing on how well the established criteria were met, you can judge your work while avoiding bias or personal taste. Artists and designers might perform an independent critique of their own work, or they might discuss the work critically with another person or a group. Most often in a college or art school setting, the group critique is employed. In a one-on-one critique, the artist or designer meets with the client (or, in the case of a student, the instructor) for a more intimate discussion. This form of critique can be especially beneficial if the artist or designer has worked with the client on a long-term basis. It allows for a very frank and honest discussion and for a deeply personal exploration of the intricacies of the work.

Ground Rules for Group Critiques

Because every person has a different set of experiences and thus a different perspective, a group critique can be very useful for soliciting a broad range of views on a work. For the

Global Connections

The Expanding Thought Process of Shahzia Sikander

What can we gain from applying a contemporary vision to a traditional format?

An artwork or design can evolve as the work is being produced. While some changes are motivated by outside forces such as an accident with the materials, others arise from the continuation of the artist's thought process, which can expand and shift focus as the forms are generated. Shahzia Sikander's expansive painting *The Scroll* began as a self-portrait using the established convention of miniature painting. Over the course of its development, it evolved into a more universal narrative regarding the role of a modern Pakistani woman. Sikander took the convention of the miniature, traditionally a single small painting, and developed it into a 5-foot-long work featuring over a dozen interconnected vignettes (fig. 2.19). Her finished work challenges established notions about illustrating traditional rituals and contemporizes the aesthetic into a personal, individualized voice.

2.19 Shahzia Sikander, *The Scroll*, 1989–90. Vegetable color, dry pigment, watercolor, and tea on wasli paper, 20 × 70 in.

discussion to be most productive, however, certain ground rules must be followed:

- *Listen to others.* To understand other people's perspectives, you have to actively listen to what they say. Listening to others is particularly important when the group is critiquing your work, but it is also necessary when someone else's work is the focus of the critique; to participate in the discussion, you must know what the others are saying. Listening to what is being said about others' work also has a less obvious advantage: you may be able to relate the comments and insights to your own work in the future.

- *Focus on criteria.* Link your comments to the criteria of the assignment or problem, and not to subjective taste. While personal taste will always play a role in how an artwork or design is viewed, focusing on the criteria will ensure that the discussion is beneficial to the person whose work is being reviewed, and to the other participants taking part in the appraisal. Remember that the main value of a critique is in the analysis of how the work has met the challenge presented.

- *Be positive.* Very little good comes from harsh or unconstructive criticism. Offer comments in a positive and constructive manner, and avoid negative or destructive comments. For example, instead of saying, "The colors you've used look awful," try the following: "The palette you've used is very dark, and the images are hard to distinguish. If you use a lighter palette, the forms will stand out and be more prominent." It's also important to put personal feelings and rivalries aside. Resist the temptation to say something negative about someone's work because that person harshly criticized your work or a friend's work in the past.

- *Be open.* A key factor in a successful critique is being open to the comments of others. Being open can be difficult when your own work is the focus of the critique and the comments are not glowing. It's natural at first to bristle when someone is critical of your work. However, keep in mind that objective critiques are not personal, and others may be able to see things in your work that you are not able to see because you are too close to it. Take some time to reflect on other people's comments. Even if you decide that you don't agree with a particular criticism, it may give you new insight to your own creative endeavors and assist you in future work.

Approaches to the Critique

There are several methods for looking at and evaluating a work of art or a design. These can be used in a discussion or group critique, or when independently analyzing one's own or another artist's work. Each has its own inherent strengths and will generate a clear focus for the discussion.

Descriptive Analysis

The simplest approach to critiquing an artwork or design is through a descriptive analysis. In this method, the formal aspects of the work can be listed and described, relating the design principles and elements to their use in the work. Applying this approach to a magazine cover designed by David Carson (fig. 2.20), we can provide the following descriptive analysis:

In David Carson's cover design for *Ray Gun* magazine, there is one large image of Elvis Costello, a partial view of his face placed off center, bleeding off the left side of the cover. The image is tucked away behind the type and becomes the background. The type of the name *Elvis* is large—it grabs the viewer's attention and establishes a focal point of the composition. The rest of the text that runs across the cover is barely readable because many of the lines of text are stacked on top of one another. This application of text that looks like it has been roughed up or partially erased is a hallmark of Carson's deconstructed design esthetic, which is sometimes referred to as "grunge" style. Carson uses a dark analogous color scheme of blue, blue-violet, and violet. The background is almost a

2.20 David Carson, Cover for *Ray Gun*, April 1994.
Carson's postmodern style is evident in this cover for the magazine *Ray Gun*. His work on this and on *Surfer* magazine brought new innovations to graphic design.

blue-black with only parts of the shoulder of Costello's leather jacket barely visible, peering out of the darkness, creating an asymmetrical composition. The dark hues and partial facial image create a sense of mystery.

Formal Analysis

Another common way of analyzing an artwork or a design is to focus on the form and content, or the objective and subjective elements. The formal or objective elements include the materials the artist has used; compositional factors such as point of view, balance, and format; and the design elements (e.g., the use of line, shape, space, value, or color). The content or meaning of the work itself is more subjective. What is the artist or designer trying to say through the work? A piece of art or design may work formally, but we might disagree with its message or meaning. Being able to understand the difference is important to one's growth as an art professional. To make this clearer, let's take a look at Audrey Flack's *Wheel of Fortune* (fig. 2.21) and analyze it using the criteria we have presented for a formal analysis.

Audrey Flack's postmodern, photorealistic style is apparent in her painting *Wheel of Fortune*. When we look at the formal elements of this painting, we notice the bright, saturated color palette. Flack balances the composition in a triangular fashion using the grapes, the skull, and the reflection of the skull in the mirror to keep the viewer's eye moving around the composition. She uses a fairly shallow sense of space, crowding the items into the foreground. There is a high degree of verisimilitude in her realistic representations of the surface quality and textures of the objects. Her painting could be considered a vanitas painting, meaning that it is about the transience and fragility of life; it uses many of the traditional vanitas elements, including a candle, a calendar, and an hourglass. All of these are symbols of the passage of time. The tarot card and crystal ball reflect one's desire to know the future, while the die at the bottom of the painting refers to the uncertainty and element of chance in daily life.

2.21 Audrey Flack, *Wheel of Fortune*, 1977–78. Oil over acrylic on canvas, 96 × 96 in.
Flack liked to challenge herself with the complex surface quality of the objects in her paintings. The representations of glass, metal, and jewels in particular reflect the artist's mastery of her paint technique and use of media.

Comparative Analysis

A third means of analyzing a work is to compare it to another work of art or design. This could be done by contrasting artwork from two different periods or styles, such as Art Nouveau and Art Deco, and looking for the differences and similarities between the works. Art historians favor this method because it allows for a side-by-side evaluation of relationships. Those relationships can be between the formal elements present or the conceptual basis of the work. Two artworks with seemingly similar iconography and content can be seen in the work of Linda Gass and Susan Stockwell (see figs. 2.22 and 2.23).

CONCEPTUAL CONNECTIONS

In any type of critical analysis, it is important to consider visual and conceptual perception—where do the viewer's eyes go first? Consider how the artist or designer has communicated the concept or core of the work. Was the message clear, or how could it be improved?

2.22 Linda Gass, *Sanitary?*, 2009. Hand-painted silk and machine-quilted rayon and polyester thread, 30 × 30 in.
Gass's Land Use Series deals with her concern for the environmental state of her beloved hometown of San Francisco. The textures in her stitched paintings directly relate to the area's topography.

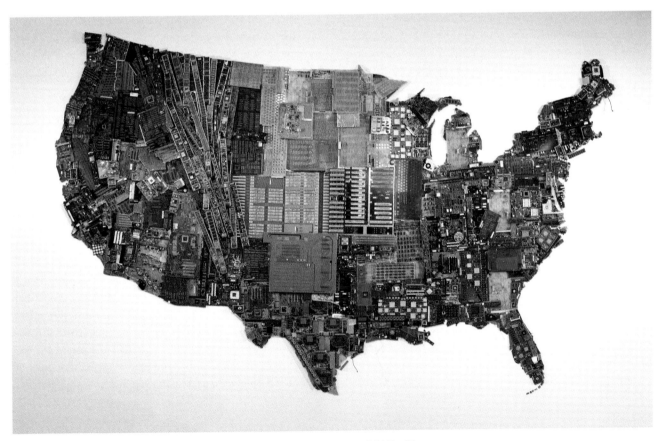

2.23 Susan Stockwell, *America*, 2009. Recycled computer components, 118 × 86 1/2 × 2 in.
This relief installation is presented in landscape format with a strong horizontal movement. Stockwell's use of discarded computer components to create a brightly colored map of the United States encourages the viewer to reflect on themes of wastefulness and beauty.

Both Linda Gass and Susan Stockwell use maps as the formal underpinning of their work. Gass uses quilting to depict a topographical map of a landfill near San Francisco Bay. Stockwell assembles a more traditional-looking representation of a map of the United States using a relief technique. Both works are presented in a rectilinear fashion. Gass uses an intense and varied palette, while Stockwell uses the toned-down colors of industrial materials. In terms of meaning, what these works have in common is an underlying commentary on our relationship with the natural environment. Stockwell's map uses discarded and recycled computer components. Her work is a very personal comment on our consumer culture and the waste it generates. The highly decorated surface of Gass's work contradicts the fact that what we are confronted with is a map of a landfill. Her work is an environmental message of concern for the effects of this space on the neighboring city. Each artist expresses in visual terms their political sentiments and concerns regarding the environment.

2.24 Dennis Oppenheim, Artist Rendering of *Blue Shirt*, 2003. Oppenheim has produced many public art projects. Despite his careful work on *Blue Shirt*, however, construction of this architectural sculpture was halted in response to objections from members of the public.

Accountability

After you have reflected on your work and on the comments others have given you about it, accept responsibility for what you have done: the good and the bad. People often try to blame someone or something else when a project is not successful: the materials, computer problems—even the weather. In the end, it all comes down to your character and having the integrity to own up to your shortcomings and mistakes. You will gain the respect of your peers and others if you accept the blame when things fail. Focus on examining what went wrong and why it happened. Write down the reasons why the project or piece failed. Often, you can learn more from a true failure than you can from an overwhelming success.

One example of a project that was rejected before its completion was Dennis Oppenheim's *Blue Shirt* (fig. 2.24). The sculpture was to be constructed on one of the terminals at General Mitchell International Airport in Milwaukee, Wisconsin. While Oppenheim meant for the work to be a heroic monument to the city's industry and work ethic, large constituencies within the city thought the work trivialized or disparaged their blue-collar traditions. Sometimes, despite our best efforts, our work may not be accepted by others. Every piece is a learning experience.

Sometimes it's wise to put a project aside and come back to it when you have some distance and are not as emotionally invested. A new day can bring new insights. Maybe things took more time than you initially had, or the materials you selected were not appropriate or accessible. Whatever the situation, reexamining your work after some time has passed is always beneficial. Take this approach with all of your works. People don't always analyze their successes as acutely as they do their failures, but analysis of both types of projects can lead to learning and growth.

Lastly, if you believe in it—stick to it. Believe in yourself. This is not always easy to do. If you look at many great artists, designers, or inventors, you will find that they faced obstacles in their paths. Galileo was placed under house arrest for publishing his ideas about the earth being at the center of our solar system. Similarly, even one of the most popular memorials of the twentieth century, the *Vietnam Veterans Memorial Wall*, was met with outrage and protest (fig. 2.25). When Maya Lin first showed her model for the memorial, critics decried her work as a gash in the earth. They felt that it was undignified because it did not represent the soldiers it memorialized as heroic. People were used to seeing monumental statues of men in valiant poses with grand sweeping gestures,

2.25 Maya Lin, *Vietnam Veterans Memorial Wall*, 1982. Black granite, 2 acres.
"The Wall," as it is often called, was so controversial when it was constructed that there were protests against the site. The design was too innovative and abstract for many to accept. It received so many objections that a traditional figurative bronze was built and placed alongside it in 1984. Today, Lin's design is highly regarded and has even been copied.

not a stark, minimalistic polished wall of names. The public, however, has embraced her design. People line up to make rubbings of the name of a loved one or a lost comrade. The memorial is one of the most popular sightseeing destinations in Washington, DC, and has been proclaimed a masterwork of modern art.

THINK ABOUT IT

- What is the *creative process*, and what does this process mean to you?
- What do you think about the Brancusian concept of "truth in materials"? Explain why you either agree or disagree with the concept.
- What idea-generating strategies have you used in the past? Which were the most effective, and why?

- How is sketching and envisioning part of your art practice? What role does it play for you in developing your work?
- What does being accountable for your work mean to you?

IN THE STUDIO

The project will allow you to practice the first three steps of the creative process: *identify*, *investigate*, and *evaluate*. Create a visual representation of the word *force*. Select one shape, such as a square, circle, or triangle, and use as many or as few as you require to depict the word's visual meaning. Develop your composition using only black and white and/or shades of gray (figs. 2.26, 2.27, 2.28). Start by *identifying* the criteria, *investigating* the topic, and *evaluating* the context or meaning of the piece. If you are stuck, try listing synonyms for the term *force*. What shapes come to mind when you think of these words?

2.26 Student Work: Jessica Myers, *Force*, 2016.
Myers creates a visual concept of force by showing smaller triangles being violently displaced by a large, piercing triangle.

2.27 Student Work: Sarah Navin, *Force*, 2016.
Navin creates a subtle sense of force. She scatters the elements in the top right of the composition and emphasizes force by joining the elements together in the bottom left. Navin demonstrates that interpretations and treatments of the subject matter do not necessarily have to be literal.

2.28 Student Work: Kara Hackett, *Force*, 2016.
Hackett uses the triangle forms arranged around an off-center focal point to develop a sense of force. By varying the weight of the lines used in her composition, she creates a dynamic visual representation.

VISUAL VOCABULARY

brainstorming
comp or comprehensive
context
criteria
critique
design language

design process
execution
free association
mind map
model
prototype

rough
thumbnail
truth in materials
visual ideation

Perception, Composition, and the Principles of Design

LOOKING AHEAD

- Why is it important for artists and designers to understand visual perception?
- What factors inform the choice between portrait and landscape orientation, and between open and closed composition?
- What are the main principles of design?
- Why is balance important for an artwork or design?
- Why do artists and designers have to think about scale and proportion?
- What is emphasis, and how is it achieved?
- How do unity and variety complement each other?

WHENEVER WE LOOK AT A WORK OF ART OR A DESIGN, WE SEARCH FOR some sort of organization and meaning. The human mind dislikes disorder and craves structure. We start by looking at a work of art or a design in its entirety and then focus in on its parts. For an artwork or design to be effective, there must be some visual connection among all of the design elements—the lines, shapes, colors, and so on (fig. 3.1). To establish this connection, the composition must have an overall visual and conceptual unity.

When composing a work, artists and designers must think about how it will be perceived by its audience. They must also consider how they can use the main principles of design—balance, scale, proportion, emphasis, unity, and variety— as a set of organizational strategies for presenting visual information. As you will

3.1 Michael James, *Rhythm/Color: Improvisation*, 1985. Cotton and silk; machine-sewn, 100 × 100 in. James uses fifteen square blocks set up in a grid. The diagonal lines within each block create curving shapes that unify all of the elements. His use of radiating diagonals at the border keeps the visual focus centered, leading the viewer's eyes back into the composition.

see in this chapter, using the principles of design in new and visually challenging ways can make the audience stop and take a second look. A double take is a sign that an artwork or design has been successful in making a connection with its audience.

Perception

The need for comprehension and order is embedded deep within the human psyche. The human mind takes in its surroundings, and if those surroundings are in disarray, it may sense danger and trigger the primal flight-or-fight response. When faced with something new or unexpected, the first question the mind asks is "Is it safe?" If the answer is *yes*, the next questions are "What is it?" and then "What does it mean?" Our brain is constantly asking and answering these questions, often without our conscious awareness, in an attempt to make sense of the world.

Although all of our senses are involved in perception, as visual artists and designers we are most interested in understanding how **visual perception** works. Throughout the creative process, understanding how we and others see objects helps us make effective compositions that take advantage of our innate visual responses.

Gestalt

When looking at an artwork or design, the viewer or audience is first drawn to the work as a whole, or as a **gestalt**. Once we have taken in a work in its entirety, only then do we begin to examine its separate components. After the initial perception of the whole, the human eye is typically drawn to the edges of an object, seeking out the periphery in an attempt to capture all available visual data. The eye sends these visual impulses to the brain, which tries to make sense of the arriving stimuli. This initial cognitive response to stimuli is how we conceive and comprehend form (fig. 3.2).

The concept of gestalt as it is applied to art was adapted from the Gestalt school of thought in psychology, which was first developed in the early twentieth century and is characterized by its view of the person as a whole being. Artists responded to the ideas put forth by the Gestalt school by recognizing, to a greater extent than before, that an artwork as a whole is more than merely the sum of its parts. In other words, they came to understand that when the separate elements of an artwork are perceived as a whole, the collective artwork is far greater than any of its individual elements.

This type of thinking and analysis can be demonstrated when looking at the diagram in figure 3.3. What do you see? Most people who look at this illustration will immediately see the Star of David. Within a few seconds, they may notice

3.2 Elín Hansdóttir, *Trace #7*, 2010. Pigment print on archival paper, 16 1/2 × 16 1/2 in.
When we first see this image, we begin by taking it in as a whole; we then look at the edges of the central shape and move inward to try to understand the totality of the message. As our brain makes sense of the visual information it receives, we may come to understand that Hansdóttir's work depicts the metamorphosis of form from one dance movement to another.

a black triangle surrounded by three red dots. After further study, they will find that the image is made up of ten hexagons and three red circles. Gestalt assessment takes in the totality of the visual data presented—in this case, the Star of David—and then uses cognitive functions to try to make sense of the object by grouping elements, separating them, and matching them to our stored memories.

In a complete artwork or design, the gestalt effect can be even more complex. For example, consider a work such as *Before, Again II* (fig. 3.4). Joan Mitchell wants the audience to take in the entire painting. No one part of the canvas or

3.3 Gestalt Illustration.
As the viewer takes in the totality of the work, he or she understands that the whole is greater than the individual parts.

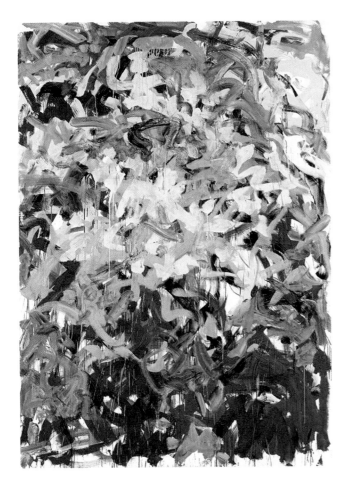

3.4 Joan Mitchell, *Before Again, II*, 1985. Oil on canvas, 110 × 78 3/4 in.
Mitchell aims to have the viewer experience the gestalt or totality of the canvas. The use of white and the related tints adds unity to bring the various gestural elements of the composition together.

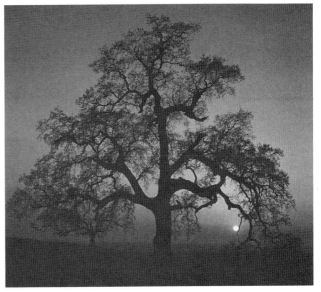

3.5 Ansel Adams, *Oak Tree*, Sunset, 1932. Gelatin silver print, 10 1/4 × 12 in.
When viewing this photograph of an oak tree, the viewer immediately recognizes that she or he is looking at the form of a tree. While Adams tries to show the beauty in nature, he does not sentimentalize it. His aesthetic lies in framing the subject and in the darkroom management of the print.

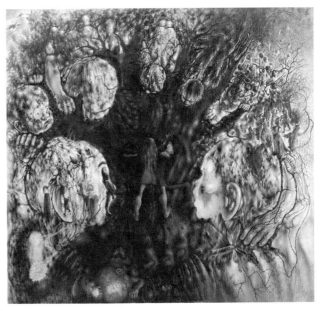

3.6 Pavel Tchelitchew, *Hide and Seek*, 1940–42. Oil on canvas, 6 ft 6 1/2 in. × 7 ft 3/4 in.
The viewer is likely to have an emotional response to Tchelitchew's eerie imagery. Within the spaces of the branches appear children's faces. It is uncertain if the children are ghostly apparitions or playing some sort of game.

gestural brushstroke, no matter its size, is meant to be more important than any other. These various marks and colors combine to make a whole that is truly greater than its parts.

Visual and Conceptual Perception

As mentioned above, artists and designers are interested in understanding visual perception, which is essentially how we see the world. When we look at a tree, we see a tree. Our rational mind examines all of the relative factors—the size of the tree, the bark, the leaves, and so forth—and uses our memories and logic first to identify the object as a tree, and then to determine what kind of tree it is (fig. 3.5).

Conceptual perception, which involves the imagination and often an emotional response to the item we see, adds another layer to the process of visual perception (fig. 3.6). How do we feel about the tree? If the tree is a willow, do we feel sad? If it's a young sapling, do we become concerned for its preservation and well-being? Do we associate anything in particular

CONCEPTUAL CONNECTIONS

How much of your memories and personal life history play a role in visual perception? How does your memory affect your conceptual perception or comprehension when viewing an artwork or design?

with the type of tree? Does a fir or spruce tree remind us of Christmas? Might a tree that has gnarled branches remind us of an elderly person with arthritis? These questions suggest a few of the many ways in which our immediate perception of an artwork or design can evoke an emotional response and spark our imagination.

Both types of perception—visual and conceptual—help us interpret an artwork or design. First, we see or examine the work using our visual perception abilities; we observe its size, colors, shapes, and so forth. Then, sometimes after a barely detectable delay, our mind uses conceptual perception to bring together all of these elements and decide how we feel about the work and its message. As artists and designers, knowing how this process works can inform the choices we make as we think about the composition of a piece we are creating.

Starting Points for Composition

Composition refers to the way the parts of an artwork or design are assembled to make a unified whole. It can be the arrangement of the individual elements on the two-dimensional surface of a **picture plane**. It can also refer to the actual act, method, or process of combining the elements to create a whole. Composition uses a variety of techniques to pull all of the various elements together as one. In this section, we'll explore some starting points for thinking about composition—choices artists and designers must make about visual orientation, open versus closed composition, directing the viewer's gaze, and the relationship between concept and point of view. Then, in the final section of this chapter, we'll examine the compositional concepts that are commonly referred to as *the principles of design*.

Visual Orientation

One of the first factors that an artist or designer must address when beginning any two-dimensional work is the **visual orientation** of the piece. There are two basic methods of orienting the page: landscape and portrait. **Landscape format** is a horizontal arrangement, such as the typical orientation of a computer monitor, television set, or movie theater screen. It is so named because one would easily be able to set up the panoramic view of a landscape in this format. **Portrait format** is a vertical arrangement, such as the typical orientation of a page in a novel or a textbook. It is so named because most portraits (i.e., renderings of an individual person, especially a person's face or head and shoulders) are created vertically. If viewers are not told which way to orient a page, most will orient it in portrait format, likely because we are most familiar with this configuration from reading and writing.

The subject matter should dictate visual orientation. A major consideration is eliminating unnecessary empty space on either side, or above or below, the central figure or figures. Thus, the landscape format is often used for landscapes because it reduces the amount of empty sky at the top of the work. Similarly, portrait format is typically used for portraits of individuals because it eliminates unused space on either side of the person's frame (fig. 3.7). For more complex pieces that depict multiple forms in complex relationships with one another, the most appropriate format is the one that complements the arrangement of those forms and suits the artist or designer's intent (fig. 3.8).

Open and Closed Composition

Artists and designers must also decide how the figures they are depicting will interact with the **picture frame**. Here, the choice is typically between open composition and closed composition.

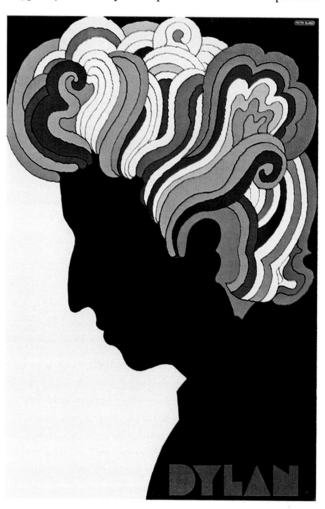

3.7 Milton Glaser, Bob Dylan Poster, 1966. Offset lithograph, 33 × 22 in. Glaser's use of a silhouette for Dylan's face in this portrait-oriented poster contrasts with his use of color in the swirling locks of hair. The representation of the hair was developed from Glaser's interest in the decorative aspects of Islamic art combined with his fondness in the colors and shapes of Art Nouveau.

3.8 Diane Fenster, *Canto Five/Union of Opposites*, 1995.
Fenster's digital collage is presented in landscape format to complement the artist's arrangement of the various images and words. Her work is autobiographical and deals with issues of self- and gender identification.

In a **closed composition**, all of the elements within the design or image must fit within the confines of the frame. Because the results are often static, most contemporary artists tend to avoid using fully closed compositions, except when they want to draw attention to or play with its conventions (fig. 3.9). In an

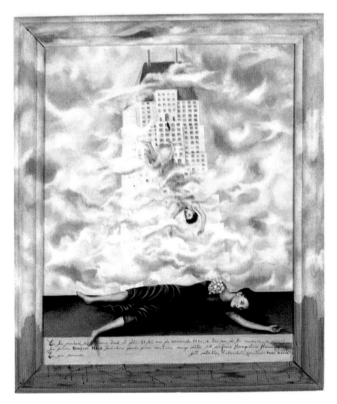

3.9 Frida Kahlo, *The Suicide of Dorothy Hale*, 1938–39.
Kahlo plays with the convention of closed composition: she uses the frame not as a standard containment device but instead as an extension of the picture. The fog that seems to escape the frame symbolizes her subject's personal torment.

3.10 Joe Marvullo, *Caboose Sundial*, no date.
Marvullo uses an open composition to draw the viewer into the image. Additionally, the intense red and yellow hues are balanced against the dark shadows that illustrate the photograph's main subject—the sundial indicated by its title.

open composition, some parts of the forms are cut off, making it seem as though the forms continue beyond the boundaries of the work. Because the forms appear to break through the frame, into the viewer's world, open compositions tend to be more dynamic and engaging (fig. 3.10).

How Viewers Read a Page

When you create a composition—whether in landscape or portrait format, or in open or closed composition—keep in mind that there are very specific ways in which your viewer will "read" the picture plane, whether it is filled with words or images. The viewer's approach greatly depends on his or her cultural background. In the West, a page is read from the top left moving across to the bottom right. Thus, Western viewers tend to look first to the top left of the page, then scan from left to right as their eyes move down the page, finally exiting the page at the bottom right. Therefore, when working in a Western context, you should avoid placing your most important information on the bottom right portion

of the page, as doing so will lead the viewer's eye off the page and out of your work. You will not be able to hold the viewer's attention.

Another point to keep in mind is that a person's eyes are drawn to a focal point, which is often the largest item on a page. Subconsciously, viewers then move their eyes to the next largest object and then in progression to the smallest items on the page. Think about how your eyes move when you look at the front page of a newspaper—first they are drawn to the masthead, then to the largest image on the page, then to the next largest headline or image, and so on. Understanding how the relative size of items on a page influences viewing habits can help you create a work that keeps viewers' eyes moving across the page. A work will successfully hold a viewer's attention if the elements encourage the viewer to look in circular or triangular directions. Attention to this principle of the hierarchy of reading visual elements can be seen in the most successful artworks and designs, such as Robert Rauschenberg's oil and silkscreen painting *Retroactive I* (fig. 3.11).

Concept and Point of View

When thinking about visual orientation, open versus closed composition, and how you will direct the viewer's gaze, you should also take a moment to choose your **point of view**—the vantage point from which you will depict the content of your work. This choice requires you to think conceptually about your composition; doing so will help you identify the vantage point that will establish the strongest connection between the viewer and the meaning being conveyed by your artwork or design.

To find the right point of view, imagine that you are looking through the viewfinder of a camera. If your subject does not take up enough room in the frame, you may need to move closer. Conversely, if you are too close, you may need to move farther away to fit your entire subject inside the camera "window." Shifting the perspective in this way can help create closeness or distance between your subject and your audience, which in turn will affect the message or content you are trying to convey in your work. For example, the point of view that Frida Kahlo uses in her painting *The Suicide of Dorothy Hale* (fig. 3.9) distances the viewer from the subject and the subject's torment. As Kahlo's painting demonstrates, composition and concept go hand in hand. When you choose the most appropriate point of view, your message will gain clarity.

The point of view used most commonly in artworks and designs is the **eye-level point of view**. Alice Neel uses this point of view in her painting *Linda Nochlin and Daisy* (fig. 3.12). Neel places her subject on the same level as the viewer, creating a sense of close, personal space and intimacy. She juxtaposes the mothers confronting stare with the daughter's wide-eyed, innocent stare.

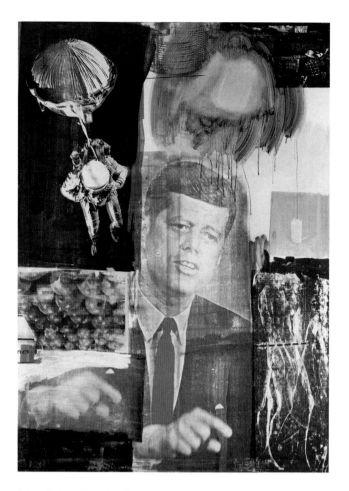

3.11 Robert Rauschenberg, *Retroactive I*, 1963. Oil and silkscreen-ink print on canvas.
When looking at this painting, the viewer's eyes are initially drawn to the large image of President Kennedy, which is the main focus. They are then drawn in a circular fashion from the red image in the lower right corner to the image of the astronaut in the top left corner and back around the page.

In addition to eye level, there are several other points of view through which a connection can be established. In Bavari's BMW ad, for example, the vantage point moves away from eye level to create an **aerial**, or "**bird's eye**," **point of view** (fig. 3.13). An aerial view can range from a vantage point that is relatively close to the subject, hovering just inches or so above, to a position that is a great distance away, such as the view in the ad.

On the other hand, a **low-angle**, or "**worm's eye**," **point of view** forces the viewer to look up at the subject from below. This point of view tends to be a forced perspective, and therefore it may feel a bit unnatural to the viewer. Often it adds a surreal quality to the work (fig. 3.14). It can also provide a novel way of looking at a traditional object from a new vantage point.

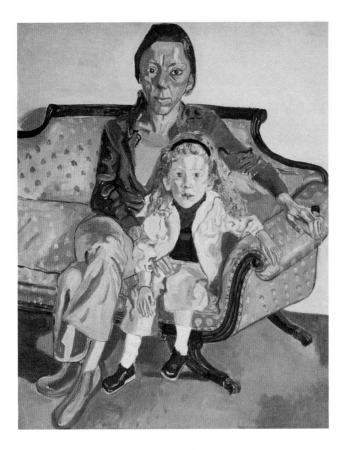

3.12 Alice Neel, *Linda Nochlin and Daisy*, 1973. Oil on canvas, 56 × 44 in.
In this painting, Neel shows us one particular mother and child, not an iconic pair. Neel uses an eye-level point of view, establishing a connection between the figures and the viewer.

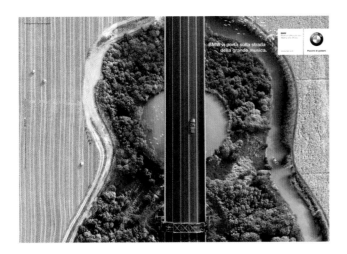

3.13 Alessandro Bavari, Advertisement for BMW, 2015.
Using an aerial point of view, Bavari designs the countryside around a road that also looks like the stings of a guitar. The viewer is given the sense of looking down on a landscape that lies far below.

3.14 Todd Livingston (Writer), Robert Tinnell (Writer), and Neil Vokes (Artist), *The Black Forest 2*, 2005.
In this page from a graphic novel about a WWII pilot and a mystic, Vokes use a worm's eye point of view to heighten the drama. The figures tower over the viewer, creating a foreboding, menacing feel that adds tension and excitement.

CONCEPTUAL THINKING ACTIVITY

Point of view is an essential compositional element. Develop a drawing or create an image using a worm's eye point of view. Think about the dynamic movement and drama created by this type of view point. Where is this type of composition best used?

Principles of Design

In addition to thinking about the starting points for composition discussed above, artists and designers also need to consider the **principles of design**—the fundamental concepts that guide the assemblage of the parts of an artwork or design into a unified whole. Below, we'll briefly examine how these principles—balance, scale, proportion, emphasis, unity, and variety—can work together to support a strong composition.

Balance

As humans, we strive for a sense of balance—not only to stand or sit upright, but also in visual terms. In art and design, **balance** is the perceived equilibrium among the various components of a work, whether size, weight, value, or color. Despite what this term implies, however, visual balance isn't completely even, static, or inactive. There are four basic types of balance, each with its own specific attributes and uses: symmetrical, asymmetrical, radial, and crystallographic.

- **Symmetrical**. If a work is bisected or cut vertically down or horizontally across the middle and both halves are mirror images, then that work is considered to be symmetrical. In more precise terms, that work is considered to have **bilateral symmetry**. While absolute symmetry is fairly easy to achieve, it can feel static or unexciting. To break the tedium, artists and designers often subtly vary

the elements from one side of the composition to the other. In **approximate symmetry**, both halves are similar and evenly balanced, but the elements on either half differ slightly, allowing for greater design complexity (fig. 3.15).

- **Asymmetrical**. Technically speaking, any composition that is not purely symmetrical is asymmetrical. However, artists and designers commonly use this term to refer to a composition in which one of the elements dominates the picture plane, taking up more than half of the composition (fig. 3.16). Asymmetry is likely the most widely used type of balance.
- **Radial**. Radial compositions have a common center or axis. The elements of the design either radiate out from, or point toward, the center. Additionally, because of this directional focus, this form of balance sets up a clear focal point (fig. 3.17). In nature, radial symmetry is found in flowers, spiderwebs, and even the inner structure of bones. In art and architecture, the use of radial balance can be seen in everything from cathedral rose windows to optical art.
- **Crystallographic**. Not every design has to have a specific or dominant focus. Rather, the entire picture plane may be the focus of the composition. Works that take this latter approach often employ crystallographic balance, in which elements of similar shape and size are repeated across the composition (fig. 3.18). In works with this type of balance, the artist wants the viewer to understand the work in its entirety. No one element or part is more important than any other.

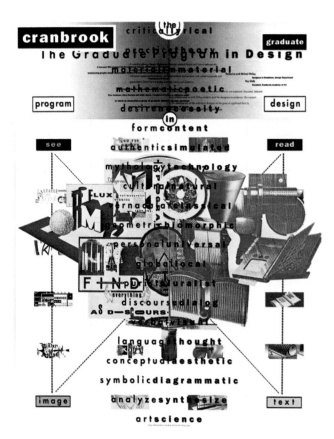

3.15 Katherine McCoy, Poster for Cranbrook's graduate program in design, 1989. Offset lithograph poster (two-sided), perforated with postcards on the reverse, 28 × 22 in.
At first glance, this work looks symmetrical. The foreground duotone element appears to be one large image; however, on closer inspection, the viewer can see the myriad elements that make up the central image. The words at the corners are all different, further developing McCoy's message. This use of approximate symmetry produces a more complex imagery that holds the viewer's attention for a greater length of time.

3.16 Roy Lichtenstein, *Blam*, 1962. Oil on canvas, 68 × 80 in.
The jet airplane takes up the majority of the picture plane. Lichtenstein uses an open composition that allows parts of the aircraft to spill off the edges of the page. Both the plane and the pilot are placed on asymmetrical diagonals to add to the underlying feeling of motion.

3.17 Kathleen Ruiz, *Stunt Dummies*, 2003.
This navigation icon appeared as part of an interactive online art project that allowed users to explore seven virtual worlds, inspired by the seven deadly sins. Ruiz's radial composition draws attention to the central figure of the eye, encouraging us to question our relationship with video games and technology, and their cultural impact on social interactions and individual identity.

3.18 Lisa Milroy, *Shoes*, 1985. Oil on canvas, 69.5 × 89 in.
In this work, there is an underlying grid format, with the repetition of the shoes demonstrating crystallographic balance. No one pair of shoes is more important than any other. Milroy wants the viewer to take in the work in its totality.

Scale and Proportion

Two other factors to consider in a composition's overall design are scale and proportion. **Scale** commonly refers to the size relationship between a form as it is depicted in an artwork or design, and a similar form that exists in the real world. Thus, to create something "to scale" means to accurately replicate a form with all of its components uniformly reduced or enlarged according to a standard system of measurement—an inch might represent a foot in a scale model, for example. In a scale model, all components are said to be "in proportion" to one another, with the term **proportion** referring to the size of the parts of the form or image relative to its whole.

Scale and proportion are not only important to consider when rendering a figure that actually exists; they should also be applied when imagining new forms or designing new objects. When we think of scale and proportion in relation to designing new objects, including tools and utensils (fig. 3.21), we commonly compare the size of the item to our own form. The item must feel natural or fit comfortably when used by a human being. To ensure that newly designed items can be comfortably used by as many different people as possible, many products are developed based on the principles of **universal design**. Also known as *barrier-free* or *inclusive design*, universal design takes accessibility needs into account in order to design functional products for all users.

When thinking about proportion, artists and designers often turn to the **golden mean** (sometimes referred to as the *golden ratio*) for inspiration. The golden mean can be found by dividing a line into two parts, in such a way that the ratio of the shorter part to the longer part is the same as the ratio of the longer part to the entire line. Mathematically, the golden mean is approximately 1:1.618. This ratio is important within the world of art and design because it is widely considered to represent the most aesthetically pleasing proportions. In application, it is commonly used to create *golden rectangles* and *golden spirals* that can then serve as a basis for works of art or designs (fig. 3.22). Famously, the ancient Greeks used this concept of proportion in the design of the Parthenon, and Leonardo da Vinci used it in many of his sketches and paintings, calling it the "divine proportion."

More broadly, spirals are often used in artworks and designs to direct the viewer's eye to a specific point or area. A spiral is a flat curve or series of curves that constantly increases or decreases in size and proportion in circling around a central point or axis (fig. 3.23). The effect is similar to that of a radial composition (discussed above). In nature, the spiral form can be seen in such things as the shape and curve of a ram's horns and in many types of shells such as that of a snail or a nautilus.

In the Western tradition, scale and proportion have also been used to create the illusion of space or depth, with larger objects appearing to be closer to the viewer and smaller objects appearing to be farther away. Artists and designers can manipulate such assumptions about the relationship between size and distance by exaggerating scale and proportion for emphasis or style. By changing the size or weight of one object such that it no longer corresponds to our expectations about how that object would relate to other forms in the real world, artists and designers can use scale and proportion to draw attention and further the message of their artwork or design.

Global Connections

Symmetry and Meaning in Native American and Tibetan Art

What is the underlying philosophical significance of symmetrical design?

There is usually an underlying philosophical reason for the use of pure symmetry. This type of balance is most often found in religious or spiritual works, including weavings, sand paintings, and mandalas. In many Native American works, symmetry is used as a visual metaphor for harmony or balance between the physical earthly world and the more ethereal spirit world. Artists of the Pacific Northwest tribes, for example, often use symmetry as a visual embodiment of the belief that everything in nature must be balanced for there to be harmony and peace (fig. 3.19).

Another example of the use of symmetry can be found in the Tibetan art form of sand painting, also known as *dul-tson-kyil-khor*, meaning "mandala of colored powders" (fig. 3.20). In this case, symmetry is used to symbolize the sense of harmony that is sought in the Buddhist religion. The iconography used in the sand-painted mandalas, which includes geometric shapes and ancient spiritual symbols, is considered to be sacred. These mandalas are typically constructed as part of a ceremony that takes several days, and they are often used as tools for reconsecrating the earth and its inhabitants. Once a mandala is complete, it is often destroyed in an act that signifies the impermanence of life. Afterward, the sands are gathered and placed in an urn. At the closing of the ceremony, half of the sand is distributed to the audience, while the other half is deposited in a nearby body of water. The water carries the healing blessing to the ocean, where it will be further distributed to other parts of the world (Yoo, 2014).

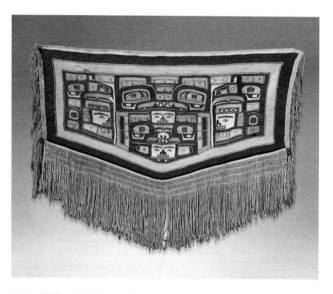

3.19 Chilkat blanket, early twentieth century.

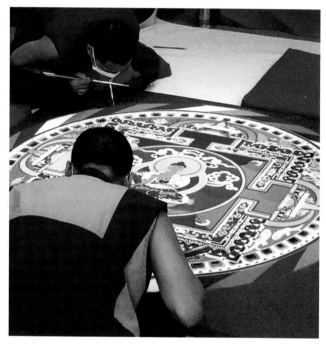

3.20 Buddhist Monks Completing a Sand Painting.

3.21 Three Piece Kitchen Essentials Set.
Three views of an ergonomic set of red plastic dining utensils: spoon, knife, and fork. The molded handles allow the tools to fit comfortably in a variety of hand sizes. The colorful, contemporary design adds to the appeal of these well-crafted utensils.

CONCEPTUAL THINKING ACTIVITY

Considering the concept of human scale, create a utilitarian implement or tool. Your response could be a rendering or a three-dimensional scale object. Think about how the object would feel in someone's hand and how it would be used.

For example, an object may be depicted as much larger than its actual size, to the point of hyperbole. Conversely, an object may be depicted much smaller than we would expect, perhaps diminishing its power or significance.

3.22 The Golden Mean, the Golden Rectangle, and the Golden Spiral.
The rectangle that serves as a border in this diagram is a golden rectangle: its longer sides are approximately 1.618 times longer than its shorter sides. The colored lines at the top and bottom of the diagram help to highlight the golden mean that serves as the basis for this rectangle: the ratio of the red line to the blue line equals the ratio of the blue line to the purple line. The spiral that moves across the diagram has been constructed by drawing a curved line that follows the outer edges of the squares of uniformly decreasing size that compose the rectangle.

3.23 Leonardo Erlich, *The Staircase*, 2005. Metal structure, wood, vinyl tiles, 14 3/4 × 11 1/2 × 50 ft.
The spiral format used in this view of a staircase generates a feeling of deep infinite space. Notice that the viewer's eye is drawn to the center of the spiral, which is placed off center to create a more complex and interesting composition.

Emphasis

Emphasis is the way in which artists and designers focus the viewer's attention on a specific area of visual importance. It is central to communicating the message of the work. A work can have multiple points of interest, but in most cases there will be a hierarchy to these components. As mentioned earlier, in the discussion about directing the viewer's gaze, the viewer's eye is first drawn to the largest image or feature on the page or picture plane, then to the next largest, then

the next, and so on. In addition to relative size, the following techniques—isolation, contrast, and placement—can be effective in creating emphasis.

Isolation

Isolation is the separation of one visual component from the others such that it will stand out and grab the viewer's attention. Any component of a design—such as an object or a figure, a color, a shape, or even a texture—can be used as the isolating factor. For example, in a Volkswagen VW Beetle ad, art director Helmut Koenig isolated the car in the upper left corner. The remaining, empty space acts as a visual metaphor for the size of the compact car (fig. 3.24).

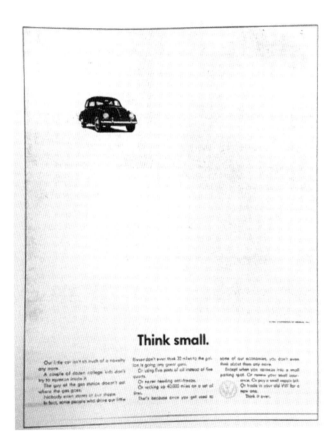

3.24 Doyle Dane Bernbach, Advertisement for Volkswagen VW Beetle, c. 1960.
Art director Helmut Koenig isolated the car in the upper left corner, using the vast yawning space to accentuate the size of this compact car. The minimal use of the space echoes the art concept of minimalism.

CONCEPTUAL CONNECTIONS

How can the scale and proportion of the rendered or graphic elements create visual emphasis? How does the size of the visual elements create an underlying rhythm and repetition within the work?

Contrast

Difference created through the juxtaposition of two or more values, colors, textures, or other elements within a composition is known as **contrast**. The juxtaposition of values can be used to direct the viewer's attention. By sharply contrasting one value to another value—such as dark to bright—a specific area can be highlighted. The Renaissance concept of **chiaroscuro** was an artistic invention that created emphasis by using dramatic lighting to frame the main subject against a very dark background. Francisco Goya uses this effect in his monumental painting *The Third of May* to place the focus on the central figure of the peasant who seems to be radiating light (fig. 3.25). Similarly, the use of contrasting colors—for example, antagonistic pairings such as warm (red, orange, yellow) and cool (blue, green, gray) or light (airy blues, pinks, or yellows) and dark (deep gray, green, or black)—can be effective in highlighting an area of visual importance (fig. 3.26).

Placement

Placement is the location of an element, object, or image, which can establish it as the primary focus of a composition. Recall from earlier in this chapter that Western viewers tend to read a page from top left to bottom right, meaning that items placed in the upper left portion of the picture plane will often draw greater attention than those placed in the lower right. Placement can also indicate the size of a figure, with figures that seem larger drawing more attention. For example,

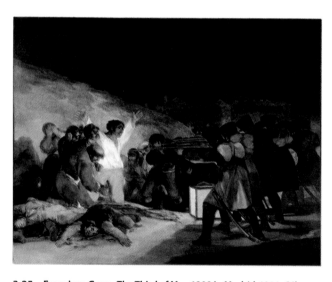

3.25 Francisco Goya, *The Third of May 1808 in Madrid*, 1814. Oil on canvas, 102 × 134 in.
Goya uses chiaroscuro to draw attention to the main figure of the peasant, who stands with his arms outstretched and seems to be radiating light in an almost Christ-like manner. The contrasting darkness can be read as a metaphor for the darkness of the tyranny of oppression. The lines of the soldiers' rifles also direct attention to the illuminated peasant.

3.26 Fiona Banner, *Parade*, 2006. 177 Kit model planes, nylon wire, dimensions variable.
Banner focuses the viewer's attention through her use of color by depicting one bright red plane among a large achromatic group.

placing an item in the upper right portion of the picture plane can create the illusion that is smaller or farther away, while positioning an item in the lower left portion can make it seem larger or closer to the viewer. If objects are placed in the central portion of the picture plane, then their relative size can be determined only in relation to the other objects on the plane. Terry Schoonhoven draws on these conventions in the mural he created for the Los Angeles Metro Rail's Union Station (fig. 3.27).

All of these techniques can help an artist or designer establish a **focal point**—the area of greatest visual emphasis or interest in a work. The focal point, in turn, directs the viewer to the heart of the work's message, whether it is a communication about a client's product or a personal statement about the artist's own feelings or beliefs.

Unity and Variety

Unity and variety are the yin and yang of composition. Visual **unity**, also known as *visual harmony*, implies cohesion—meaning there is visual agreement among the various elements. A unified composition evokes the feeling that each element works with all of the others in a fluid or pleasing manner. Each item or element must, in some manner, relate to the others for there to be a connection. Using similar elements or having an underlying structure can unify a work. **Variety** provides visual interest. To keep the visual elements from becoming a confusing array of disparate items, however, the varied elements must still have a common thread, such as geometric form, biomorphic form, linear elements, color, or texture. In her painting *Under the Surface #10*, Emmi Whitehorse uses a variety of shapes and line styles to provide visual interest while unifying the composition through her use

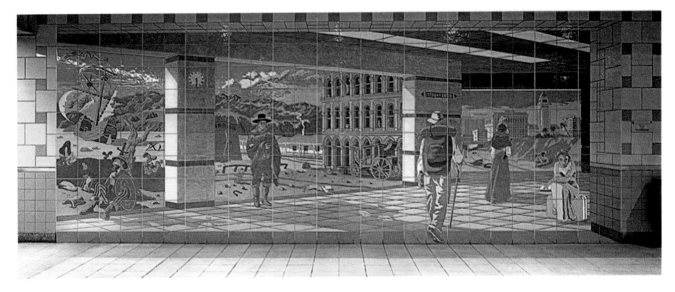

3.27 Terry Schoonhoven, *Traveller,* **1991. Terra-cotta and ceramic tile, 312 × 120 in.**
In this ceramic tile mural, the man with the black hat and the woman walking away from the viewer are almost exactly the same size. However, the man appears to be closer due to his spatial location in the picture plane. The travelers depicted in this mural span a time period from 1500 to the present, suggesting a voyage through time as well as space.

of curved lines and warm hues (fig. 3.29). Unity and variety work together to hold the audience's attention and ensure that the message of the work will be delivered and understood.

Proximity

One way to achieve unity is through **proximity**—the physical distance between objects, forms, textures, and so forth. In visual perception, one of the first things we begin looking for is how the elements are grouped together. If they are isolated from one another, they may appear to be unrelated. However, if they are placed in close proximity to one another, they are likely to be viewed as a group. By **grouping** elements in a design together, an artist or designer can convey how those elements are connected, and that they should be seen as one entity rather than as separate and unconnected. The concept of grouping allows the artist or designer to take contrasting elements and place them near enough to each other that the elements look like they belong together (fig. 3.30).

Rhythm and Repetition

Rhythm and **repetition** can be very effective tools for creating unity. In music, rhythm is sustained through the repetition of beats. Similarly, in visual art, rhythm is sustained through the repetition of design elements—colors, shapes, textures, and so on. Even repetition of the same format or perspective can establish an underlying rhythm (fig. 3.31).

In art and design, the two most commonly used types of rhythm are *alternating* and *progressive*. An **alternating rhythm** repeats elements in a regular sequence, such as a-b, a-b, a-b. Typically the repeated elements are varied in subtle ways, to enhance visual interest (fig. 3.32). A **progressive rhythm** repeats elements that gradually change in a uniform way as they recur. In effect, the element that is repeated *progresses* or *moves forward* in a slightly altered way at regular intervals throughout the work (fig. 3.33).

Pattern

When a discernable element or group of elements repeats in a regular and predictable way, it is referred to as a **pattern**. Patterns can be composed of any combination of lines, shapes, colors, textures, and so forth. They are commonly used on wallpaper and floor tiles, and in some types of traditional cultural designs. The element or group of elements that is repeated in a pattern is known as a **motif** (fig. 3.34). Patterns are usually easy to define and identify because they repeat motifs at regular intervals.

The Grid

The use of a **grid** or underlying geometric structure is often used to create unity in page layouts and designs. A checkerboard is an example of a very basic grid structure. To add visual interest to artworks and designs, the underlying grid can be set on an angle, and the cells or boxes of the framework

Katharina Grosse's *Cincy*

How can the entire gallery space become the artwork?

At this point, you might be wondering whether all artworks and designs need a focal point. In most cases, the answer is yes—a focal point gives direction and emphasis, and it is typically at the crux of the message of the work. However, the choice to have one focal point, or multiple focal points, or no focal point depends upon what the artist wants to achieve. In works where the intent is for the entire work to be taken in as a whole, with no one part taking on greater significance than any other, the artist may decide not to have a focal point. An example of this approach can be found in Katharina Grosse's site-specific installation *Cincy*, which was developed specifically for the Contemporary Arts Center in Cincinnati, Ohio.

Grosse's multidimensional work combines painting, sculpture, and architecture. Using every available surface in the exhibition space—its walls, floors, windows, and ceiling—Grosse develops an immersive environment that is saturated with color (fig. 3.28). In addition to spray-painting the walls, Grosse fills the space with 8 cubic meters of dirt and topsoil placed over a Styrofoam base, producing a hill, which is also sprayed with acrylics. Her work physically encompasses the audience, with the shapes

3.28 Katharina Grosse, *Cincy*, 2007. Acrylic on wall, floor, glass, Styrofoam, and soil, 189 × 291 × 464 1/2 in.

and color surrounding the viewer. The effect feels almost like walking into a painting. Grosse wants the viewer to experience the visceral feel of the movement and texture of the colored elements.

Visit the online resource center to view the Contemporary Voices feature.

3.29 Emmi Whitehorse, *Under the Surface #10*, 1989.
The variety of shapes and linear elements creates visual interest, while the sense that these elements flow together across the canvas creates unity. Many of the curves directly relate to other curves. This design was influenced by Whitehorse's Navajo heritage. The warm hues are reminiscent of the desert and also work as a unifying factor.

can be varied within the overall scheme or pattern of the network (fig. 3.35). Most newspapers, magazines, and webpages are produced using a grid system, which may be used exactly the same on all pages or divided into different sub-modules or cells as needed. By subdividing the main cells within the grid, artists and designers can achieve more interesting and creative uses of space while still maintaining an overall relationship between all the components of a work.

A Holistic Approach

Although the various principles of design have been examined separately here, in practice artists and designers tend to

3.30 Daniel Spoerri, *The Hungarian Meal (The Restaurant of the Galerie J. Paris)*, from the series "Tableaux-pièges," 1963. Assemblage, metal, glass, porcelain, fabric on painted Masonite, 40 1/2 × 81 × 13 in. This aerial view of a tabletop reveals the remnants of a meal. This is not a photographic documentation of an actual event, but a carefully ordered and staged picture. The proximity of the objects shows the connections among them, and through those connections it creates a narrative.

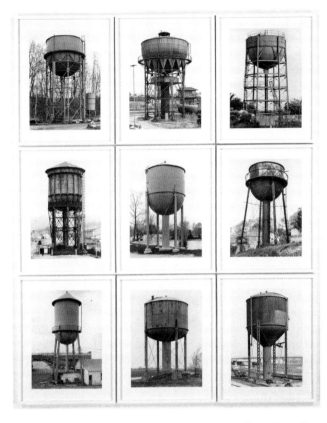

3.31 Hilla and Bernd Becher, *Water Towers*, 1980. Nine gelatin silver prints, 61 1/4 × 49 1/4 in.
In *Water Towers*, Hilla and Bernd Becher repeat the same format and frontal view to capture images of different water towers, creating a continuity and rhythm that acts as a unifying element in this series of photographs.

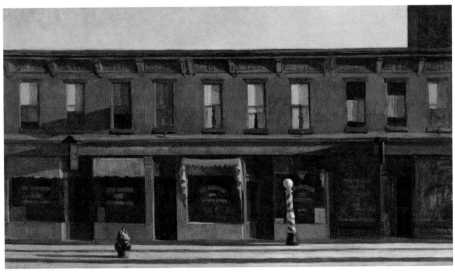

3.32 Edward Hopper, *Early Sunday Morning*, 1930. Oil on canvas, 35 3/16 × 60 1/4 in.
Hopper establishes an alternating rhythmic repetition through his use of the rectangular shapes of the doors and storefront windows. This repetition produces the sensation that the doors and windows will continue infinitely, generating a sense of uniformity and cohesion in the painting.

3.33 Sonia Delaunay, *Rhythm Color no. 1076*, c. 1939.
The semicircular and arc shapes gradually change as they echo through-
out Delaunay's work, establishing a progressive rhythm. The hues are
also repeated in regular intervals throughout, further enhancing the
overall unity.

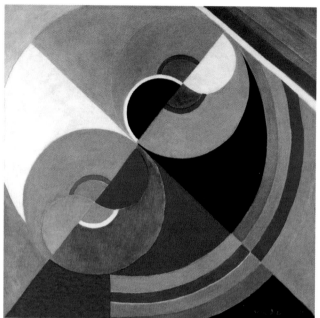

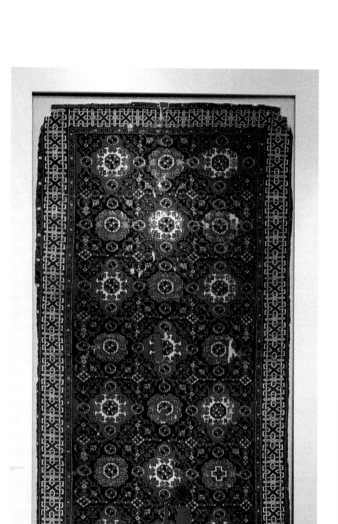

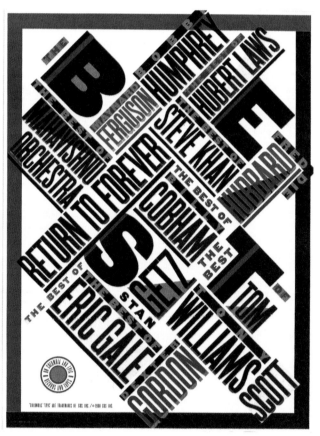

3.34 Early Ottoman Carpet, c. 1500.
This main area of this carpet consists of two primary motifs, while a
third motif repeats along the outer edges of the design. The intricacy
of the design adds visual interest and was influenced by the designs
and ornaments of the historic area tribes.

3.35 Paula Scher, Poster for CBS Records, 1979.
Scher used an underlying grid, but she turns the entire structure
on a 45-degree angle to produce a more dynamic design. Russian
constructivism and nineteenth-century wood-type posters also
influence her work.

3.36 Judy Chicago, *The Dinner Party*, 1974–79.
This installation (left image) is composed of twenty-five place settings on three tables. The triangular form moves the audience around the work. Chicago wants the viewer to take in the work in its entirety. Each place setting adds variety and makes a statement about a famous woman from history, such as the Greek poet Sappho (right image).

CONCEPTUAL CONNECTIONS

How does your distance from the subject relate to how it may be rendered or developed in a composition? How can grouping elements within a composition describe their relationship and unify the composition?

take a more holistic approach to composition, thinking about how they can best draw on the various principles to achieve their overall message or intent. Whichever techniques are used, the goal is for the viewer to be able to respond to the clues the artist or designer has planted within the work. Remember, the viewer's brain wants to find order and meaning in a work, and the artist or designer can help them by making effective choices about composition. This experience is also holistic—only after seeing the work as a whole can the viewer begin to dissect it and uncover its greater meaning (fig. 3.36).

THINK ABOUT IT

- What is the relationship between visual perception and our innate desire for order? How might you draw on an understanding of this relationship when composing your own works?
- How are "reading" a page and producing an artwork or design tied to one's cultural and geographic upbringing? How can we appreciate works of art from other cultures? How has your upbringing and culture influenced your work?
- Why might an artist or designer choose to use symmetrical balance in a work? When looking at a symmetrical artwork or design, what questions should you ask about the underlying philosophical basis of the work?
- Reflecting on the work you've done in the past, have you favored one form of balance? If so, why do you think this has been the case? What does this say about you and your work?
- What is the *golden mean*, and why is it considered to be important in relation to composition?
- Is a focal point necessary in an artwork or design? Explain your reasoning and give examples.
- What factors create a unified composition? How can you create unity in your own work?

IN THE STUDIO

There are four main principles in composition: balance, scale, emphasis, and unity. Choose one of these principles to explore further, keeping in mind that each is related to the others.

For example, you might explore balance by creating a complex composition (11" × 14" or larger) using radial balance. Develop your composition using only black, white, and/or

3.37 Student Work: Jason Bilous, *Radial Design*, 2016.
To create interest, Bilous employed the compositional principle of balance. He placed the radial element off center to create a more dynamic and interesting composition. Bilous's design was influenced by Op Art, which are artworks or designs composed of, or inspired by, geometric abstraction.

3.38 Student Work: Kara Hackett, *Radial Design*, 2016.
Hackett used the principle of balance in her design by creating a floral theme and a bison that both radiate from the central element. The floral theme and the bison overlay add depth and complexity to her radial design.

3.39 Student Work: Jessica Meyers, *Radial Design*, 2016.
Meyers was inspired by her interest in marine biology to develop this octopus-like design. Meyers emphasized balance by reinforcing the radial movement through the background forms, which resemble seaweed.

shades of gray, no color (figs. 3.37, 3.38, 3.39). Keep in mind all of the compositional considerations covered in this chapter, including visual orientation and the use of open or closed composition. Remember, a closed composition distances the viewer from the work, while an open composition brings the audience into the work.

VISUAL VOCABULARY

aerial (or "bird's-eye") point of view
alternating rhythm
approximate symmetry
asymmetrical
balance
bilateral symmetry
chiaroscuro
closed composition
composition
conceptual perception
contrast
crystallographic
emphasis
eye-level point of view
focal point

gestalt
golden mean
grid
grouping
isolation
landscape format
low-angle (or "worm's eye") point of view
motif
open composition
pattern
picture frame
picture plane
placement
point of view
portrait format

principles of design
progressive rhythm
proportion
proximity
radial
repetition
rhythm
scale
symmetrical
unity
universal design
variety
visual orientation
visual perception

Two

The Elements of Two-Dimensional Design

Now that we have covered the design process that forms the basis of art and design creation and introduced the concept of composition, we can take a closer look at the **elements of design**, which are the fundamental components that fill the space of any artwork or design. The first five chapters in Part 2 will cover five of the principal elements of design: line, shape, texture, value, and space. The final chapter in Part Two will cover the means by which artists and designers create the illusion of motion on a static surface, which can be thought of as a separate element. Color is also considered to be an element of art and design, but because of the complexity of using color, it will be discussed separately in Part 3. There we will also cover the concept of digital color and ways of using color in digital and computer-related media.

The elements of design can be thought of as the materials with which we construct art and design. Just as an architect must find suitable building materials to construct a physical structure, so too must artists and designers identify the most suitable elements for constructing the imagery on their page, canvas, wall, or other surface. As you will discover, each element of design has its own unique characteristics, and each can be used in its own way to effectively convey the message that the artist or designer wants to express.

P2.1 **Charmion von Wiegand,** *Individual Worlds,* **1947.**

FUNDAMENTALS

Line

OF ALL THE ELEMENTS OF ART AND DESIGN, LINE MAY BE THE MOST
basic or elemental. A single line can be used to create an effective design. The
LSO logo uses one continuous, flowing line to create the three initials of the Lon-
don Symphony Orchestra (fig. 4.1). The semi-representational shapes are recog-
nizable enough to be seen as letters, but they also allow the logo as a whole to
be seen as an elegant, unified graphic.

A work of art can also be composed of a single line. Georgia O'Keeffe achieves
this in her painting *Winter Road I* (fig. 4.2). She uses a solitary line to illustrate
the vast expanse of space found in the deserts of the American Southwest. She
expresses emotion by varying the thickness of the line and allowing the line to
undulate in order to portray the rolling terrain. O'Keeffe employs perspective by
narrowing the ribbon of paint as it moves back in space, thus giving the impres-
sion of the road moving off through the hills of the high desert.

4.1 The Partners, London Symphony Orchestra Logo.
The line in this logo has a painterly feel—a fluid motion that plays off the musical reference to the orchestra
itself.

The use of line stretches farther back in time than the use of any other art element. Who knows when our first artist ancestors picked up a half-charred stick from a fire and began to draw on a cave wall (fig. 4.3)? We may not know what their intent was—maybe to describe the events of the day, to plan a hunt, or to create something visual to be used in a religious ritual. Whatever the case, we can safely assume that they were driven by a creative impulse and the desire to communicate something of importance to others. By our very nature, we are creative beings. As artists and designers, our goal is to take control of these natural impulses and apply them in a thoughtful, constructive, and purposeful manner.

4.3 Bison with Arrows, *Cave of Lascaux*, c. 14,000 BCE.
These line drawings, which appear in a cave in southwestern France, may be some of the first drawings ever created. Notice that the line is not even throughout. It is thicker in some areas, likely to accentuate the mass of the animal's form. The concept of filling in the forms came later.

4.2 Georgia O'Keeffe, *Winter Road I*, 1943. Oil on canvas, 22 × 18 in.
Using only a solitary line, O'Keeffe is able to represent the expansiveness of the American Southwest. She places the line on a diagonal, which adds to the feeling of movement within the work.

CONCEPTUAL CONNECTIONS

How does the line thickness help to convey meaning in this piece? How is the principle of proportion achieved through the use of line?

Line Defined

In geometry, a **line** is defined as an infinite series of points (fig. 4.4). It may also be seen as the shortest distance between two points. A line can be short or long, heavy or thin, and made from a wide variety of materials or media. What is common to all lines is that they contrast from their background. For instance, if a straight white mark is drawn on a white wall, a line is created, but it can't be seen because it blends into the wall. To be seen, a line must stand out, either by being lighter or darker or of a different color or texture than the surface on which it is created.

a

b

c

4.4 Defining Line.
(a) A series of points. As the space between the points diminishes, a line is created. (b) The human eye will fill in the gap between the two points to create a line. (c) A solid straight line.

4.5 Keith Haring, *Subway Sketch*, 1982.
Haring honed his use of linear forms and archetypal figures in his subway drawings. His use of public spaces as his canvas brought art out of more traditional venues and into people's everyday lives.

When most people think of line drawings, they tend to think of dark lines set against a light background. Street artist Keith Haring challenged this common assumption with a series of **reverse value drawings** he created in the New York City subway system in the early 1980s (fig. 4.5). Using light-colored chalk on black backgrounds that were intended to be covered by advertisements, Haring created dynamic line drawings that caught the public's eye and provoked a broad discussion about the use of public spaces as locations for art. His innovative work inspired generations of street artists to cut out the middlemen of the more traditional venues for art, such as galleries and museums, and bring their art directly to the public.

Characteristics of Line

There are four main characteristics of a line: measure, direction, character, and line quality. Every line contains each of these components, though in any one design or work of art, one may be more dominant or pronounced than the others.

Measure

As its name implies, the **measure** of a line is just that: the physical aspects of a line that can be measured, as with a ruler or a tape measure. These aspects include a line's length, height, and (depending upon the material or media used) width or depth. However, if the line becomes too wide or broad, it may not be read as a linear element but as a shape. The varying thickness of a line can lead the viewer through an artwork or design. For example, in *Winter Road I* (fig. 4.2), O'Keeffe uses the measure of the line to represent the width of the road; as the line moves over the hills into the distance, it carries the viewer's gaze with it.

Direction

The **direction** in which a line is placed—horizontal, vertical, on a diagonal, or curved—can convey movement or stillness (fig. 4.6). Horizontal and vertical lines produce strong, stable structural elements, but they tend to be static, showing little or no movement. Diagonal and curved lines, on the other hand, do tend to show movement. Typically, a greater feeling of motion can be achieved by using a more intense angle or a deeper curve, as seen in figure 4.6. Within a larger composition, the direction of a line can also help to lead the viewer's eye to a specific part of the artwork or design. Notice, for example, how the lines in Barbara Glauber's design (fig. 4.7) wrap around the CD packaging, pulling the viewer toward the back cover, where each line leads to the name of a song on the album.

Character

A line's **character** may be the most variable aspect of a line. Character is derived from the media the line is created with. Each material will bestow a given line with a unique feel

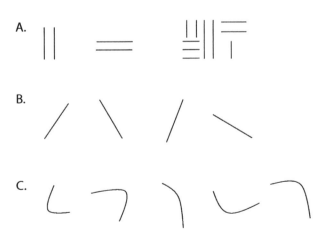

A.

B.

C.

4.6 Line Direction.
(A) Horizontal and vertical lines make stable visual elements, but are typically static. (B) Diagonal lines show movement—the steeper the angle, the greater the feeling of movement. (C) Curved lines also show movement—the tighter the curve, the stronger the feeling of movement.

4.7 Barbara Glauber, *A User's Guide to They Might Be Giants* CD Cover, 2005.
Glauber uses the product barcode as the conceptual basis for her design. She employs diagonal lines of varying thickness to generate a feeling of dynamic energy and movement.

Pencil

Computer

Computer
Paint Brush

Paint Brush

Charcoal

4.8 Line Character.
Although the lines are all the same length, the choice of media changes the feel of the line. Notice that each medium used conveys a different emotional quality.

(fig. 4.8). As an example, we could create two lines that are about the same length and that go in the same direction, but by using different materials or media to make each of the lines, the entire feel of each one will be different. Choosing the right medium will have a direct impact on the piece as a whole and on its implied emotional content.

Quality

Line quality combines the physical characteristics of a line—its measure, direction, and character—with the emotional feel the line conveys. In a sense, it could be considered the gestalt of the line, covering both its meaning and use in one cohesive concept. A line's quality emerges from the combination of choices an artist or designer makes about a line's measure, direction, and character. Each of these choices should work together to support the line's contribution to the composition as a whole. Not long ago, it was generally believed that only traditional media, such as paint, pencil, or charcoal, could effectively vary a line's quality. Today, however, with more sophisticated software and the use of a pressure-sensitive stylus and a digital tablet, the gap between digital and traditional media is beginning to disappear (fig. 4.9).

Types of Line

Lines can be straight, curved, angular, smooth, dotted, scratchy, bold, or faint; they may even have arrows or other details at either end (fig. 4.10). The variety is endless. The type of line that an artist or designer uses gives the work its form and substance, and it can tell us a lot about the artist or designer's creative intent and attitude toward the work. For example, smooth curved lines can create a flowing outline, confining the form; bold jagged lines can show the power and immediacy with which the work was produced; faint lines can suggest delicacy and gently lead the viewer through the work. In this section, we will explore a number of categories artists and designers commonly use to conceptualize different types of line, although in practice not all lines clearly fall into

4.9 Lo Lo Ngie, *She Entered into His Space*, 2004.
Today, even a computer-generated piece can have varied line quality. In this poster, the illustrator uses digital lines of varying quality to suggest an intimate, dynamic relationship between the forms.

4.10 Basic Line Types.
The variety of line types an artist or designer can produce is endless. Here we see several examples, each of which has its own distinctive feel.

CONCEPTUAL THINKING ACTIVITY
Create a vocabulary of line by filling a blank piece of paper with at least 100 different lines. Consider measure, type, and character.

any one of these categories. Whatever type or combination of types of line an artist or designer uses, each line should work with the composition to further the artist or designer's aim of creating a unified pictorial arrangement.

Contour Line

A **contour line** is sometimes referred to as an outline. But it is much more than that. A contour line is a line created by an artist or designer to define the outermost edge or periphery of a form on a flat surface. Often, contour lines are used to represent the boundaries of a three-dimensional form in two-dimensional space (fig. 4.11). In such cases, they

4.11 Gaston Lachaise, *Back of a Nude Woman*, 1929. Black ink on cream, medium-weight, slightly textured wove paper, 17 7/8 × 12 in.
Contour lines create an imagined boundary of a figure as seen from a specific vantage point, indicating the volume of the form. The darker lines show the dominant focus of the movement or gesture. The curvilinear lines Lachaise uses generate a rhythmic flow to enhance the feeling of movement with the figure's gesture.

translate physical boundaries into marks on a page. Notably, these marks correspond to the perimeter of an object as seen from a specific point of view or vantage point; if the artist or designer were to view the object from a different vantage point, the visual boundaries would change. Thus, the contour lines used to represent the boundary of a three-dimensional object will vary depending upon the artist or designer's vantage point when viewing an object. So, in some sense, the exact lines an artist or designer chooses to create could be considered arbitrary because the three-dimensional form continues to move around in space. At the same time, the choice of *vantage point* is not arbitrary—artists and designers carefully choose the angle from which they view and represent their subject in order to communicate something significant to their audience.

A stylistic variation on the use of contour lines is the use of a **continuous contour line**—a line created when the pen (or other drawing instrument) is not lifted from the page once the first mark is made until the drawing is finished (fig. 4.12). In one form of this process, the lines are not allowed to cross

each other. Using a continuous contour line is an interesting exercise because it takes advance planning on the part of the artist or designer. Most of the time when we draw, we lift the drawing instrument on and off the page numerous times, without even thinking.

Gestural Line

A **gestural line** gives the viewer the feeling of how the artist's hand moved. In gesture drawing, the action comes from the shoulder and engages the entire arm. This creates bold, expressive lines that convey power and motion (fig. 4.13). Showing specific details is not important—the intention is to express the weight and movement of the figure in a few strokes. The lines generated can also reflect the speed at which they are drawn. This type of linear notation can be developed into more complex images. Alberto Giacometti often used tightly layered, deliberate yet free-feeling gestural lines to represent the shape and volume of the figures in his drawings (fig. 4.14).

4.12 Felix Sockwell, *Jazz Masters Club* Poster, 2004.
The use of the continuous contour line creates a very free feeling—a sort of doodle effect. Here the use of a continuous contour line is meant to visually represent the free style of the jazz music the poster is announcing.

4.13 Brian Curtis, *Gesture Drawing*, 2019. Ink and charcoal on Gator Board, 40 × 47 in.
In gesture drawing, the artist or designer attempts to capture the feeling of the figure's movement. Broad, sweeping lines are often used to capture the weight and tension of the figure in motion. Curtis shows the progression from gesture drawing to blocking out the figure.

4.14 Alberto Giacometti, *Head of a Bearded Man and Head of a Man*, c. 1958. Ballpoint pen on paper, 31.4 × 25.6 cm.
Giacometti builds up the gestural lines and produces a wide dark-to-light value range within his work. The result is a dynamic drawing in which the viewer can actually see the motion and broad movements of the artist's hand within the work.

Decorative Line

A **decorative line** is used purely for embellishment. As such, decorative lines may have little to do with the natural rendering of a form. When using decorative lines, an artist or designer may choose to orient all of the lines in one direction only—diagonally, horizontally, or vertically. These sorts of lines may be varied in width or shift direction to embellish the curvilinear feel and contours of the objects depicted (fig. 4.16). When used in this way, the contours describe the surface within the forms much as a topological map describes landforms. In design, decorative lines are often used to add visual interest to empty spaces or direct the viewer's gaze to an area of significance.

Implied Line

Not all lines are **actual lines**, rendered by a pencil or other medium as a connected and continuous series of points. **Implied lines** (also known as *psychic lines*) are invisible lines that lead the viewer's eye in the direction the artist desires. Creating an implied line can be as simple as using an arrow

to point the way or placing two points with empty space between them (fig. 4.17).

The gaze of a person (or even an animal) can also work to create an implied line. The viewer will automatically look in the same direction in which the person in the artwork is looking (fig. 4.18). Our natural curiosity makes us want to explore what the person is looking at. After all, it must be important if the artist or designer directed the subject's gaze toward it. The effect is often subtle, but it can be highly effective in communicating with the viewer.

Using Line

Artists and designers can use line in many ways. They may use it descriptively, to depict the technical aspects of a form or a space, or they may use it in a more creative way, to heighten specific visual effects. For example, line weights can be manipulated to create emphasis—by making one or more lines heavier than the others, the artist or designer can focus the viewer's attention on a specific part of the artwork or design. Now we will take a closer look at how line can contribute to a variety of visual effects, and how it can contribute to the other elements of two-dimensional design—shape, texture, value, space, and motion. In all cases, the key to achieving an intended effect is to select the type of line that will have the right visual impact.

Generating Shapes

Lines may be used to generate shapes (fig. 4.21). A single line can enclose a space to create a simple shape, or several lines can meet to create more complex forms. In addition, several lines can be placed close to one another without touching to suggest a specific shape or form; this method involves the viewer more intimately, as it engages the imagination to define the forms. (Note that shape will be discussed in greater detail in Chapter 5.)

Creating Texture

Different textures may be achieved through the use of line. Variations in line type, as well as the use of different tools and media, can produce a multitude of differing textures. Even in simple pencil or ink drawings, carefully placed lines can create rich and varied textures (fig. 4.22). (Note that texture will be discussed in greater detail in Chapter 6.)

Global Connections
Calligraphy

When do the linear forms used in writing become art?

Calligraphy is the art of beautiful writing. Similar to gestural lines, **calligraphic lines** express a sense of the artist's hand in motion. These lines are lyrical, flowing, and decorative, and they are produced through fluid, graceful movements, usually with an underlying rhythm. Calligraphic styles have developed in various regions of the world, including Europe, Asia, and the Middle East. Whereas the European style tends to be purely decorative, the East Asian (Chinese, Japanese, and Korean), South Asian, and Middle Eastern styles all have an underlying religious or meditative significance.

Traditionally, calligraphers had to undergo many years of training before they were allowed to begin working on their own. In Japan, artists such as Ikkyu Sojun devoted their lives to calligraphy and the art of *sumi-e* or Japanese brush painting (fig. 4.15). In addition to gaining renown as an artist, Ikkyu was also a highly respected Zen master who influenced the Fuke sect of Rinzai Zen Buddhism. The Buddhist verse shown in figure 4.15, which was written by Ikkyu, shows the nuanced motion and masterful control of the artist's hand necessary to produce the varied, fluid marks of the calligraphic style.

4.15 Ikkyu Sojun, *Monk in a Landscape*, c. fifteenth century. Hanging scroll, ink on paper, 30 1/4 × 12 5/8 in.

4.16 Sarah Buddelmeyer, *Spilled Coffee*, 2017.
The use of decorative lines produces a distinctively graphic image. The differing thicknesses and patterns of the lines depict the contours of the coffee cup.

CONCEPTUAL CONNECTIONS

How do decorative lines create meaning in this piece? How does the use of line create unity and variety?

4.17 Implied Line.
(Left) An arrow pointing the way can create an implied or psychic line as the viewer's eyes follow the tip of the arrow into the empty space in front of it. (Right) Two points can create an implied line as the viewer imagines an invisible line connecting the two points.

Creating Value

The use of overlapping lines can generate value, which is the relative quality of light and dark. The more lines that are placed on top of one another, the darker the area will become. This method of producing value with line is evident in Henry Moore's work. Figure 4.23 shows one of his drawings, which is part of a series he created during

4.18 Susan Macdowell Eakins, *Two Sisters*, 1879. Oil, 57 1/4 × 45 3/4 in.
We follow the subjects' gaze, which keeps our eyes moving around the center of the picture. As seen in the image on the right, an invisible triangle is formed between the two women's faces and the hands holding the embroidery.

Jochem Hendricks's *Eye-Drawings*

How can you draw with your eyes?

Conventionally, we think of the eye's role in the creative process as fairly passive—we *perceive* objects, images, and design elements through our eyes, but we typically *create* art by manipulating materials with our bodies. However, Jochem Hendricks's "eye-drawings" force us to question this way of thinking. Eye-drawings are renderings done directly with the eyes. The process involves the use of a mechanical device conceived by Hendricks, which uses infrared and video recording to capture the movements of the artist's eyes (fig. 4.19). Computer software then translates the eye movements into lines that appear on a computer screen and can be printed using an inkjet printer (fig. 4.20).

To create his eye-drawings, Hendricks simply looks at an object and moves his eyes around to capture the object's form. He can control the level of detail in the drawings by spending more or less time looking at a particular aspect of the object. As Hendricks (n.d.) has stated, this method turns "the organ of perception ... into the organ of expression." The body of work that he has created through this method, collectively called *Eye-Drawings*, investigates the process of looking at everyday items and questions the influence our experience of our vision has on that process. It suggests that the act of viewing an image is often as significant as the images that are viewed.

Visit the online resource center to view the Contemporary Voices feature.

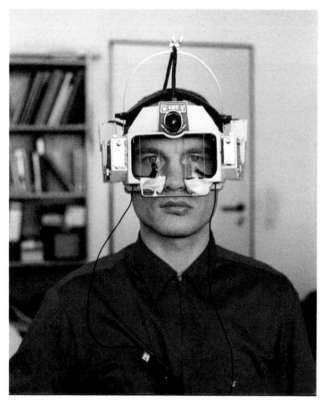

4.19 Jochem Hendricks wearing the eye-drawing device.

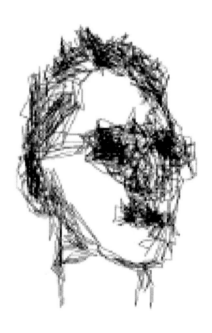

4.20 Jochem Hendricks, *Portrait of Judith Ammann*, 1992.

4.21 Line as Shape.
A single line can define a shape, as demonstrated by the irregular shape and circle in the upper left corner. Or, several lines can meet to create more complex shapes, as shown by the rectangle and star in the upper right corner. Finally, a series of parallel lines can suggest the outline of a shape, as illustrated by the shapes on the bottom row.

CONCEPTUAL THINKING ACTIVITY

Create a line drawing with ink or marker. Use the media to develop different "marks" that reveal texture and relate to the quality of the images rendered.

4.22 Vincent van Gogh, *Tree with Ivy in the Asylum*, 1889. Pencil, reed pen and brush and ink on paper, 24 × 18 1/2 in.
By using lines of varying type and weight, van Gogh was able to produce a variety of textures in his pen-and-ink drawings. The length of each stroke adds to the visual sensation of each element's tactile qualities.

4.23 Henry Moore, *Women Winding Wool*, 1949. Crayon and watercolor on paper, 13 3/4 × 25 in.
Moore's use of lines to create value establishes a sense of depth. The strand of yarn that joins the two women together reinforces the linear elements of the drawing. Moore creates a compact, almost claustrophobic space by cutting off the heads and feet of the figures.

World War II, when the residents of London would seek shelter during German air raids. Notice that the darker areas are produced by the buildup of overlapping lines, while the lighter areas are achieved by placing fewer lines in a given area.

Line can also be used to develop areas of value through hatching and cross-hatching (figs. 4.24 A and B). **Hatching** is a drawing technique in which lines that run parallel to each other are used to create value. Often, these lines are set on an angle. This technique often appears in pen-and-ink drawings, and it was commonly used to generate value in early printed illustrations (fig. 4.25). In hatching, the tighter the space between each line, the darker the resulting area will become. In **cross-hatching**, another set of parallel lines is placed at a diagonal to the original set of hatched lines. This intersection of lines allows for more complex and darker values to be produced. A loose form of cross-hatching used primarily in drawing is known as *scumbling* (fig. 4.24 C). Akin to scribbling, scumbling is the use of loosely drawn, sometimes choppy, lines with variable spacing to create value.

Another method of using line to generate light or dark values, which is similar in format to hatching, is placing lines next to each other in parallel but varying their thickness. Placing thicker or heavier lines beside one another will produce areas of darker value. This way of using lines tends to be more decorative than descriptive. (Note that value will be discussed in greater detail in Chapter 7.)

Establishing Space

Line can also be used to establish a sense of space. For example, using a combination of thicker and thinner lines can make one part of the image appear closer to the viewer. We tend to view heavier, thicker lines as being nearer to us, while narrower, finer lines appear to be farther away (see fig. 4.16 for an illustration of this effect). Alternatively, space can be established through hatching or cross-hatching, with areas of darker value appearing to recede into the distance (refer back to fig. 4.24). Overlapping lines can also generate spatial relationships. When one line crosses over another, sitting on top of the first, a spatial relation is developed—one is in front of the other.

Conversely, lines can be used to suggest a lack of depth or to provide a confusing sense of space. When the values created through the use of line do not correspond to the viewer's expectation of depth, or when the lines in a composition do not overlap to suggest a spatial relationship, the result can be a shallow, ambiguous sense of space. This approach can

 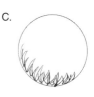

4.24 Line as Value.
(A) Hatching—hatched lines are normally set on a diagonal and evenly spaced. (B) Cross-hatching—two sets of parallel lines cross each other to create more complex values. (C) Scumbling—loosely drawn lines overlap to show value.

4.25 Elisabetta Sirani, *Holy Family with St. Elizabeth and St. John the Baptist*, c. 1650–60. Etching on paper, 6 1/2 × 7 in.
Sirani is able to achieve a wide variety of gray values in this picture through her use of hatching and cross-hatching.

be used to give a very flat feeling to the artwork or design. It can also be used to confuse viewers, preventing them from being able to discern any feeling of depth in the space portrayed. (Note that space will be discussed in greater detail in Chapter 8.)

Suggesting Movement

As noted earlier in this chapter, the use of line can suggest stillness or movement (see fig. 4.6). Horizontal and vertical lines are stable and therefore static; thus they typically do not contain the feeling of movement or the potential for movement. Diagonal lines and curved lines are much more effective in conveying the sense and feeling of movement. The greater the arc of the curve or steepness of the angle, the more pronounced the speed of the movement. For example, compare the feeling of movement in figure 4.7 to the static nature of the image in figure 4.16.

Conveying Symbolic Meaning

Line can also be used to convey a **symbolic meaning**—a message communicated through lines, shapes, or objects that stand in for something else. To create symbolic meaning, linear elements must invoke a learned cultural response. For example, through years of watching TV medical dramas, most people have come to recognize the line pattern generated by an EKG (or electrocardiogram) machine. Moreover, they associate a regularly spiked EKG line with a beating healthy heart, and a flat EKG line with death. Artists and designers can use the meaning that the linear imagery conveys in their work. For example, the advertising agency for Milk-Bone dog biscuits used the EKG line as the basis for one of their promotional campaigns (fig. 4.26). The agency wagered that most people would see the line and take particular meaning from it.

4.26 Kraft Milk-Bone Advertisement, 2004.
The use of an EKG line sends a symbolic message to the viewer: giving your dog Milk-Bone brand treats will keep your pet healthy and active.

CONCEPTUAL CONNECTIONS

How do the character and direction of a line help to convey symbolic meaning? What principle of art and design does line accentuate?

THINK ABOUT IT

- Why is line the most basic or elemental of all of the art elements?
- At what point does the width of a line become so thick that the line becomes a shape?
- In what ways can media affect the characteristics and qualities of a line? Can you think of a new medium or combination of media that could be used to develop a unique linear composition? How might you go about creating such a composition?
- What are some examples of how a line might be used to convey a symbolic message? How might you use one of your ideas for symbolic line in an artwork or design?

IN THE STUDIO

This project is an exploration of line character. It will help you understand how different media can produce lines with varying personalities. Begin by dividing a large piece of paper into sixteen equal parts. Using a pencil, sketch out a balanced and unified composition structured around one continuous line that goes through all of the sixteen boxes or areas. The result should be an organic shape or design.

Go over your line using at least two types of media (e.g., a brush and paint, a B lead pencil, a pen and ink, charcoal, or a marker) and add different types of line (e.g., horizontal or vertical lines drawn using a ruler, dotted or dashed lines, curved lines, or implied line). Use only black and/or gray media, and try to be inventive with your use of line (figs. 4.27, 4.28, 4.29).

4.27 Student Work: Sarah Navin, *Line Character Collections*, 2016.
Navin uses script and reversing the traditional black line on white background in her study of line character.

4.29 Student Work: Julie Crowe, *Line Character Collections*, 2016.
Crowe reverses her line color from black to white in several boxes within the composition. She develops a rhythmic design that uses the entire page effectively.

4.28 Student Work: Jessica Meyers, *Line Character Collections*, 2016.
Meyers uses a black square with a white line to create a focal point. She also uses coffee cup stains in the upper left portion of her design as a unique line element.

VISUAL VOCABULARY

actual line
calligraphic line
calligraphy
character
continuous contour line
contour line
cross-hatching

decorative line
direction
elements of design
gestural line
hatching
implied (or psychic) line
line

line quality
measure
reverse value drawing
scumbling
symbolic meaning

Shape

LOOKING AHEAD

- What is a shape?
- What characteristics define a shape?
- How can we classify shapes by type?
- What are positive and negative shapes?
- How do artists and designers use shapes?
- How can shapes convey symbolic meaning?

AS NOTED IN CHAPTER 3, THE HUMAN MIND CRAVES STRUCTURE.
When given a series of seemingly random marks scattered across a surface, the brain will try to find order in the apparent chaos. It starts by looking for relationships among the marks, seeking edges or boundaries in an attempt to discern familiar forms. This process is called *form perception*, and at its core is the recognition of shapes.

Shape is the first category of classification for the brain. Before it can fully piece together all of the visual information that together creates a particular form, the mind seeks out the basic shape or shapes that constitute that form. We can experience this process by looking at M. C. Escher's *Plane Filling I* (fig. 5.1). At first glance, we see black shapes spaced fairly evenly across the composition. On closer inspection, we begin to notice the other design elements, particularly texture and value, and we come to recognize that those shapes are actually fantastical creatures. Moreover, we come to realize that the white shapes are actually another collection of mythic-looking animals.

5.1 M. C. Escher, *Plane Filling I*, 1951. Mezzotint in black on cream laid paper, 6 × 8 in.
The shapes in Escher's work fit together like pieces of a puzzle. All of the elements are interrelated, creating a unified image.

At its essence, design can be thought of as an arrangement of shapes. Therefore, shape may be considered the second most fundamental of all the design elements, after line (see Chapter 4). Just as lines can define shapes, shapes can become the building blocks for more complex objects and forms. It's how those shapes are used—what an artist or designer does with them in a composition—that makes the piece function, giving it purpose and meaning.

Shape Defined

In common usage, the term *shape* has many synonyms, including *form, figure, silhouette, profile, appearance*, and *structure*. Yet in art and design, these terms all take on slightly different meanings. *Form*, for example, is used more generally, referring broadly to the overall configuration of a visual entity as well as the parts that make up that entity. The term *shape*, in its strictest sense, refers to a two-dimensional form, meaning it may have height and width but no depth. The simplest definition of a shape is a line that encloses itself—as the line wraps around itself, it produces a distinct form that we call a shape (fig. 5.2). A shape can also be an element or group of elements that is perceived visually as a unified area. The unifying factor may be the shape's value, color, or texture. In other words, any area that is encompassed or that is defined by a visual change at its outer edge could be considered a shape.

Characteristics of Shape

As the definition of shape suggests, shapes have two defining characteristics. First, every shape has a clear border or perimeter that defines its edges, distinguishing the shape from its surroundings. In relation to shape, this perimeter is usually referred to as an outline or a **contour**. Second, shapes are two-dimensional. Below, we will examine how artists and designers can explore these essential characteristics to inform their use of shape meaningfully.

Contour

A shape's contour provides a boundary that defines the edge of the shape, differentiating it from other forms or elements on the picture plane. A productive way to explore the concept of contour is to look at the use of **silhouette**. A silhouette is an outline or contour of an object or form that is solidly filled in, usually in black. Although the filled-in area provides little detail, the contour of a silhouette can communicate a great amount of visual information. Imagine a silhouette image of you and three of your closest friends; chances are, you would be able to identify each person simply by seeing the outline of their form.

We can think of all shapes, even those that are not solidly filled in, as having a silhouette. When considered in this way, *silhouette* tends to mean the same as *contour*. This concept of silhouette is often used in fashion design, where the silhouette is the outline or profile of a garment (fig. 5.3). Because an article of clothing's outline can be seen at a distance before its more specific details are fully visible, the silhouette has a strong initial visual impact. In other words, the silhouette gives a general first impression, and the color, pattern, and embellishments of the fabric build on that initial impression.

5.3 The Fashion Silhouette.
In fashion, silhouette refers to the overall shape of a garment, which can indicate the style of the garment. Commonly used fashion silhouettes include the natural, column, hourglass, and egg shapes.

5.2 Shape.
As the line encloses on itself, a shape is formed. The line creates a boundary so that the area or form has its own identity.

Kara Walker's Silhouettes

How can shape affect meaning?

Silhouettes were popular in early American culture, where they were often used in political caricatures and personal portraits. Contemporary silhouette artist Kara Walker uses this art form to tell stories of personal suffering that can be seen as a window into the African American experience, speaking to issues of slavery and civil rights. Her life-size cutout silhouettes provide satirical comments on servitude and racism (fig. 5.4).

Much of Walker's work is often presented as disconnected fragments (fig. 5.5). The characters depicted seem generic, almost stereotypical at first. They lack defining facial features, suggesting that they could be anyone. Her intention is to have the audience fill in missing elements and add their own narrative, even imagining themselves in the place of the silhouetted figures. The larger-than-life scale of her silhouettes also adds to their visual and emotional impact.

Visit the online resource center to view the Contemporary Voices feature.

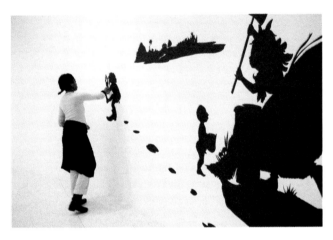

5.4 Kara Walker Installing a Silhouette Work at the Walker Art Center in Minneapolis, Minnesota.

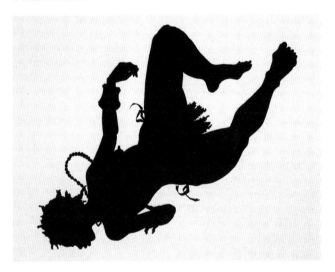

5.5 Kara Walker, *African/American*, 1998. Linoleum cut, 36 5/8 × 42 in.

Two-Dimensionality

By definition, shapes are two-dimensional. This means that, unlike three-dimensional objects, shapes have neither physical **mass** (i.e., weight) nor physical **volume** (i.e., the space an object occupies). Yet shapes can be used to represent three-dimensional objects on a two-dimensional plane. Doing so requires an artist to create the illusion of depth through the use of **shading**. This shading allows the artist to show the strength and direction of a light source illuminating the form, producing a sense of mass and volume (fig. 5.6).

Types of Shape

There is a great variety of shapes to work with, and there are many ways to divide shapes into different types. For example, we could classify shapes based on the types of lines that form

CONCEPTUAL THINKING ACTIVITY

Using only a black ink or marker, develop a silhouette that represents a recognizable object. What are the characteristics and underlying shape of the image?

their contours as well as the relationships between those lines. Using this approach, we could divide shapes into four general categories:

- **Rectilinear** shapes are composed of straight lines. They tend to be angular, with sharp corners where the lines meet (fig. 5.7).
- **Curvilinear** shapes are made up of circles or curves. Compared to rectilinear shapes, they tend to be more fluid, convey greater movement and depth, and express greater gracefulness and elegance.

5.7 Inca Poncho, *Bolivia*, 1380–1520.
Rectilinear designs cross cultures and time periods. The angular shapes and patterns used in this garment have both decorative and social implications.

- **Geometric** shapes have their origins in mathematics. Each has a formula or algorithm underlying its construction. The categories of rectilinear and geometric often overlap. For example, true rectangles, squares, and triangles are all geometric shapes, but they can also be classified more broadly as rectilinear shapes because they are composed of straight lines. Similarly, perfect circles and geometric ovals may be classified either more specifically as geometric or more broadly as curvilinear.

- **Organic**, or **biomorphic**, shapes are composed of fluid, free-flowing lines (fig. 5.8). As such, they are often referred to as *free forms*. Organic shapes are often inspired by the natural world, and all natural things—including humans, animals, and plants—can be represented by organic shapes.

In the next section, we look at several more complex categories into which we can divide shapes. These categories relate not only to how the shapes are constructed, but also how they function within a work, and the type of message they convey.

Representational Shapes

Representational shapes, also referred to as *objective shapes*, look like the real-world objects that they are intended to represent. This category includes **naturalistic shapes**, which are

5.8 Charles Clary, *Nano-diddleitis, Movement #12*, 2013. Complex organic shapes with fluid curvilinear lines run through Clary's piece. The primary colors in the three main elements act as a focal point for the work.

realistic or factual representations created from direct observation. They attempt to capture real-world people or objects as they truly exist, without any attempt to romanticize or manicure the representation. Yet representational shapes are not always used to depict objects and scenes as they exist in the real world. Through artistic interpretation, they can be used to convey scenes that seem realistic but exist only in the artist's imagination (fig. 5.9).

Nonrepresentational Shapes

Unlike representational shapes, **nonrepresentational shapes**, also known as *non-objective shapes*, have very little or no relationship to the natural world. They are distilled through the mind of the artist or designer and are used for their aesthetic impact. In some cases, nonrepresentational shapes may be suggested rather than defined by distinctive outlines (fig. 5.10).

Abstract Shapes

Abstract shapes exist somewhere between representational and nonrepresentational shapes. They represent people or objects that exist in the real world, but these forms have been altered, refined, or synthesized into nonrealistic depictions by

5.9 Dina Brodsky, *Present, Past*, 2012. Oil on Mylar mounted on Plexiglas, 6 × 6 in.
On a visit to India, Brodsky was struck by interconnectedness of the country's past and present. She depicts this dichotomy using representational shapes with Western cultural iconography. The background images are more stylized, while the female figure in the foreground has a contemporary sensibility, capturing the connection between history and contemporary life.

5.10 Meg Kaplan-Noach, *Scratch Drawing Series: Untitled #8*, 2009. Acrylic and oil pastel on arches, approx. 26 × 26 in.
Kaplan-Noach's use of line creates shapes that are not intended to refer to the natural world. Her work is about connecting with the viewer through color intensity, intuitive mark-making, and space.

CONCEPTUAL CONNECTIONS

How does the artist's use of rhythm and repetition create an emotional content? If curved lines were used in place of the straight lines, how would the gestalt of the artwork change?

5.11 Paul Rand, Poster for the American Institute of Graphic Art, 1968. Rand assembles a few simple shapes with the letters from the institute's name partially hidden. This design resembles an abstracted clown's face using a simple color to unify the composition, creating a cohesive visual statement.

the artist or designer (fig. 5.11). Abstract shapes can take many forms, but they always have their roots in the natural world.

The use of abstract shape in Western art has its roots in **Cubism**—a style first developed by Pablo Picasso and Georges Braque beginning in 1907. Cubism was innovative in that it allowed artists to free themselves from the confines of merely copying or imitating nature. It permitted artists to use shapes in new ways to depict objects from multiple angles at once, making it seem as though their parts exist in the same space at the same time (fig. 5.12). Today, the influence of Cubism lives on not only in fine art but also in design. Following the principles of Cubism, designers often streamline and simplify forms, turning them into refined **logos** and graphic elements (fig. 5.13).

Decorative Shapes

In Western art, **decorative shapes** are typically used purely for ornamentation. They often appear on their own or in combination in graphic designs, but they can also be used alongside representational shapes in more complex compositions (fig. 5.14). In some cases, the line between decorative shapes and

representational shapes is not clearly defined. Consider Miriam Schapiro's use of shape in her collage *High Steppin' Strutter I* (fig. 5.15). Schapiro is credited with establishing the Pattern and Decoration (or P&D) movement in visual art. Working primarily in the 1970s and 1980s, the P&D group challenged the conventional Western view that the decorative use of shapes and patterns was of little value or significance. In their works, they often gave decorative shapes a place of prominence by situating them in the foreground of their compositions.

Positive and Negative Shapes

When thinking about shapes in terms of their use, importance, and placement on the picture plane, we can also categorize them as either *positive* or *negative*. **Positive shapes** represent the main objects within a composition. They typically fill the primary space and are the first shapes to attract the viewer's attention. **Negative shapes**, on the other hand, are the shapes that surround the positive shapes. They can also be thought of as the empty or surrounding area. Sometimes

5.12 Georges Braque, *Violin and Palette*, 1909. Oil on canvas, 36 1/8 × 16 7/8 in.
Braque renders the neck of the violin in profile and the body of the instrument from the front. The instrument is stripped of its dimensionally and exists in the same space as the table and sheets of music. The objects in the painting are represented through combinations of nonrealistic angular shapes, or "cubes."

the play as well as those characters' relationship to the setting in Africa.

When the positive and negative elements are fully integrated and work together so closely that the viewer cannot identify which are positive and which negative, the composition is known as a **figure-ground reversal**. As shown in figure 5.17, the positive and negative elements are so balanced and interrelated in a figure-ground reversal that they work together to form a unified composition.

5.13 Macintosh Finder Icon.
Cubist influences are everywhere. In this Macintosh icon, the facial features are depicted from two vantage points at once: from the front (on the left) and in profile (on the right).

Actual and Implied Shapes

Finally, we can categorize shapes as either actual or implied. **Actual shapes** have visible contours that clearly distinguish them from their surroundings. **Implied shapes**, on the

CONCEPTUAL THINKING ACTIVITY
The Macintosh Finder icon (fig. 5.13) shows just how prevalent Cubist imagery is in our daily lives. Document another similar example of shape and design from your daily life.

they are referred to as *negative space*. Looking back to figure 5.6, for example, we could classify the two pears as positive shapes and the surrounding area as negative shape or negative space. Some artists and designers use the terms ***figure*** and ***ground*** to describe the use of positive and negative shapes—the figure consists of the positive shapes, while the ground (or "background") consists of the negative shapes.

It's important to consider both the positive and negative shapes when developing a composition or design. All too often, novice artists and designers neglect the negative areas of a composition, and things may end up looking jumbled or overcrowded. In your own work, take time to look at the space that surrounds the main shapes. Also, you might play around with the relationship between positive and negative shapes, or even integrate the two. Consider the composition David McNutt created for the playbill and poster for the play *"Master Harold" . . . and the boys* (fig. 5.16). The integrated positive and negative images communicate the interconnection among the main characters within

5.14 Nancy Sahl, *Elektra Swing*.
The naturalistic rendering of the two central figures and the decorative concentric arcs communicate the movement of swing dancing. The computer-generated gradations help to establish the volume and weight of the shapes.

5.15 Miriam Schapiro, *High Steppin' Strutter I*, 1985.
Schapiro assembles collages from cut paper and fabric. She calls these works *femmages*, a term that highlights the female laborer's relationship with traditional hand-sewn work. She balances simple flat areas of color with the more decorative appliqués.

5.16 David McNutt, Playbill for *"Master Harold" . . . and the boys*, 1985.
McNutt blurs the distinction between positive and negative shape, using outlines of the face of an older black man, the face of a young white boy, and the continent of Africa to create a single shape that represents the main characters and setting of the play. The image becomes a narrative guide to the subject matter of the drama.

other hand, have invisible borders that are suggested by the perceived relationships among disconnected marks (for an example, see the final two shapes in fig. 4.21). In a sense, an implied shape is an optical illusion—it exists only in the viewer's perception of invisible lines connecting marks on a picture plane.

Using Shape

On a fundamental level, artists and designers use shapes to represent people or objects (e.g., by using representational or abstract shapes), or to create aesthetic appeal (e.g., by using nonrepresentational or decorative shapes). Yet shapes can also

be used for broader purposes in art and design—to achieve order, to guide the viewer's eye through a composition, or to communicate a message. The following discussion explores some of these more intricate and meaningful uses of shape, organized around two principal themes: the use of shape to unify a composition, and the use of shape to convey symbolic meaning.

Unifying a Composition

As shapes interlock with one another, they act as a unifying element. They hold the work together in a way similar to how a jigsaw puzzle works, with each shape dependent upon the others to complete the whole. In naturalistic or realistic art, the unifying effect of shape is often subtle. In other styles,

5.17 Shigeo Fukuda, Poster for Keio department stores, 1975.
Fukuda was renowned for his use of optical illusions. In this figure-ground reversal, the two series of legs move in different directions, yet they are interconnected with each other. The negative shape of one series is the positive shape of the other.

5.18 Charmion von Wiegand, *Individual Worlds*, 1947. Oil on canvas, 30 × 25 in.
Von Wiegand uses carefully interconnected shapes to unify his composition. The lines that form the contours of the shapes flow together, binding the myriad of seemingly incongruent shapes together into a cohesive artwork.

5.19 Roni Tresnawan, ED Initials Electric Plug Shape.
Tresnawan's use of interlocking rectilinear and curvilinear shapes creates a clean, unified logo. The overall shape has a dual function—it looks like an electrical plug (signaling the company's line of electrical home appliances) but also depicts the initials of the brand. The letter E is suggested in the negative space, forcing viewers to engage with the design to supply the missing elements.

this effect is often more apparent. For example, in his abstract piece *Individual Worlds*, Charmion von Wiegand uses clearly defined, interconnected shapes to create strong visual integration across the entire picture plane (fig. 5.18). Graphic designers often make use of the unifying effect of interlocking shapes to create clean, straightforward logos and other graphics. Roni Tresnawan, for example, combined simple interlocking shapes to create a clean, coherent logo for an electrical company (fig. 5.19).

Designers who work with text often use blocks of text to create unifying shapes. In books and magazines, for example, paragraphs are typically set in text blocks of consistent width, forming implied rectilinear shapes that work to unify the design across multiple pages. When creating poster and cover designs, many artists and designers make creative use of text to generate unifying shapes (fig. 5.20). By

CONCEPTUAL CONNECTIONS

How can interconnecting your visual elements develop unity and variety? What other means of using visual proximity can unify an artwork or design?

5.20 Lee Bearson, *Rolling Stone* Cover, 1995.
Bearson uses blocks of text as shapes. He angles them in a faux-perspective to produce volumetric forms, generating an optical illusion of three-dimensionality. The shapes implied by the text blocks work in an almost subconscious manner to reinforce the underlying harmony of the work.

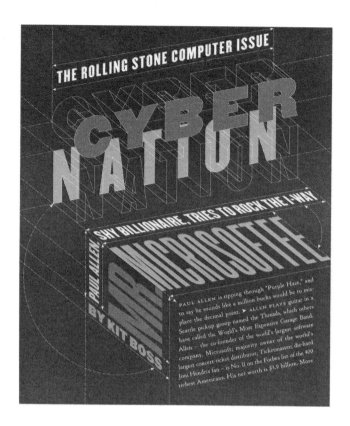

carefully controlling the shape, size, and positioning of the text blocks, they can use these implied shapes to guide the viewer's eye around the composition and draw attention to the most important words.

Conveying Symbolic Meaning

Shapes that are widely understood to convey a particular meaning are referred to as **symbolic shapes**. Common examples include a heart, used to communicate love, and the stick male and female figures used to indicate the location of public washrooms. Perhaps the shape most widely used to convey symbolic meaning is the circle, which is almost universally understood to represent an endless cycle or infinity, because it has no beginning or end. This meaning often appears in Western popular culture, for example in the concept of the "circle of life" in the movie *The Lion King*. Circles conveying endlessness or infinity can also be found within more complex symbols such as the yin-yang or the mandala. An important aspect of symbolic shapes is that their associations with the meanings they convey are culturally constructed. Therefore, when using a given shape, artists and designers must be sure that they understand the cultural context in which it will be viewed.

The use of shapes to convey symbolic meaning extends into prehistory, when early humans carved **pictograms** into

rock surfaces (fig. 5.23). A pictogram, sometimes called a *pictograph*, is a symbolic shape that represents a specific word or thing. In most cases, pictograms look like a simplified silhouette of the real-world objects they represent. In the modern world, pictograms are commonly used to convey important information that allows people to navigate an unfamiliar place without having to speak the local language. The symbols shown in figure 5.24 were designed in 1974 for the US Department of Transportation to serve this purpose. Today, these symbols are widely used in places where large crowds of people may congregate, such as airports, bus or train stations, hospitals, sports arenas, and amusement parks.

Graphic designers often use symbolic shapes when designing logos. Logos are easily readable and identifiable designs that consist of one or more shapes and/or text. They are used as a means of identifying or branding an organization or company and its products or services. The shapes used to create logos often communicate a symbolic message about the entity the logo represents. For example, the arrow in the Federal Express logo suggests speed of delivery (fig. 5.25). Other examples include the Nike swoosh, which also denotes speed; the NBC peacock, which originally signaled the television network's shift to color programming; and the golden arches of McDonald's.

How does symbolic meaning vary across cultural contexts?

Certain shapes have an especially strong symbolic significance within a particular region or nation. The bald eagle, for example, is a distinctively American icon, expressing the supremacy and authority of the United States. The US Postal Service uses a streamlined bald eagle shape as its logo, thereby communicating its identity as a powerful and authoritative American institution, while also tapping into the underlying psychological association between birds and swiftness to suggest speedy service (fig. 5.21).

In Myanmar (formerly Burma) and India, the symbol of the peacock conveys a meaning similar to that of the bald eagle in the United States. In those countries, peacocks are viewed as not only beautiful but also fiercely dominant, willing and able to defend their territory with force. Thus, the peacock was adopted as a prominent symbol for the Burmese democracy movement in the latter part of the twentieth century (fig. 5.22). The peacock on the movement's flag is running with its head stretched far in front of its body, suggesting that it is heading confidently into the future, leading the way to freedom and democracy. This example shows how a symbol's meaning can change dramatically depending on the cultural context: while Westerners tend to associate the peacock with flamboyancy and shallowness (think of the phrase "to strut like a peacock"), in Southeast Asia this bird is seen as strong, robust, and proud.

5.21 **Sonic Eagle Logo, United States Postal Service, 1993.**

5.22 **Burmese Democracy Movement Flag, c. 1988.**

5.23 **Ancient Pictograms, Newspaper Rock, Utah.**
These pictograms were carved into a rock surface thousands of years ago. Their exact meanings are uncertain, but their shapes suggest recognizable forms. They serve as evidence that the use of symbolic images predates written language.

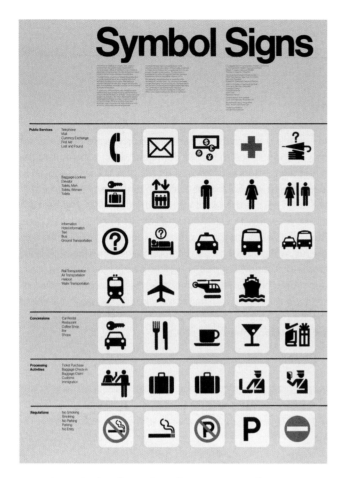

5.24 Roger Cook and Don Shanosky, Department of Transportation Signage Symbol System, 1974. Offset lithograph on white wove paper, 29 7/8 × 21 9/16 in.
These symbols are designed to be used on signage to communicate important information nonverbally. Using these symbols, a person can navigate through a foreign airport or train station without understanding the local language.

5.25 Federal Express Logo.
The arrow created in the negative space between the E and x of this logo suggests speed and directness. The subtle use of this arrow communicates an almost subliminal message: using FedEx will get your package delivered fast.

CONCEPTUAL CONNECTIONS

How can changing kerning, the space between letters, change the visual orientation? How you might use kerning in your work to create symbolic or abstract shapes?

THINK ABOUT IT

- What distinguishes a line from a shape?
- Why are silhouettes so effective at representing real-world objects and people? In what ways might you incorporate silhouettes into your own artworks or designs?
- What is negative space? Why should you pay careful attention to it when creating your own artworks and designs?

- What are the differences between representational, nonrepresentational, and abstract shapes? What is each one most effective at conveying?
- How might you develop a language using only shapes or pictograms? What might be some advantages and disadvantages to using this sort of language as a means of communication?

IN THE STUDIO

This project requires you to explore ways of working with interlocking shapes. It is based on the traditional Chinese tangram puzzle. Begin by drawing a square on a piece of thick paper, then add lines to divide the square into seven or more angular shapes. Cut along the lines to separate the shapes, then reassemble the pieces in different ways to create six new recognizable forms. The puzzle pieces should touch one another but not overlap (figs. 5.26, 5.27, and 5.28).

5.26 Student Work: Katina Eckert, *Puzzle Assignment*, 2016. Eckert created her puzzle with many pieces, which allowed her to develop complex forms.

5.28 Student Work: Tyra Gillard, *Puzzle Assignment*, 2016. Gillard placed her completed puzzle off center to develop a dynamic composition. She also created complex backgrounds for her tangram solutions to add visual interest.

5.27 Student Work: Steven Parker, *Puzzle Assignment*, 2016. Parker used texture rubbings on his main puzzle form and contrasted it with black silhouettes for his tangram solutions.

VISUAL VOCABULARY

abstract shape
actual shape
contour
Cubism
curvilinear
decorative shape
figure
figure-ground reversal
form

geometric
ground
implied shape
logo
mass
naturalistic shape
negative shape
nonrepresentational shape
organic (or biomorphic)

pictogram
positive shape
rectilinear
representational shape
shading
shape
silhouette
symbolic shape
volume

Dry.

A memoir.

Augusten Burroughs.

Author of *Running with Scissors*

Picador.

6

Texture

LOOKING AHEAD

- **What is texture?**
- **Why should artists and designers think about the textures of their subjects and their materials?**
- **What characteristics can texture have?**
- **What are the differences between actual, simulated, and invented textures?**
- **What are some ways artists and designers can use texture in their works?**
- **How can type be used to create texture?**

SOFT, HARD, SCRATCHY, SMOOTH, ROUGH, STICKY, GREASY, SILKY,

gritty, sandy, velvety. When you read each of these words, you feel them—not physically, through your skin, but in your mind. If you were to look at a visual representation of these textures—for example, in a photograph of a feather, a painting of a rock, or a sketch of rough tree bark—the sensation would likely be even stronger. Texture has the power to tap into core aspects of the human experience and communicate on a visceral level. Merely thinking about the tactile quality of an object or a surface can evoke an emotional response, often because it causes the mind to recall a past pleasant or unpleasant sensation. When using texture in their work, artists and designers draw on their own vast array of stored memories of textures and emotions, and they try to anticipate what emotions certain textures will evoke in viewers.

6.1 Chip Kidd, *Dry*, 2003.
Kidd's use of texture reverses our initial mental image of the word *dry*—the text on this book cover seems to be wet and washing away before our eyes. Subtle humor such as this can be an effective conceptual element in art and design.

In two-dimensional art, texture can create the illusion that a smooth, flat surface is far more rich and complex than it is. It can also help to add depth to the figures depicted, even suggesting that those figures are part of the viewer's world. Consider graphic designer Chip Kidd's use of texture in his book cover design for *Dry*, which makes it seem as though the letters are standing out from the background and slowly washing away (fig. 6.1).

Texture Defined

In its narrowest definition, **texture** is the tactile surface quality of an object or a substance. When referring to two-dimensional artworks such as drawings, paintings, and graphic designs, we use the term in two ways: (1) to refer to the physical texture of the artwork's surface, and (2) to refer to the visual representation of a physical texture (fig. 6.2). Representations of texture are important in two-dimensional works because they add visual interest and further define the objects depicted.

Characteristics of Texture

Every object and substance has its own distinctive texture. We can describe and differentiate these complex textures by identifying the various tactile characteristics that combine to produce them—for example, their softness, hardness, smoothness, or roughness. As we break complex textures down into their component characteristics, we might notice that certain characteristics or qualities appear more often in certain types of objects. For example, natural objects tend to have **natural textures**, which are typically rough and uneven, while factory-produced objects tend to have **human-made textures**, which are typically smooth and even (fig. 6.3).

When working on your own artworks or designs, you should think carefully about the textural characteristics of both the materials with which you are working and the things you are depicting. When choosing a material, ask yourself the following questions:

- What is extraordinary or unique about this material's texture?
- What distinguishes this material's texture from that of other materials?

6.2 Edward Weston, *Cabbage Leaf*, 1931. Gelatin silver print, 7 1/2 × 9 7/16 in.
When we think about texture, what we are really thinking about is the surface quality of an item. Weston's crisp photograph shows the texture of the cabbage leaf in great detail, leaving viewers with a sense of what it might feel like to touch the leaf.

6.3 Ross Lovegrove, *Pod Lights*, 1996–97.
Lovegrove uses surface uniformity as part of his design for the skin of these lamps. Surface uniformity is a feature of most human-made, or artificial, textures.

- How can I use this material's inherent texture to enhance the representations of textures I'm creating in my work?

To become familiar with the textures of objects you might choose to depict in your work, take the time to notice the textures you encounter in the world around you, and note what makes them similar to and different from other textures. You might even stop to make a rubbing or **frottage** of a texture that interests you (fig. 6.4). Doing so will engage your sense of touch and help you gain a more direct understanding of

6.4 Creating a Texture Rubbing.
Creating a rubbing of a physical object's surface can help you gain a deeper understanding of that object's texture. In creating a texture rubbing, pressing soft lead or charcoal against a thin piece of paper (such as tracing paper) works best.

CONCEPTUAL THINKING ACTIVITY

Create a catalog of texture rubbings. Find at least 25 visually different textures. What differences do you notice between natural and artificial textures?

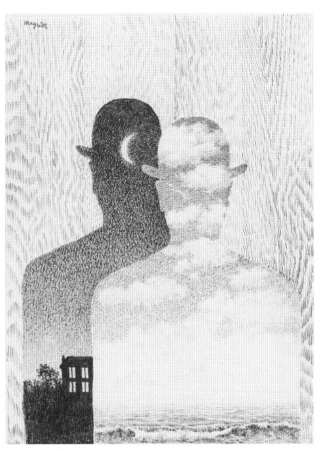

6.5 Rene Magritte, *The Thought Which Sees*, 1965. Pencil on paper, 15 3/4 × 11 3/4 in.
Magritte used graphite on paper to create rubbings he later used in his works. The background of this drawing is a texture rubbing of wood planks. Magritte combines rubbings with hand-drawn elements to create evocative forms that play off the human psyche.

the texture. You may even find a way to use the rubbings you produce in your work (fig. 6.5).

Types of Texture

There are three basic types of texture that artists and designers can use in their work: actual texture, simulated texture, and invented texture. An artist or designer working with the inherent texture of a material is using an **actual texture**, also known as a *real texture* or a *physical texture*. A **simulated texture**, also known as a *visual texture*, creates the illusion of an actual texture. Finally, an **invented texture** visually conveys a surface quality that exists not in the physical world but in the artist or designer's imagination.

Actual Textures

Each mark an artist makes creates a surface and, therefore, an actual texture. The manner in which the artist applies

a medium will have a direct effect on the work's surface quality—a brush, a sponge, a finger, and so on will all create different marks and textures. Likewise, different materials can create different surface qualities.

Sculptors and others who specialize in three-dimensional art and design are acutely aware of how a material's textural qualities can affect their work. Yet artists and designers who create two-dimensional art must also consider these qualities when choosing a material. A painter, for example, may choose to use watercolors because they can be diluted with water to create thin **washes** of paint. These washes are transparent and can be used in overlapping layers to create complex areas of light or dark value, color, or form. A similar effect can be created through the use of inks, as found in traditional Asian ink-wash paintings (fig. 6.6).

A common way to add actual texture to a painting is by applying thick, heavy layers of paint, either with a brush or a palette knife. This technique, known as **impasto**, shows each individual stroke of the brush or knife (fig. 6.8). Traditionally,

6.6 Hasegawa Tōhaku, *Pine Wood*, late sixteenth century. Ink on paper, 61 × 140 in.
The effect of the ink on this rice paper screen is similar to that of watercolors on paper. The use of heavier and darker applications or washes makes the figures of the trees appear to fade mysteriously into the distance.

CONCEPTUAL CONNECTIONS

How does the media change the actual texture of the work? How can changing from a wet to dry media alter the look and feel of an artwork or design?

Global Connections
Evocative Textures in Aboriginal Dreamtime Paintings

How and why has texture become such an integral part of Dreamtime paintings?

Aboriginal painters in Australia have developed a distinctive style of painting in which they apply small dots of paint to create fine textures. This technique has its roots in traditional Aboriginal sand paintings, with the dots of paint creating a texture that is visually similar to that of tiny piles of sand. Aboriginal artists often use this technique in paintings that refer to their belief in "Dreamtime," an ancient period when humans and spirits lived together. An example of this style of painting appears in figure 6.7. In this painting, Aboriginal artist Johnny Warangkula Tjupurrula uses dots of paint to produce textures that represent ground covers. While at first glance the painting might look abstract, it actually represents a map with identifiable tribal campsites. Tjupurrula also includes Aboriginal symbols in his work, which add a deeper layer of meaning for those who can read them.

6.7 Johnny Warangkula Tjupurrula, *Water Dreaming*, 1974. Synthetic polymer paint on canvas board, 28 × 22 in.

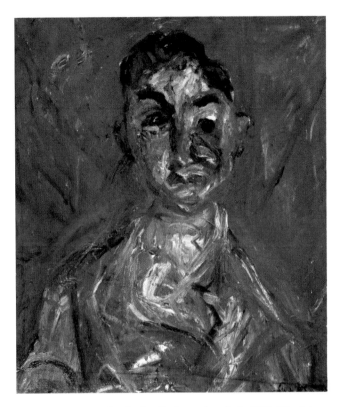

6.8 Chaim Soutine, *Butcher Boy (Le Garçon boucher)* c. 1923. Oil paint on canvas, 11.7 × 16.2 in.

Soutine uses thick impastos of paint, reducing the image of the named in the work's title to a series of hurried brush strokes and slashes of the palette knife. The bright intense color and visible brush strokes reveal the immediacy of the act of painting.

artists employing the impasto technique used oil paint. However, many contemporary artists prefer to use acrylics because they take less time to dry and are less likely to crack. Different types of materials—for example, sand, ground marble, metal shavings, or graphite—can be added to the paint, allowing the artist a freer hand to create tactile surfaces.

Collage, an art form in which various materials are pasted together on a surface, also creates actual texture. Pablo Picasso and Georges Braque developed collage during the early 1900s as a part of the Cubist epoch. The first of these mixed media works were composed using a technique called **papier collé**, which involves the combination of pieces of paper. Many Cubists liked to use newspaper clippings as well as a variety of art papers in their works. Newspaper clippings add an extra layer of complexity in that the text of the articles can be read and becomes part of the work itself (fig. 6.9). Collage can be made from a limitless array of media besides paper, including cloth, wood, aluminum foil, and everyday objects from flipflops to sports equipment. Virtually any item an artist or designer can think of can be used to create a collage (fig. 6.10).

CONCEPTUAL THINKING ACTIVITY

Collage was one of the first uses of mixed media. Develop a collage using newspaper and your own drawings. How might the text or images from the newspaper influence your renderings?

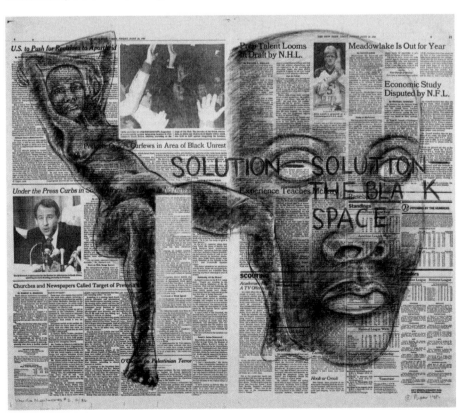

6.9 Adrian Piper, *Vanilla Nightmares #2*, 1986. **Charcoal and red crayon, with erasing, on tan wove paper (newsprint), 23 × 28 in.**
Piper used pages from the *New York Times* for this collage. The articles she chose discuss apartheid in South Africa and act as a meaningful counterpoint to the black female figures she sketched on top of them.

6.10 Jason Mecier, *Ford Edge ad,* 2007.
Mecier used sports equipment, flip-flops, flowers, tools, and even a uku-lele to create the image of the sport utility vehicle. The products he used directly relate to a person with an active lifestyle.

Simulated Textures

Unlike actual textures, simulated textures cannot be perceived through the sense of touch. Rather, they are visual illusions that aim to represent an actual texture that exists and can be felt in the real world. Techniques used to create simulated tex-ture include shading, drawing parallel lines, scribbling, hatch-ing, cross-hatching, and stippling. (See Chapters 4 and 7 for more on these techniques.) In addition, patterns can work well to establish visual texture.

While artists have long strived to realistically simulate actual textures in a purely visual form, the **Photorealism** movement that began in the late 1960s intensified this aim. Photorealist artists such as Richard Estes and Nancy Hagin (fig. 6.11) endeavor to achieve an almost photographic qual-ity in their paintings. A closely related style that pushes the quest for **verisimilitude** to an even greater degree is **trompe l'oeil**, which literally means "fool the eye." These hyperreal-istic works are meant to trick the viewer into mistaking their depictions for actual forms, as seen in figure 6.12.

Today, some artists and designers and designers use image scanners when working with texture. Scanners are capable of producing a visual simulation of almost any surface or texture in a digital format (fig. 6.13). Their ease of use and afford-ability makes them a democratizing tool, opening up digital technology to a wide variety of artists and designers.

Invented Textures

Sometimes artists and designers want more freedom than simulating an existing texture allows. In such cases, they may decide to use a texture that originates in their imagination. Invented textures are designed to fit a particular aesthetic concept, creating new visions and new ideas. An example of this type of texture appears in Robert Arneson's *Nuclear Warhead #1* (fig. 6.14). The textures Arneson has invented using acrylic paint are dramatic, emphasizing his point about

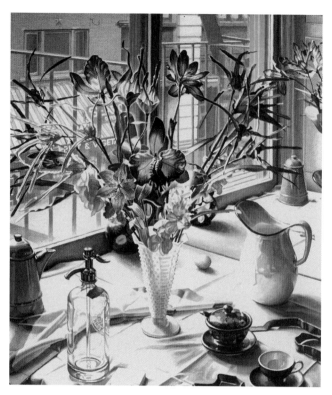

6.11 Nancy Hagin, *Milk Glass Bouquet,* 1986. Acrylic on canvas.
Hagin uses a wide range of textures to create photorealistic represen-tations of objects in her still-life painting. She chose the objects not only for their pictorial value but also to show off her ability to render an assortment of surface qualities and finishes.

the horrors of nuclear war. Invented textures can also be purely decorative, or they may be used solely to add visual interest.

Using Texture

Texture is a powerful design element because it has the ca-pacity to elicit an immediate, unconscious response from the viewer. Indeed, different textures can unleash a wide variety of physical and psychological responses. Because of its close connection with the sense of touch and its ability to evoke emotions, texture can tap deeply into the human psyche. The tactile, sensual nature of texture can convey an object's surface qualities, either in a naturalistic way, or to surprise the viewer by showing a surface other than what would be expected. In some cases, texture can even guide the viewer's experience of the layout of forms on a page. Below, we will explore some other ways artists can employ texture to enhance their works and connect with their audiences.

Creating Patterns

As mentioned in Chapter 3, any element that repeats itself at regular intervals can produce a pattern. While the most obvious patterns tend to consist of shapes and colors, repeated

6.12 Pat Rosenstein, *Untitled*, 2003. Acrylic on canvas, 31 × 44 in.
Rosenstein's painting is eye catching. At first glance, it looks like a photograph of the back of a canvas in the artist's studio.

6.13 Scanned Liquid Design.
Any object or substance that can be placed on top of the glass plate of an image scanner can be scanned. To scan liquids, as seen here, simply pour the liquid into a clear container and place the container on the scanner's glass plate.

CONCEPTUAL CONNECTIONS

A scanner can produce simulated textures. How could you use simulated textures in your work? What do you think is the visual difference between developing a collage using digital media and developing one using traditional methods?

6.14 Robert Arneson, *Nuclear Warhead #1*, c. 1980s. Woodcut in colors, 42 1/2 × 56 1/2 in.
Arneson's use of invented textures give the sensation of burnt, decaying flesh. To enhance the gruesome nature of the work, the artist sprayed the bottom portion of the image with water, thinning the paint and allowing it to run off the canvas, simulating the appearance of dissolving skin.

textures can also create distinct patterns. Although textural patterns are not always conspicuous, they can still help to unify a composition in a subtle way. The regular repetition of different textures can also enhance visual patterns created through the repetition of shapes and colors, as illustrated by the Kente cloth sample shown in figure 6.15.

Establishing Depth and Space

Texture can also help to establish a sense of depth and space within a work of art. When you look at your surroundings, you may notice that the objects closest to you appear in much greater detail than do objects farther off in the distance. This phenomenon is known as **atmospheric perspective**, and it is caused by the interaction between light and particles in the atmosphere. Artists can replicate this effect by depicting the textures of objects in the foreground of their work in precise detail, and then gradually decreasing the textural detail for objects that are meant to appear farther away (fig. 6.17).

6.15 Kente Cloth, Asante, Africa, twentieth century.
Kente cloth is an icon of African cultural heritage. Asante Kente is identified by its bright colors, geometric shapes, and bold designs. The textural patterns created by the threads in this cloth help to enhance the pattern established through the repetition of shapes and colors.

☽ new perspectives

Willie Cole's *Sunflower*

How can burning or branding create texture and evoke the senses?

Visual artist Willie Cole has developed an innovative way to create textural patterns using the steam iron. Since the late 1980s, Cole has been interested in the steam iron for both its domestic and its economic symbolism, including its connection to the domestic role of women of color. He has also said that the steam iron, with its shape and vent hole patterns, reminds him of the form of African masks and shields, as well as symbolizing Ogun, the Yoruba god of iron and war (Cole, n.d.; Weitman, 1998).

Cole first used steam irons as physical components of his sculptures, but he soon began experimenting with the decorative potential of the scorch marks their faceplates could produce. He began collecting irons after realizing that each individual brand of iron had a different faceplate and therefore created a different mark. He found that each iron would scorch the fabric or other media at a different rate, creating varied textures and areas of value. These marks became the basis for a series of works, many of which display textural patterns (fig. 6.16). Cole believes that the scorching process, or as he calls it, "the branding process," evokes the spirit of entity. He also feels the odor given off in the act of scorching the fabric is something with which many viewers have past associations from childhood.

6.16 Willie Cole, *Sunflower*, 1994. Scorched canvas and lacquer on padded wood, 80 1/5 × 78 in.

Visit the online resource center to view the Contemporary Voices feature.

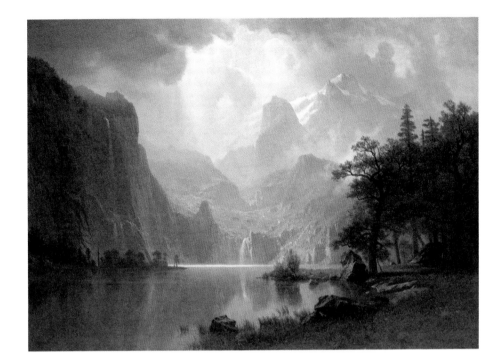

6.17 Albert Bierstadt, *In the Mountains*, 1867. Oil on canvas, 36 1/2 × 50 1/4 in.
Bierstadt was an astute observer of nature and understood the concept of atmospheric perspective. The foreground is full of texture, detail, and intense color. As objects recede into the background, their color fades to gray and their detail and texture are lost.

Tactile Evocation

As suggested at the beginning of this chapter, artists and designers can use texture as a means of connecting with viewers on a deep, visceral level. Textured surfaces suggest a physical reality, even when the texture is merely simulated in two dimensions. The more convincing the representation of reality, the greater the viewers' sense that they might actually reach out and touch an object or surface depicted in a work. Consider Vija Celmins's use of graphite to convey the texture of water (fig. 6.18). Her depiction has such a high degree of verisimilitude, looking almost like a photograph at first glance,

that it evokes in the viewer the cool, wet sensation of the gentle waves.

Art for the Visually Impaired

Art museums have long sought ways to allow visitors with visual impairments to experience visual art. While traditional methods rely on audio-recorded or printed Braille descriptions of the art, in recent decades many museums have hosted exhibits that feature texture-based reproductions that visitors can actually touch. One example is the Exhibition for the Visually Impaired that appeared at the Boca Raton Museum of Art in Florida in 2002 (fig. 6.19). This exhibit

6.18 Vija Celmins, *Untitled (Ocean)*, 1970. Graphite on acrylic ground on paper, 14 1/8 × 18 7/8 in.
Celmins developed her own method of layering graphite to produce a smooth, uniform surface without any marks or strokes. At first glance, the result looks more like a photograph than a graphite drawing.

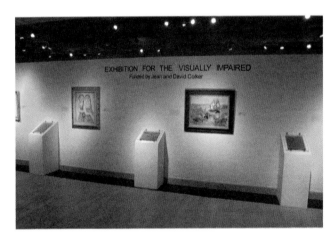

6.19 Exhibition for the Visually Impaired, Boca Raton Museum of Art, 2002.
In this exhibition, paintings are displayed on the wall, and a textured reproduction of each one sits on a pedestal just to the left of the original. The exhibition allows visitors to encounter the artwork in a new way, through touch.

6.20 John Marin, *Sea and Boat #1*, 1942. Detail from an etched-glass reproduction.
This close-up of a detail from the etched-glass reproduction of a seascape painted by John Marin shows how the glass is frosted in some areas to heighten visitors' tactile experience.

provided etched-glass reproductions of several masterworks, with the simulated textures of the original paintings represented by actual textures (fig. 6.20). The museum encouraged visitors to touch these reproductions, allowing individuals to gain a new understanding of the work by experiencing it in a tactile way. Other museums have given visitors a similar experience by providing texture-based reproductions created through the use of special inks that expand to create actual textures when treated with light or heat, or through the use of 3D printers.

Type as a Textural Element

Graphic designers and typographers understand that the selection and use of a specific typeface can create a particular look and sensation. Examine the blocks of text in figure 6.21; notice that while the same words appear in each block, the feel or texture of each block changes with each different typeface. Different textures can also be created by varying the size of letters, the spacing between words and letters, and the spacing between lines.

Type can be manipulated to create texture beyond the realm of text design. Many contemporary visual artists have used type and blocks of type as major components in their

When you read this you will see how the choice of typeface can change the look and feel of your work. The choice of type can create texture. Now that you know this, you can choose your type more carefully.

When you read this you will see how the choice of typeface can change the look and feel of your work. The choice of type can create texture. Now that you know this, you can choose your type more carefully.

WHEN YOU READ THIS YOU WILL SEE HOW THE CHOICE OF TYPEFACE CAN CHANGE THE LOOK AND FEEL OF YOUR WORK. THE CHOICE OF TYPE CAN CREATE TEXTURE. NOW THAT YOU KNOW THIS, YOU CAN CHOOSE YOUR TYPE MORE CAREFULLY.

6.21 Typeface as Texture.
Type selection is very important. By varying the typeface and its attributes, including italic and bold, artists and designers can transform the visual texture of their work.

CONCEPTUAL CONNECTIONS

How can your selection of a typeface produce unity and variety? How do different typefaces relate to the "mark" or texture created in traditional media applications such as drawing or painting?

work. Graphic designer Rodrigo Sanchez, for example, has used type as an intrinsic element to create texture in the childlike illustration of Shrek that he created for the cover of the Spanish magazine *Metropoli* (fig. 6.22). While the image initially appears to have been drawn using crayons, a closer look reveals the image is made up of type. The texture is generated by overlapping layers of type.

Shrek,
un ogro poco convencional
de un cuento
de hadas
poco convencional
en una película de animación poco convencional

6.22 Rodrigo Sanchez, *Metropoli* cover, 2005.
Sanchez's innovative use of type creates a textured illustration of Shrek. The illustration, as well as the magazine's masthead, was created by repeating the same line of text—*Shrek es el nuevo heroe* ("Shrek is the new hero")—over and over.

THINK ABOUT IT

- Why does our sense of touch have such an unconscious psychological connection to past memories? What is one of the first tactile sensations you can remember?
- Why was the development of collage so important to the development of modern art and design?
- When might an artist or designer want to use an invented texture? What new and different textures can you invent and work into your own artworks or designs?
- Aside from image scanners, can you think of any other relatively new technologies that might open up new possibilities for working with textures? How might you use these technologies when creating your own work?
- How are texture and pattern related?

IN THE STUDIO

This project requires you to engage your senses of sight and touch to gain a deeper and more direct understanding of the power of texture as a design element. Begin by creating 15 to 20 rubbings or frottages of textures from your surroundings. To create each one, place a thin piece of paper against a textured surface that interests you, and lightly rub a soft lead pencil (4B–6B) or charcoal over the surface of the paper. Note that tracing paper works best, but regular blank copy or notebook paper will also work. Next, select two or more of your rubbings to incorporate into an original, unified composition. Your composition should be achromatic and must include texture rubbings as well as simulated

and/or invented textures (figs. 6.23, 6.24, and 6.25). Keep in mind all of the elements and principles of design we have discussed so far, including whether you are developing an open or closed composition, and remember that textures have the power to elicit an immediate, unconscious response from the viewer.

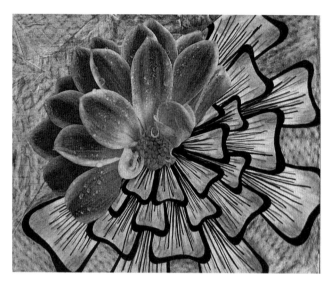

6.23 **Student Work: Taylor Pelligrino,** *Texture Assignment*, **2017.**
Pelligrino uses a radial floral design as her compositional concept. She uses a mixture of photographic elements, line drawings, and texture rubbings.

6.25 **Student Work: Collin Riebe,** *Texture Assignment*, **2017.**
Riebe uses an anime style figure as the focal point of his composition, with radial web imagery and real leaves in the background. He also uses texture rubbings in several parts of the imagery, including the broom.

6.24 **Student Work: Erica Pallen,** *Texture Assignment*, **2017.**
Pallen creates a more abstract, surreal composition. She uses photographic elements and texture rubbings in her composition.

VISUAL VOCABULARY

actual texture
atmospheric perspective
collage
frottage
human-made textures

impasto
invented texture
natural textures
papier collé
photorealism

simulated texture
texture
trompe l'oeil
verisimilitude
wash

Value

LOOKING AHEAD

- What is value?
- What is the difference between local value and relative value?
- What characteristics define value?
- How do high-key and low-key values generate mood?
- In what ways do open-value compositions differ from closed-value compositions?
- How can value affect our sense of depth, space, and volume in a composition?
- What techniques can be used to create value?

WE LIVE IN A WORLD OF LIGHT AND DARK, OF DAY AND NIGHT. Together, light and dark provide definition and form. When light hits an object, it exposes that object's surface and shape. Where the intensity of the light is strongest, we perceive a **highlight**. As the form moves away from the light source, the areas become visually darker, creating a **shadow** (fig. 7.1). This **contrast** between light and dark occurs in degrees, creating a sense of depth and volume (fig. 7.2), and keeping our universe from seeming like a flat place that exists on a single plane. Indeed, we are able to negotiate our environment without stumbling or falling down because degrees of contrast enable us to perceive shape, volume, texture, and detail.

7.1 **Robert Mapplethorpe,** *Ajitto,* **1981. Photograph, 17 3/4 × 13 7/8 in.**
Mapplethorpe's use of highlights and shadows accentuates and defines his subject's form. His use of dark values also helps to amplify the sense of compressed space communicated by his subject's pose.

7.2 Lena Guttromson, *More than Numbers*, 2011. Ink, pencil, digital, 11 × 8 1/2 in.
Using pencil, ink, and digital media, Guttromson is able to achieve a wide range of values, from very light grays to black. The varying degrees of light and dark add depth and volume to her composition, drawing attention to her subject's face.

CONCEPTUAL CONNECTIONS

How does creating value by hand or digitally change an artwork or design? How would selecting one method over the other influence the gestalt of the work?

Value Defined

In relation to art and design, **value** refers to the relative lightness or darkness of a surface. When applied to a specific color, this concept is known as **chromatic value**. When applied to an environment devoid of color, such as that found in grayscale renderings, it is known as **achromatic value**. In this chapter, we will look most closely at achromatic value, but we will return to the topic of chromatic value when we examine color in Chapter 10.

Local and Relative Value

Local value is the actual value of an object or a surface—its intrinsic lightness or darkness, without regard to the amount of light that falls on it. As this definition suggests, our perception of local value is affected by light. If we were to shine a bright light on an object, the areas in highlight would appear to be lighter (or have a higher value) than the object's local value, and the areas in shadow would appear to be darker (or have a lower value) than the object's local value.

In addition to being affected by light, our perception of a surface's value is also influenced by the values of the surrounding surfaces. The same shade of gray, for example, will look lighter when surrounded by black than it will when surrounded by white. When we talk about two or more values in relation to one another, we often use the term **relative value** to highlight the fact that our perception of the values is relative. Relative values can be difficult to compare when we work with colors, but this task becomes much easier if we convert the colors to grayscale (fig. 7.3). If we think in terms of grayscale, we can assign every shade of every color a comparative shade of gray. Yellows, for example, often correspond to light shades of gray, while violets often correspond to dark shades of gray. Reds and greens tend to fall in the middle range.

7.3 Relative Value.
On the left is the original photograph, which shows nine pencils in color; on the right, the same photograph is displayed in grayscale. Notice that the relative value of each color is easier to determine in the grayscale image.

7.4 Value Scales.
Here are two examples of a value scale for showing the range of values from white to black, which is also known as a gray scale. There can be an infinite number of values within a particular value scale.

CONCEPTUAL THINKING ACTIVITY

Create a catalog of value scales. Each should have at least seven distinct steps or values. Use shading, stippling, hatching, cross-hatching, and at least two non-art media to develop your catalog.

Value Scales

The transient effect of light on a surface creates a range of values. To identify and make sense of these values, we can arrange them in a sequential order, moving from either light to dark or dark to light. The result is known as a **value scale** (fig. 7.4). The number of steps in any value scale is determined by the level of precision the artist or designer needs for a given project. Most often, an odd number of steps is used, to produce an exact midpoint. In an achromatic value scale, this midpoint is known as *middle gray*.

Artists and designers can create value scales in various ways. A lot may depend upon the media and materials that are in a specific piece. Value scales can be created in graphite, ink, or paint, just to name a few. These scales are a useful tool, allowing artists and designers to visualize the different range of values one might use in an artwork or design.

Manually mixing paints according to a predetermined formula can be a good way to learn about values. However, many more experienced artists prefer to mix by sight, as they feel this gives them more control over the values and also produces a more visually accurate result. For artists and designers working in a digital environment, computer programs can provide a quick and easy means of creating value scales. Digitally generated gray scales, such as the one shown in figure 7.4, can be useful to artists working in nondigital environments as well, but digitally generated color scales rarely match the exact values of nondigital colors. (See Chapter 11 for more on digital color.)

Characteristics of Value

As suggested above, values can be characterized as light, dark, or somewhere in between, relative to the surrounding values. The interplay between dark and light values creates varying degrees of contrast. Juxtaposing values that are close to one another on a value scale results in low contrast, while juxtaposing values that are far apart from one another on a value scale results in high contrast. Contrast is fundamental to art because it allows the viewer to distinguish one form from another, adding visual interest to the overall composition.

Types of Value

We can classify values into ranges based on their relative lightness or darkness. When discussing these ranges in relation to their use in artworks or designs, we often use the term *key*, which refers to the overall palette or variety of values within a particular work. The importance of the key is that it sets the general mood or feel of the artwork or design. Works may use predominately high-key or low-key values, or they may use a full range of values. They may also juxtapose high-key and low-key values to create high contrast.

High-Key Values

High-key values include the range from the very lightest values to the midpoint along a value scale. On the gray scale, these values run from the lightest gray to middle gray. High-key values represent the warmer side of the scale and have a soft, fuzzy quality to them, like a light mist. When placed against a light background, they tend to have low contrast and can blend into the surroundings. Light areas and values tend to have a gentle, soft, and uplifting feel. Bright, luminous values tend to be full of energy and vibrancy. Light backgrounds remind us of sunny days and give us a feeling of warmth. These are all positive associations; they project feelings of happiness and create a cheerful mood (fig. 7.5).

Low-Key Values

Low-key values include the range from the very darkest values to the midpoint along a value scale. On the gray scale, these values run from black to middle gray. Low-key values are on the cooler end of the value scale. When placed against a light background, they produce high definition and strong contrasts, and they are clearly visible and readable. Darker values have a propensity to generate a sad, mournful, or ominous feeling. Dark backgrounds with light images or images seen

7.5 Anna Ancher, *Interior*, ca. 1916–17. Wood and oil, 17.4 × 14.9 in. High-key values fill the composition with light and luminous color, giving the work a cheerful and upbeat mood.

in silhouette often create a sense of foreboding. The darker the image, the more mystery it can convey (fig. 7.6). Further, dark palettes tend to evoke feelings of tightness, reminding the viewer of cramped, enclosed spaces.

7.6 Carol Reed (Director), *The Third Man*, 1947. Film.
The darkness of this scene conveys a sinister feel. It also adds to the feeling of suspense and mystery as the movie's antihero works his way through a maze of water pipes and tunnels to escape capture.

Continuous Values

Unlike high-key or low-key values, **continuous values** encompass the entire range of values along a value scale. Continuous values represent the world as it actually appears, in full ranges of light and dark. Thus, artists and designers often choose to use a full range of values when they are aiming for realism or naturalism in their work. In addition, most photographs taken in daylight settings or under full-spectrum artificial lighting display a full range of values (fig. 7.8).

High Contrast (Chiaroscuro)

During the Renaissance, European artists developed a method of using extreme or exaggerated light and dark to generate high contrast. The technique became known as **chiaroscuro**, the term in Italian for light and dark. Chiaroscuro produces an atmospheric effect in which the main subject is surrounded by a field of extremely deep dark values and seems to be emerging from the darkness. The use of extreme contrast between high-key and low-key values establishes a strong focal point and allows for a significant play of lights and darks across the surface of the subject. Beginning in the seventeenth century, artists such as Caravaggio and Artemisia Gentileschi took the exaggerated use of high contrast even further as they developed a style called **tenebrism** (fig. 7.9). The backgrounds of many tenebrist painters' works, including Gentileschi's, are intensely dark—almost black, producing visual drama that might be considered theatrical in nature.

The Black on Black Pottery of the San Ildefonso Pueblo

How is black pottery made from red clay without using any glaze?

Within the state of New Mexico there are thirteen Native American pueblos (or villages); each is the territory of and is run by a different tribe. While they are close in proximity, each pueblo is an autonomous group with its own beliefs, religion, and tribal systems. And every pueblo has its own unique style variations on traditional art forms.

The technique of black on black has become a hallmark of the pottery produced in the San Ildefonso Pueblo. The development of this style has been attributed to Maria Martinez (fig. 7.7). Martinez is known for her symmetrical design. Created using the coil method of fabrication, the walls of these pots are very thin and highly crafted.

The lustrous black ceramic ware is created from red clay. Its jet-black color is produced in the firing process. As the dung and wood bonfire reaches its desired temperature, the fire is smothered with wet dung, which gives off a heavy, thick smoke, producing the rich black ware. All of the values within this low-key style are in the darker array of dark grays and black. The use of this limited value range gives the design a subtle and elegant look. Its shiny finish is produced by polishing the surface using a damp coating of a liquid clay called slip. The glossy surface is sometimes mistakenly called a glaze; however, the high luster is actually the result of a process known as burnishing. After Martinez develops

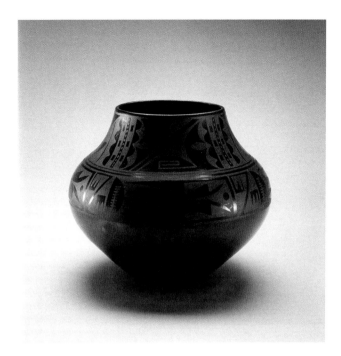

7.7 Maria Martinez, *Jar*, 1937. Blackware, 11 1/8 × 13 in.

the shape of the pot, she applies the slip and burnishes, or rubs, the pot with a hard surface, most often a smooth stone. Burnishing results in a glossy surface once the pot is fired.

7.8 Sean Kennedy Santos, Advertisement for Puma, 2006. Photograph.
This ad for Puma athletic shoes uses a full range of values. Part of the sophistication of this image is that it never overtly displays the product. Instead, it uses the shadow of the basketball player and the curvilinear painted lines of the court to draw the viewer in and convey its message.

CONCEPTUAL CONNECTIONS

How does using a continuous-tone value range affect an artwork, photograph, or design? Can using a specific value application enhance the balance or emphasis of a work?

Using Value

To a great extent, an artist's or designer's use of value will determine how viewers perceive a composition. Values help to establish relationships between forms—the degree to which objects and areas in a composition blend together or appear as distinct entities. Variations in value also help to establish a sense of space and depth within a composition, and they can create the illusion of volume in a two-dimensional object.

When creating value, artists and designers can select from a wide range of techniques, media, and materials. The manner in which a particular medium or material is used—for example, the pressure exerted through the movement of a pencil,

7.9 Artemisia Gentileschi, *Judith Beheading Holofernes*, 1612. Oil on canvas, 57 1/2 × 42 1/2 in.

Gentileschi's use of high contrast draws the viewer's eye to her painting's subjects while also creating a sense of mystery in which the enveloping black background dominates the canvas. The use of dramatic lighting to create high contrast is a characteristic of the Baroque style of painting that emerged in Rome in the 1600s.

7.10 Ulla von Brandenburg, *Matrose (Sailor)*, 2008.

Brandenburg uses watercolor washes sparingly in this portrait. Her palette consists of open values, leaving much of the surface of the paper untouched, allowing foreground and background to merge. The solid forms of the sailor's face seem to melt across the picture plane.

pen, or brush—will affect how values appear. Many artists and designers strive to push the limits of what has been done before and how media and materials have been used in the past. The goal is to develop new avenues of expression.

Open-Value Versus Closed-Value Compositions

Areas of value can be open or closed in structure. In **open-value compositions**, the areas of value are blurred or blended from one shape or region to another (fig. 7.10). The relatively loose method of using value that characterizes open-value compositions creates interactions between forms rather than defining or separating them.

The opposite holds true for closed areas of value. In **closed-value compositions**, the values create distinct edges that establish clear boundaries between forms (fig. 7.11). This approach is used to isolate shapes or areas in much the same way as the lines in a children's coloring book separate the areas to be colored from one another. This approach is commonly used in graphic designs.

Establishing Depth and Space

Like texture, value can help to establish a sense of **depth** and space within two-dimensional compositions. As we saw in our discussion of chiaroscuro, relatively dark values typically appear to recede into the picture plane—they seem to be farther away or at a greater distance from the viewer. Relatively light values, on the other hand, typically appear to advance—they seem to be closer to the viewer, in part because there is the illusion that more light is reaching the lighter objects. Gradually lowering values for items as they recede into the picture plane creates a sense of depth by reproducing an atmospheric perspective (fig. 7.12). (Recall from Chapter 6 that atmospheric perspective is a visual phenomenon caused by the interaction between light and atmospheric particles, resulting in objects closer to the viewer appearing brighter and in greater detail than objects farther away.)

7.11 Peter Max, Program Cover and Poster for the Rock and Roll Hall of Fame Induction Ceremony, 2015. © ALP, Inc
The closed-value areas in Max's work create distinct shapes or forms. The values are limited by the edges of the forms, clearly establishing boundaries between them.

7.13 Cast Shadows.
A cast shadow gives the viewer information about the strength, quality, and positioning of the light source. As the light source grows closer to an object and/or stronger in intensity, the edge of the cast shadow becomes harder (left). As the light source diminishes in strength or moves away from an object, the edge of the cast shadow softens (right).

Simulating Volume

Careful control of light and dark values can also give the illusion that two-dimensional forms have volume. For this illusion to be effective, the artist or designer must decide on the directionality and quality of light in the composition. If the object is shown to be resting on or near a surface, the artist or designer must consider its **cast shadow**, which appears on a nearby surface or object (fig. 7.13).

7.12 Henrik Rehr, panel from *Tribeca Sunset*, 2006.
In this panel from the graphic novel *Tribeca Sunset: A Story of 9-11*, Rehr uses light and middle grays to reproduce an atmospheric perspective that adds depth to his illustration. At first glance, the viewer is reminded of a wintry day; however, the novel's narrative reveals that the falling particles are not snow but debris from the recently collapsed Twin Towers in New York City.

Techniques for Creating Value

Artists and designers can draw on a variety of techniques for creating value in their compositions. Here we examine several of the most common—shading, stippling, hatching, and cross-hatching. The choice of technique depends largely on the desired effect and the medium with which the artist or designer has chosen to work.

Shading

Shading creates a smooth, continuous gradation of value. The even application of value through shading produces flowing surfaces and soft textures, making this technique well-suited to representing clothing and skin (fig. 7.14). Shading can be accomplished with both dry media such as pencils, charcoal, or pastels, and wet media including paints and washes. (Note that shading was also discussed in Chapter 5, in relation to adding two-dimensionality to shapes.)

Stippling

Stippling produces areas of value using tiny dots fashioned by the point of a pencil, pen, paintbrush, or other tool (fig. 7.15). The closer the dots are placed to one another, the darker the area will become. Stippling requires patience on the part of the artist or designer. Each mark must be placed with care, not laid down in a hurried, scattered fashion. This form of value gradation is commonly used in illustration.

Hatching and Cross-Hatching

Hatching and cross-hatching create value through the placement of parallel lines. In hatching, the lines are drawn closely together in the same direction to create areas of value. The closer the spacing and the heavier the weight of the lines, the darker the resulting value will be. Cross-hatching works in much the same manner, but with a second set of parallel lines placed on top of the first, usually at a diagonal, to create even darker and more complex areas of value (fig. 7.16). Hatching and cross hatching work partially well with hard media, including pen and markers, and they are often used in etchings. (Note that hatching and cross-hatching were also discussed in Chapter 4, in relation to the use of line to create value.)

7.14 Georges Seurat, *Seated Nude*, c. 1887–88. Conté crayon on cream paper, 12 1/2 × 9 3/4 in.
Seurat examines the play of light across the figure of a young boy. He uses shading to create contrasting areas of light and dark, which give the image its highlights and dimension.

7.15 Pablo Jurado Ruiz, *Nomads IV*, no date. Black ink on paper, 16 × 11 1/2 in.
Pablo Jurado Ruiz used stippling to create a portrait that looks almost like a photograph. He is able to achieve a full range of values by varying the closeness of his ink dots.

CONCEPTUAL CONNECTIONS

How would changing the method of developing a range of values from shading to stippling or cross-hatching change an artwork or illustration? Would it change the emphasis placed on elements in the work?

7.16 TBWA/RAAD, Advertisement for Career Junction, 2008. This illustration for Career Junction employs a combination of hatching, crosshatching, and stippling to produce varied values. The loosely hatched lines create the lighter values, and the denser hatched and cross-hatched lines develop the darker values.

Medium and Value

As shown throughout this chapter, artists and designers can achieve a range of values using traditional media such as pencils, pens, charcoal, and paint. No one method of generating value is inherently better than any other. When thinking about how you will use value in your own artworks and designs, try to experiment with different media to see what possibilities unfold. Think about what will work with your composition as well as your content or message. Think about what your end product might be and how it may be presented or reproduced. You might even consider experimenting with alternative methods of applying value. Chuck Close took an experimental approach to developing value in the portrait shown in figure 7.18. To create this work, he used the sitter's fingerprint, made into a stamp, to apply the ink. This manner of application mimics the effect in a halftone screen printing, exposing the individual dots that make up the image on a printed page.

🌙 **new perspectives**

Kate Kretz's *Grace and Shame*

How can unconventional media be used to create value?

Value can be generated using a wide variety of media. Kate Kretz uses her own hair in her embroidery works. Employing delicate stitches that resemble the traditional drawing techniques of hatching and cross-hatching, she layers the strands of hair to create a broad range of values and depth. As Kretz (n.d.) has noted, "The scale and materials are intimate: the process of embroidery creates an intricate vision, composed of threads as fragile as those that make up our dreams."

In her 2005 installation *Grace and Shame*, Kretz included several pieces that incorporated her hair-stitching technique. For example, in *Dream*, she stitched an ethereal image of a mouth into a white linen pillowcase (fig. 7.17). The mouth is open wide, as if screaming, and inside appears a haunting image of a fetus. The values of light and dark create a depth that gives the viewer

7.17 Kate Kretz, *Dream* (with enlarged detail on the right), 2003.

the feeling of peering into an expansive chasm. The work feels both universal and personal at the same instant.

Visit the online resource center to view the Contemporary Voices feature.

7.18 Chuck Close, *Phil/Fingerprint II*, 1977. Stamp pad ink fingerprints and graphite pencil on paper, 30 × 22 1/2 in.
Close achieves a full range of values through this novel method of value application. The fingerprint is fashioned using a stamp pad. This makes the work uniquely personal in nature: not only is the image that of the sitter, but the fingerprint identifies the person as well.

CONCEPTUAL THINKING ACTIVITY

Chuck Close used a fingertip stamp to develop his portrait (fig. 7.19). Either find a stamp or develop your own (potatoes, carrots, or any item might be used to make a stamp) to create an image or rendering. How did the stamp affect the values produced?

THINK ABOUT IT

- Why is contrast between light and dark values important in art and design?
- Why is it necessary for artists and designers to be able to understand and create value scales?
- What did the development of chiaroscuro contribute to the history of art and design? What differentiates tenebrism from chiaroscuro?

IN THE STUDIO

This project will help you to increase your visual acuity in relation to developing value. In this project, you will learn to mix paint. While working, think about your use of contrast—how will the values you use enhance or detract from the visual elements in your design?

7.19 Roxy Paine, *Drawing for Containment 3*, 2010. Ink on paper, 33 1/4 × 30 in.
By combining charcoal with graphite, Paine is able to produce darker grays and deeper, richer blacks, affording him a wider range of values.

Keep in mind that artists and designers are not restricted to working in only one medium. Sometimes it is desirable to mix media. Again, experimentation is important. Many artists and designers work with a variety of media and materials on the same project. Roxy Paine is well known for his use of mixed media in his installations and drawings (fig. 7.19).

- What can the use of highlights and shadows convey about an object or a scene depicted in an artwork or design?
- How might you use nontraditional art media to create value in your own artworks or designs?

Begin by creating a non-objective design on one half of a 7″ × 10″ (or another appropriate size) illustration board or canvas board. Copy your design so that you have two variations of your design side by side. On one side, paint your design using high-key values (ranging from middle gray to

very light gray). On the other side of the design, use low-key values (middle gray to black). The middle gray that you use should be the same on both sides of your design (figs. 7.20, 7.21, 7.22).

7.20 Student Work: Desirae Jones, *High Key Low Key Value Assignment,* **2019.**
Jones creates an organic divide in her composition. The elements on each side are different, but the two sides create a balanced design.

7.21 Student Work: Joya Blackwell, *High Key Low Key Value Assignment,* **2018.**
Blackwell uses predominately geometric shapes and linear elements in her design. The curved linear elements help the design flow from one side to the other, unifying the composition.

7.22 Student Work: Erica Patton, *High Key Low Key Value Assignment,* **2017.**
Patton develops an organic mirror image design. She uses the middle gray outline of each shape to unify the concept.

VISUAL VOCABULARY

achromatic value
cast shadow
chiaroscuro
chromatic value
closed-value composition
continuous values
contrast

depth
high-key values
highlight
local value
low-key values
open-value composition
relative value

shadow
stippling
tenebrism
value
value scale

8

Space

LOOKING AHEAD

- **What is space?**
- **What is the difference between actual space and illusionistic space?**
- **What types of perspective can be used to create the illusion of space?**
- **What are the characteristics of linear perspective?**
- **What forms do two-dimensional spatial representations commonly take?**
- **How are overlapping, proximity, and vertical location used to create the illusion of three-dimensional space?**

OUR CONCEPTION OF SPACE DEPENDS ON OUR EXPERIENCES.

As such, it is subject to change as we encounter new information and new situations. When we are small children, we perceive the ground on which we stand to be flat and unmoving; our conception of our world shifts, however, when we learn that the earth is round and that it is constantly moving around the sun. New technologies also have the power to alter our notions of space and our perceptions of the world. In recent decades, computer technologies have introduced us to new understandings of space, at times even blurring the line between virtual space (e.g., in computer-generated games and animations) and the real world (fig. 8.1). Just as we must learn how to interpret the space around us and in virtual worlds, so too must we learn how to interpret space in two-dimensional artworks and designs. This interpretation depends on our awareness of the conventions artists and designers use when working with space.

8.1 Adrianne Wortzel, Dream Sequence from *Eliza Redux*, 2004.
Wortzel's work combines virtual environments, networked robotics, and installation focusing on concepts of otherness and self-discovery. She portrays a very shallow sense of space. The only depth is created by the machine overlapping one of the angels.

Space Defined

On a basic level, we can define **space** as the distance between objects as well as the area those objects occupy. **Actual space** is the physical space that objects or areas occupy, either on a two-dimensional plane (e.g., a sheet of paper, a canvas, or a computer screen) or in three dimensions. In most cases it is a measurable and quantifiable region, though the concept also applies to an infinite expanse such as our universe.

Artists have long sought ways to create the illusion of three-dimensional space on a two-dimensional picture plane. This quest centered on an understanding of **perspective**, and perhaps the greatest advancement came with the development of **linear perspective** (discussed below) in the 1500s, during the Renaissance. The word *perspective* comes from the Latin *perspicere*, meaning "to see clearly." Applied to two-dimensional art, perspective can be thought of as a learned system of using angular and other conventions to create the illusion of three-dimensionality. This system creates a type of space commonly known as **illusionistic space**.

Characteristics of Space

A defining characteristic of actual space is that it is measurable. In a two-dimensional environment, we can measure actual space in terms of length and height, and we can calculate the surface area of an object or region based on those measurements. In a three-dimensional environment, we can measure actual space in terms of length, width, and height, and we can use those measurements to calculate surface area as well as volume.

Illusionistic space is less concrete. As its name suggests, it is illusionary in nature, and as such it cannot be measured in the same way that actual space can be measured. Our interpretation of this type of space depends on our understanding of perspective, the rules or conventions of which must be learned. Thus, we will next take a closer look at the concept of perspective.

The conventions of perspective in two-dimensional art and design must be learned. Taking the time to learn these conventions will prepare you to understand not only how other artists and designers have used perspective to communicate spatial relationships, but also how you can use perspective in your own work. Here, we will examine five main approaches to perspective: linear, multiple, isometric, atmospheric, and amplified. Each one has its own unique properties, and each can be combined with other approaches in a single artwork or design to create a convincing illusion. Deciding on which perspective or combination of perspectives to use is a matter of personal taste, aesthetic sensibility, and practicality.

Linear Perspective

Linear perspective is an approach to creating the illusion of three-dimensionality that is based on a structure of parallel lines that converge at one or more vanishing points. To construct a linear perspective, the artist or designer needs to establish three things:

- **Eye-level vantage point**. The position from which an observer (in this case, the artist or designer) sees an object or a scene when looking straight ahead. The vantage point tells viewers where they are in relation to the space portrayed in the picture.
- **Horizon line**. An imaginary horizontal line, usually placed at the observer's eye level, along which elements seem to disappear from sight. The horizon line guides viewers' eyes into the farthest distance represented within the picture plane.
- **Vanishing point**. A spot on the horizon line at which a set of parallel lines appears to meet and then vanish. A linear perspective can make use of one to three vanishing points, depending upon the observer's position relative to the objects portrayed.

Linear perspectives often give viewers the sense that they are looking through a window, with the edges of the page or the picture frame acting as the window's frame (fig. 8.2). This device creates in viewers the feeling that they are looking out on an **infinite space**—a space that appears to be limitless,

8.2 Graham Dean, *Foreign Correspondent*, 1987. Watercolor, 55 1/2 × 64 in.
Dean plays with the convention of linear perspective as creating a window into the world of an artwork. The viewer is an observer of an observer, twice removed from the nameless, faceless, monochromatic people the main figure observes. The painting is a commentary on alienation.

similar to what we experience when looking off into the horizon in real life. Linear perspective is not used only to create the illusion of realistic scenes, however. Many Surrealists, for example, employed a linear perspective to heighten the unreal feeling of their landscapes.

We can divide linear perspective into three main types, based primarily on the number of vanishing points the artist employs: one-point perspective, two-point perspective, and three-point perspective.

One-Point Perspective

In **one-point perspective**, there is only one vanishing point (fig. 8.3). This perspective is commonly used to depict an object from a vantage point directly in front of the object. When employing this perspective, the artist or designer begins by drawing a horizon line and then selecting a vanishing point along this line. Typically, the vanishing point is placed at or near the center of the horizon line. Next, the artist or designer sketches the basic shape of the object and draws lines of perspective that connect the corners of the object to the vanishing point. These lines indicate where additional edges should be placed to accurately represent the object's depth. In more complex compositions, lines may also be drawn along the edges of the object parallel to the horizon line; these lines can then be used as guides for positioning other objects in relation to the main object.

One-point perspective is the most elemental form of perspective, and it is often the easiest for artists and designers to understand and use. It can be effective for depicting objects and scenes in great detail, but it tends to have an unimaginative, boxy quality to it when the horizon line and vanishing point are placed at the center of the page. Artists and designers can overcome this limitation, however, by experimenting with the placement of the horizon line and vanishing point (fig. 8.4).

Two-Point Perspective

In **two-point perspective**, there are two vanishing points (fig. 8.5). Instead of looking at the central object from a frontal view, the viewer is on an angle to the object or at the edge

8.4 Catherine Murphy, *Stairwell*, 1980.
The action in Murphy's one-point perspective painting is set below the horizon line. Her use of this nontraditional point of view and asymmetrical arrangement produces a more complex composition, holding the audience's interest longer.

where two sides of the object meet. The method for establishing this perspective is similar to the method used for creating a one-point perspective, except that the artist or designer must choose two vanishing points along the horizon line, and a line of perspective must be drawn from each corner of an object to both vanishing points. If we were depicting a square or rectangular structure in two-point perspective, one side would recede to one vanishing point and the other side to the other vanishing point, as shown in figures 8.5 and 8.6. Two-point perspective tends to produce a more complex image than does

8.3 One-Point Perspective.
In one-point perspective, there is only one vanishing point on the horizon line. The objects are seen head on from the front.

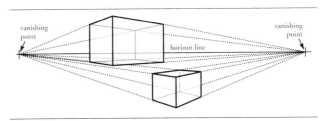

8.5 Two-Point Perspective.
In two-point perspective, there are two vanishing points on the horizon line. The objects are seen at an angle, with the perspective lines indicating how their sides recede in space relative to each vanishing point.

8.6 Ed Ruscha, *Standard Station*, 1966. Screenprint, 19 5/8 × 36 15/16 in.
Ruscha uses an extreme two-point perspective. One vanishing point is located in the bottom right corner of the composition, and the other is located past the bottom left corner, outside the frame of the work. Ruscha was a member of the Pop Art movement, and his paintings often comment on the growing consumerism in America.

one-point perspective, and therefore it may be the most widely used type of linear perspective.

Three-Point Perspective

In **three-point perspective**, there are two vanishing points on the horizon line as well as a third vanishing point that shows a vertical relationship (fig. 8.7). This third vanishing point is located either above or below the horizon line, depending upon the viewer's vantage point relative to the object. When the viewer is looking down on an object, from an aerial (or "bird's-eye") point of view, the third vanishing point is located above the horizon line; when the viewer is looking up at an object, from a low-angle (or "worm's eye") point of view, this point is located below the horizon line. Three-point perspective is often used to represent buildings or cityscapes (fig. 8.8).

Multiple Perspectives

Distorting the angle of view by combining perspectives from different vantage points within a single composition can produce dynamic imagery and drama. Giorgio de Chirico used

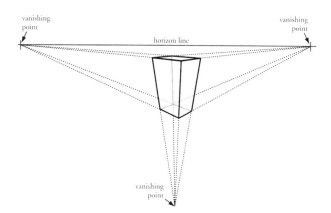

8.7 Three-Point Perspective.
In three-point perspective, there are three vanishing points—two on the horizon line and one either above or below the horizon line.

8.8 David Durbak, *Green Interior*, no date.
The use of three-point perspective generates a sense of vertical movement. All the lines are on a slight diagonal, producing a dynamic composition.

multiple perspectives in his painting *Mystery and Melancholy of a Street* (fig. 8.9). By following the perspective lines de Chirico used to create a sense of three-dimensionality in this work, we can identify at least three perspectives: one for the white building on the left, a second for the shadowed building on the right, and a third for the cart. The shifting perspective—along with the deep angles and harsh cast shadows—adds a sense of motion and also heightens the tension of the scene.

Isometric Perspective

When we think of perspective, we tend to think of linear perspective, which attempts to imitate the spatial relationships we actually see when observing the world. **Isometric perspective,**

8.9 Giorgio de Chirico, *Mystery and Melancholy of a Street*, 1914. Oil on canvas, 33 1/2 × 27 in.
De Chirico's use of multiple perspectives makes the viewer feel slightly disoriented, amplifying the sense of foreboding. The contrast between the bright daylight and the ominous shadows adds to the sense of drama.

CONCEPTUAL CONNECTIONS

How do multiple perspectives affect the sense of balance in an artwork or design? What types of emotional or psychological effects can different perspectives produce?

however, takes a more rigidly mathematical approach to representing the three-dimensional world on a two-dimensional surface. The main difference between isometric perspective and linear perspective is that the lines of projection used to represent depth remain parallel to one another rather than converging at a vanishing point. In addition, these lines are generally drawn at a 30-degree angle relative to the horizon (fig. 8.10). Isometric perspective is often used in technical drawing because the scale of the objects represented remains constant.

Atmospheric Perspective

As you may recall from Chapter 6 , atmospheric perspective is a visual phenomenon caused by the interaction between light and atmospheric particles in the real world (fig. 8.11). In two-dimensional works, artists and designers can imitate this effect by depicting objects that are farther away from the viewer as less detailed than objects that are closer to the viewer. They can also fade the colors of objects that are farther away. This gradual loss of detail and color creates the illusion of distance. Vast panoramas, especially when seen from above, create an intrinsic sense of space that gives the viewer the feeling of being physically and emotionally distanced from the subject.

Amplified Perspective

An **amplified perspective** is an exaggerated perspective in which the portion of a figure that is closest to the viewer appears to be dramatically larger than the portion that is farthest away. The technique used to achieve this perspective is known as **foreshortening**, which involves distorting a figure's proportions to make the figure appear to have less depth than it actually does. The illusion of foreshortening is created when an object or figure is sharply angled toward the viewer. In an amplified perspective, a figure may appear to be misshapen, with the part closest to the viewer seeming out of proportion to the rest of the figure. The effect is heightened by the relative distance from the viewer to the subject; the closer the viewer is to the subject, the more distorted the object or figure may seem (fig. 8.12).

8.10 Isometric Perspective.
While this cube may look very similar to a cube created through two-point perspective, it is really a mathematical projection in which the angled sides of the cube remain parallel to one another. Isometric perspective is used in many optical illusions. Here, the image can be perceived as either the outside or the inside corner of a box.

8.11 Atmospheric Perspective.
As items move off into the distance, they appear in less detail and eventually dissolve into middle gray. Desaturating colors as objects move away from the viewer is an excellent method of producing a sense of space.

CONCEPTUAL THINKING ACTIVITY

Using your smartphone camera, capture an image that portrays the concept of atmospheric perspective.

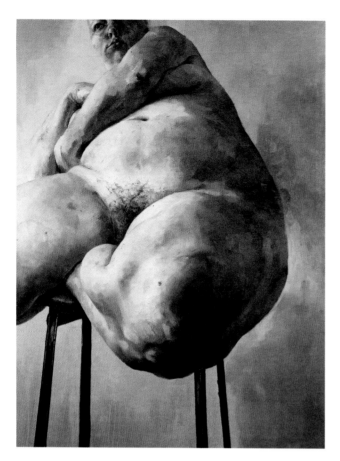

8.12 Jenny Saville, *Prop*, 1993. Oil on canvas, 84 × 72 in.
The unusual angle of the artist to subject produces a foreshortened view. The figure hangs above the viewer in a precarious manner. The un-romanticized pose is in direct opposition to more conventional treatments that idealize the female nude.

One method used to create an amplified perspective is to look at the form you are depicting and imagine its underlying geometric forms (e.g., a cube or a tube). Thinking about these underlying forms makes it easier to anticipate how different parts of the form you are depicting might move in space. Another method is to look at the negative space—the empty space surrounding your subject—and then make sure that the negative space you have created in your artwork or design matches that space.

Types of Space

To this point, we have focused on two main categories of space: actual and illusionistic. All lines, shapes, and areas within a composition occupy *actual space*, and thus all other systems for representing space exist within actual space. *Illusionistic space*, as we have seen, represents a common approach to depicting realistic forms on a flat plane. It is not, however, the only way to use space in a two-dimensional work of art or design. Below, we will revisit the concept of illusionistic space and also explore some alternative conceptions of space. As you learn about these categories, keep in mind that our concept of space and spatial representations is always evolving.

Illusionistic Space

As we have seen, illusionistic space attempts to represent three-dimensional forms in a realistic way, by conveying a sense of their depth. It is founded on the conventions of perspective, and it aims to depict the world as we perceive it through our sense of vision. Illusionistic space has dominated Western art since the concept of perspective—in particular, linear perspective—was developed during the Renaissance.

Cubist Space

Near the beginning of the twentieth century, the Cubists made a radical break with traditional forms of two-dimensional spatial representation. Instead of trying to create a realistic representation of three-dimensional space, they used their canvases to explore objects from several different perspectives at once. In a sense, the Cubists were trying to represent how we experience the act of viewing three-dimensional objects. Typically, we don't simply stare at an object from a single point in space; rather, we move our eyes around and adjust our position to get a complete view of the object from multiple angles. Our brain then assembles all of the visual snapshots we've taken into a cohesive image. Cubism attempted to separate these snapshots from one another and put them down on a page at the same time. The resulting depiction suggests that each object is being looked at from more than one angle simultaneously. This departure from realism liberated artists to explore a new realm of spatial possibilities (fig. 8.14).

Psychological Space

An area of interest for the Dada and Surrealist movements that emerged at around the same time as Cubism was the concept of **psychological space**—the space of the mind. Emphasizing the importance of the subconscious, both Surrealists and Dadaists realized that the human psyche was fertile ground for new areas of exploration. The space they wanted to represent was not a real, naturalistic space, but a form of space that exists only in the mind—a place where divergent images can coexist harmoniously side by side (fig. 8.15). This space was also the space of dreams, or what might be referred to as a dreamscape.

Decorative Space

Decorative space is a designed or invented space that is ornamental in nature. Its main function is to suit the artist or designer's aesthetic, and it makes little or no attempt to portray

Hierarchical Space in Ancient Egyptian Art

When does size show distance and when does it have an intrinsic or deeper meaning?

Not all systems of representing three-dimensional forms on a two-dimensional surface aim to depict figures in proportion to one another based on realistic spatial relationships. Many cultures across history have used hierarchical systems in which the importance of a person or object is conveyed through relative size. In these systems, the larger the figure, the greater its status or significance.

Hierarchical representations of space are most commonly found in societies ruled by a monarchy or organized according to a caste or class system. The largest elements or figures typically represent people high on the societal ladder of importance, such as a king or a queen. Conversely, the smallest elements or figures usually represent individuals with low social standing. Thus, viewers can determine each person's relative social rank by comparing size relationships.

This approach to representing space was widely used in Ancient Egyptian art. Figure 8.13 shows a bird-hunting scene that appears on the tomb of Nebamun, a wealthy Egyptian official who died around 1350 BCE. The sizes of the three human figures relate directly to the relative status of each person and have little to do with spatial relationships. The largest of

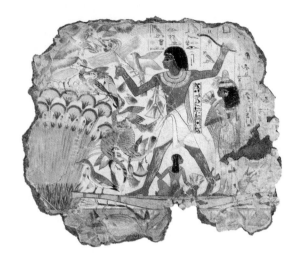

8.13 **Nebamun Fowling in the Marshes, Tomb of Nebamun, c. 1350 BCE. Paint on plaster, 32 1/2 × 38 1/2 in.**

these figures represents Nebamun. The next-largest (shown standing) is his wife, Hatshepsut, and the smallest (shown sitting) is their daughter.

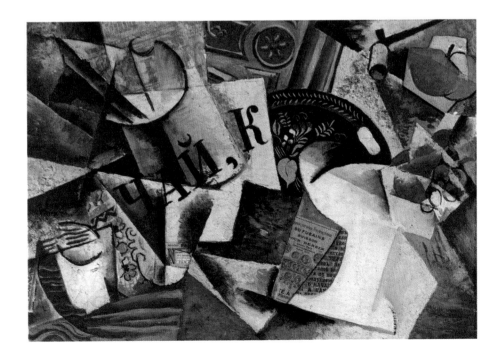

8.14 **Lyubov Popova, *Still Life with Tray*, c. 1915. Collage and oil on canvas, 15 1/2 × 23 in.**
Popova was one of the few women working in a Cubist manner. In her work, she uses a bolder, more colorful palette than did the majority of her male counterparts of the day, while still emphasizing the flatness of the picture plane.

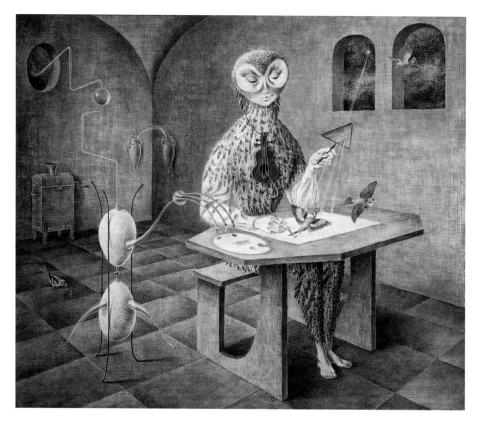

8.15 Remedios Varo, *Creation of the Birds*, **1958. Oil on Masonite.**
Varo's Surrealist painting shows a psychological space, a landscape of the mind and of dreams. The strange images she depicts—a machine that produces pigments and a feathered artist who paints images of birds that then take flight—originate not in reality but in her imagination.

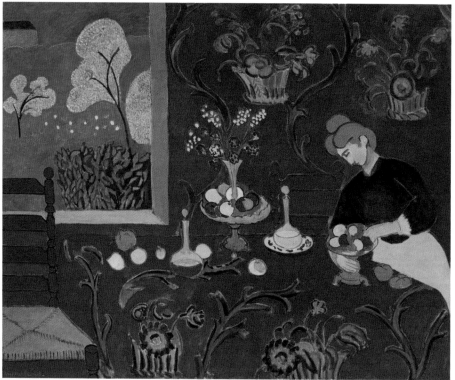

8.16 Henri Matisse, *Red Room (Harmony in Red)*, **1908–09. Oil on canvas, 71 × 87 in.**
Decorative space dominates Matisse's painting. Traditional linear perspective is present only in the chair on the left and the windowsill. In particular, the uniform use of red and the decorative outlines of branches and flowers on the wall and table help to flatten the sense of space.

CONCEPTUAL CONNECTIONS

How do artists and designers use scale and proportion in two dimensions? How can this type of spatial representation affect proximity?

objects in a naturalistic way. A key feature of this spatial depiction is that it emphasizes the flatness of the page or surface (fig. 8.16). Decorative space is often associated with modernism in art, and several contemporary movements (including

Char Davies's *Ephémère*

What type of space is virtual reality?

Char Davies is a pioneer artist working in the realm of virtual reality. **Virtual reality** (also known as VR) is a computer-generated environment that simulates three-dimensional reality. VR systems present visual and acoustic stimuli that immerse individuals in a virtual world. Most also involve feedback devices that allow participants to interact with and affect what happens in the simulated world. The more realistic the environment, and the greater the opportunity for interaction, the more participants will suspend their disbelief and accept the computer-generated representations as authentic.

Davies has completed many artworks using VR technology. Figure 8.17 shows a still image that captures a single moment in one participant's experience of her 1998 installation project *Ephémère*. This installation immerses individuals in a wholly interactive visual and acoustic experience. Audience members are not just spectators, they are full participants. The VR equipment—which includes a head-mounted display and motion sensors—tracks participants' movements, and the program reacts and responds in real time to their actions. Thus, each individual's experience of *Ephémère* is unique.

In creating *Ephémère*, Davies was inspired by an actual location in the mountains of Quebec, a province in central Canada. She used colors from this locale, emulating their rich neutral

8.17 Char Davies, Autumn Flux I from *Ephémère*, 1998. Virtual reality.

hues, to enhance the sense of reality. Participants are encouraged to think about both the exterior landscape and the inner workings of their own bodies as they move through the virtual space (Davies, n.d.).

Visit the online resource center to view the Contemporary Voices feature.

Neo-expressionism and digital creations) continue to use this form of spatial representation.

Virtual Space

Virtual space is a realm in which electronic information exists and is exchanged. Within it, artists and designers can create anything from simple digital illustrations to fully realized virtual electronic worlds. Works generated in virtual space are not tangible. At their most basic level, they are composed of computer code. They exist only inside a computer or other electronic device, and they can be viewed in their original form only on a monitor, or screen.

Artistic creation within virtual space falls under the umbrella of computational art and design. (The word *computational* derives its meaning from the root word *computer*.) This field has become increasingly popular in recent decades, as more and more artists and designers have come to realize the creative possibilities that computer software opens up. *Computational art and design* is a broad label that encompasses a wide

variety of computer-generated works, including digital illustrations, animations, and video game graphics.

Using Space

The way an artist or designer uses space can help viewers make sense of the overall composition. In particular, it can tell viewers how they should interpret the various forms and marks on the page in relation to one another. Below, we will begin by examining three common techniques artists and designers use when attempting to create the illusion of three-dimensional space on a two-dimensional picture plane—overlapping, adjusting the relative size and proximity of objects, and adjusting the vertical location of objects. Although we will consider each of these techniques separately, you should keep in mind that many artists and designers combine more than one in a single picture or design. We will also look at how transparency can affect the viewer's

sense of space, and we will conclude by considering the symbolic use of space in maps.

Overlapping

One of the most basic methods for creating the illusion of three-dimensionality is to overlap objects. As soon as one object overlaps another, a spatial relationship is established. For this technique to be effective, however, the objects must be opaque. If the objects are transparent, the spatial relationship is lost (fig. 8.18). The greater the number of elements that overlap one another, the more complex the imagery becomes (fig. 8.19).

Depicting one or more forms as overlapping the principal frame of the work—commonly known as "breaking the frame"—can also produce a sense of dimensional space. It generates the optical illusion that part of the composition is coming out of the picture, into the audience's space (fig. 8.20). This device produces a fully realized sense of space and depth.

Relative Size and Proximity

The size of an object, relative to the surrounding objects, can tell us a great deal about that object's location in space. We tend to view larger objects as being closer to us and smaller objects as being farther away from us. Thus, an object's relative size within a composition directly correlates to a viewer's perception of that object's nearness to them (fig. 8.21). The nearness of one object to another, as well as the nearness (or perceived nearness) of an object to the viewer, is known as *proximity*.

Vertical Location

An object's **vertical location**—that is, its position on the picture plane relative to the top or bottom of the frame—can also indicate a spatial relationship. For example, placing objects close to the bottom of the composition will enhance the feeling of their being bigger and closer to the viewer. Conversely, placing objects near the top of the composition

8.18 Overlapping.
In the image on the left, the shapes of the rectangles are opaque. The spatial relationships are clearly defined, and we are able to clearly see that the yellow rectangle is in front of the green, red, and blue rectangles. The image on the right shows the shapes as transparent, making it difficult to tell which shapes are in front and which are behind.

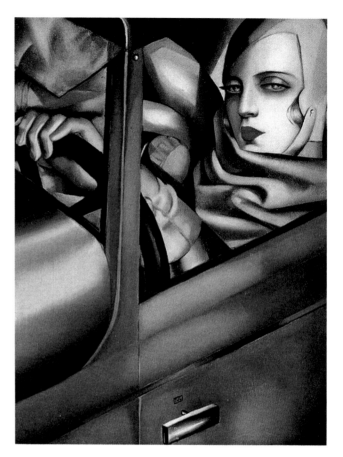

8.19 Tamara de Lempicka, *Autoritratto sulla Bugatti verde*, 1925. Oil on panel, 13 3/4 × 10.5 in.
De Lempicka produces a complex sense of space by overlapping multiple objects—the car's windshield and door overlap the woman and the steering wheel, the steering wheel overlaps her arm and the palm of her hand, her billowing scarf overlaps her neck, and so on.

8.20 Matthew Benedict, *Cobweb Castle Still Life*, 2005.
By breaking the plane of the matte, Benedict creates the illusion that the books are emerging out of the picture plane, creating a three-dimensional effect.

will make those objects seem farther away from the viewer (fig. 8.22). This technique works because we have been taught to expect that larger objects will be placed in the

8.21 **Kerry James Marshall,**
Party, **2003-07.**
The woman in white who appears
in the foreground of this paint-
ing is larger and painted in more
detail than the other people. Thus,
she appears to be nearer to the
viewer than do the other people,
and she attracts the viewer's
focus.

8.22 **Florine Stettheimer,** *Spring Sale at Bendel's*, **1921. Oil on
canvas, 50 × 40 in.**
Even though the figures within the painting are all very similar in size,
we read the figures at the bottom of the composition as being closest
to the viewer because of their location on the page.

CONCEPTUAL CONNECTIONS

How does vertical location affect the point of view of an
artwork or illustration? How does vertical location change
the sense of scale and proportion in a work?

lower portion of a page and that smaller objects will be
placed in the upper portion of the page.

Transparency

The three uses of space discussed so far in this section rely
on the use of opaque figures and shapes—elements that con-
vey some sense of density. When items are transparent, the
areas they occupy cannot be as easily defined, and the sense
of space becomes ambiguous or even confusing. Thus, artists
and designers can use transparent objects to create an uncer-
tain space that puts the viewer off balance.

Symbolic Use of Space: Maps

Artists and designers can also use two-dimensional space to
produce symbolic representations of three-dimensional areas.
Symbolic representations require viewers to be able to un-
derstand symbols. (Recall from Chapter 1 that a symbol is a
shape or other visual representation that is commonly under-
stood to stand in for something else.) For many of us, the most
familiar place to find symbolic representations of space is on
a map. We often turn to maps when we need to navigate new
or unfamiliar locales. Based on our past experience, we know

8.23　The Milton Bradley Company, The Game of Life, 2005.
In The Game of Life, players must follow a map that gives them direction, not only literally, but figuratively as well—the segmented paths lead either to success or to failure.

8.24　Steven Bleicher, *Abandoned Sweetgrass Hut*, 2018. Mixed media, 14 × 11 × 3 in.
This work celebrates our uniquely American zeal for collecting souvenirs from our travels, as tangible elements of our experiences. The use of the map, along with the inclusion of the three-dimensional beads, enhances the viewer's sense of place and space.

that a map's key or legend will tell us what its lines and shapes represent—for example, a large superhighway or small country road. We have been taught to accept that these lines and shapes stand in for actual features in three-dimensional space.

Maps can also be used symbolically as metaphors. A map of a country, state, or city, for example, can be used to suggest the political, social, or cultural embodiment of the given area. In addition, maps can be used to represent a journey or a directional sequence of events, as they commonly are in board games (fig. 8.23). Finally, maps can be used to tell a story with symbolic meaning. Figure 8.24 features a map that serves a narrative function, showing the exact location of the scene presented just above the map. In this case, the map highlights an underlying theme of Americana: our need to capture a space in time—a fleeting moment—and preserve it.

THINK ABOUT IT

- How does perception affect your sense of space?
- Why is perspective important in two-dimensional art?
- How has Cubism influenced the use of space in contemporary art and design? How has your own use of space in your artworks or designs been influenced by Cubism?
- How do you think virtual space will impact the future of art and design?
- Aside from those covered in this chapter, what other approaches or techniques might you use to depict space or spatial relationships? How might you use those approaches or techniques in your own artworks or designs?

IN THE STUDIO

This project encourages you to expand your ideas about spatial representations and relationships. Think about how maps can be used depict a journey. What might you experience while traveling, and how might you express your experiences visually? When focusing on your experience, keep in mind that going from one place to another is of secondary importance; the critical question is not *what* but *how*.

On a piece of illustration board or Bristol board, design a map of your school's campus. Consider incorporating tradiional elements of a map, such as a legend or a compass, but

try to find inventive ways to represent key features of your surroundings. Also try to convey a sense of your own experiences with navigating your campus. The goal of this assignment is for you to push past the traditional idea of what a map is, and to find a unique and personal way to represent the space around you (figs. 8.25, 8.26, 8.27). You might think metaphorically—for example, by using the human circulatory system as a reference point. Or, you might try to capture how your thoughts flow from one to another as you see different landmarks.

8.25 **Student Work: Julie Crowe,** *Mapping Space—Campus Maps*, 2016. Crowe presents a more humorous illustration of her day. The graphic quality of her drawings engages the viewer.

8.26 **Student Work: Jessica Harris,** *Mapping Space—Campus Maps*, 2016.
Harris used her cell phone and its GPS campus view as the basis of her concept. The elements on the border show a history of the University's mascot.

8.27 **Student Work: Ke'shoan Johnson,** *Mapping Space—Campus Maps*, 2016.
Johnson, a student athlete and art and design student, shows the stadium and gym complex as the most important elements in his personal map. He used an aerial view of the campus as a novel visual design.

VISUAL VOCABULARY

actual space
amplified perspective
decorative space
eye-level vantage point
foreshortening
horizon line
illusionistic space

infinite space
isometric perspective
linear perspective
multiple perspectives
one-point perspective
perspective
psychological space

space
three-point perspective
two-point perspective
vanishing point
vertical location
virtual reality (VR)
virtual space

9

Motion

LOOKING AHEAD

- **What is motion?**
- **How can the sensation of motion be visually represented in a single static image?**
- **What is kinesthetic empathy?**
- **Why is the illusion of motion often characterized by narrative sequencing?**
- **What are narrative and nonnarrative representations?**
- **What is implied motion?**
- **How does optical art use implied motion?**
- **In what ways can the illusion of movement be represented in a composition?**

SWOOSH! IN A SINGLE WORD, THE FEELING AND EXHILARATION OF movement are expressed. Visually, Nike uses that same expressive quality in their logo and in the design of their footwear (fig. 9.1). The sleek angular slope of the shoe works in much the same way as the aerodynamic lines of a sports car, inducing a sense of movement, even when the shoe is perfectly still. Through its design, the shoe conveys to the viewer its potential acceleration and speed.

For centuries, artists and designers have been interested in the concept of motion. How can the sensation and visual excitement of movement be captured? How can that feeling of movement be distilled into a single picture or image? These questions have crossed cultural and geographical boundaries, and over time, each culture has found its own solution.

9.1 Nike Running Shoes.
The sleek design and angular shape of the shoe imbue it with a look of motion. Even the Nike logo (the swoosh) echoes its potential movement.

9.2 Lara Himpelmann & Lauren Kaigg, *If I Lose Half My Sight, Will My Vision Be Halved?* 2012. Photograph.
Himpelmann and Kaigg experiment using slow shutter speeds to capture movement in a single visual image. Having the features blur into each other captures the essence of the organic repetition, like a nagging thought that won't go away.

9.3 Renato Bertelli, *Continuous Profile of Mussolini*, 1933. Bronzed terracotta, 11 3/4 × 9 in.
Bertelli constructs the shape of a face that feels as if it's in constant motion, turning around endlessly on its own axis. The blurred profile creates the illusion of motion.

Today, more than ever, contemporary artists use technology to depict movement and express motion on a two-dimensional picture plane. Virtually every designer uses digital technology on a daily basis (fig. 9.2) to convey movement. The advances in slow motion photography and the prominence of the personal computer have made new tools for artistic representations of motion readily available.

In this chapter, we will focus on the illusion of motion demonstrated in two-dimensional images.

In modern art, an interest in motion came to the forefront in Italy during the early part of the twentieth century. The movement, known as Futurism, emphasized burgeoning technology and its importance to modernity. The Futurist manifesto declared that "all subjects previously used must be swept aside in order to express our whirling life of steel, of pride, of fever, and of speed" (fig. 9.3). Futurists spoke out against all things "dull," "same," and "feminine," while promoting "war," "speed," and "masculine power." While their artworks excelled at depicting the motion and speed of modern life, their fascist, misogynist philosophy was not well received and may have been a factor in the group's short-lived tenure.

Motion Defined

All representations of movement in two-dimensional artworks or designs have one thing in common: they portray action. **Motion** can be defined as an action, or the

continuation of movement. In visual terms, it can be a subject frozen in time or the repetition of any number of visual elements, including color, value, shape, or line. Motion can lead the viewer's eye through a work of art or design, creating a sense of visual continuance.

Viewers can internalize the movement portrayed in artwork and design; they can feel it in their own bodies as they observe the action of the subject. The feeling of the movement is like a memory from the viewer's own (physical) body experience. This internalization of the movement portrayed in art and design is known as **kinesthetic empathy**. In addition, when viewing art and design, the fundamental laws of physics come into play. No one has to be told that a body in motion will continue to move through the action (fig. 9.4). The action will not suddenly stop as if frozen in time; instead, the viewer imagines that the motion will carry through to its logical conclusion. As such, conveying motion in an artwork or design can make the piece more exciting and dynamic.

Characteristics of Motion

Underlying the illusion of movement is the story, or narrative, of the artwork or design. If there is movement, then something is happening, and the imagery used tells that story. Two basic formats can effectively deliver a story: a single direct line, known as a narrative format, or a series of sequences that move in a nonlinear fashion, known as a nonnarrative format.

Linear Formats/Narrative

Artworks that tell a story are known as **narrative** artworks. They normally have a set beginning, middle, and end. They can involve series of sequential panels (or other elements) that move the story forward in a step-by-step, or linear, fashion. While some of the most common contemporary forms of narrative artworks include storyboards, comics, and graphic novels, one of the earliest narrative works is *Trajan's Column* (fig. 9.5). Standing over a hundred feet tall, this column can be read from the bottom up and tells the story of an important Roman battle. The historically accurate, detailed carvings can be seen as the forerunner to the modern-day graphic novel.

Nonlinear Formats/Nonnarrative

Disrupting the expected order of the narrative not only adds interest, but also allows the artist and designer to explore new avenues of expression. It might mean starting at the middle or end, and it can involve imparting an idea or telling a story in a more abstract manner (fig. 9.7). Working

9.4 Robert Longo, *Pigeon Man*, 1994.
The viewer expects the contoured figure in Longo's large-scale, detailed drawing to continue falling. The gesture of the figure creates the implied motion. The individual depicted is not a specific person, but an anonymous "any man." This may be one reason for its appeal—its torment is our own.

with a nonlinear format may only give the viewer a fragment of the story or a more oblique sequence of the movement. Web designers, game developers, and others often work in a nonlinear fashion because their audiences— whether they are visiting a site or playing a game—have the freedom to move in any number of directions at any given point.

Types of Motion

There are two basic types of movement: implied and optical. Everything else is a subgroup of these two forms. Implied movement is psychological; it uses gestures, compositional placement, and design elements to portray the feeling of movement. Optical movement, on the other hand, involves both psychological and physiological phenomena.

Implied Motion

Implied movement is primarily a psychological phenomenon. It is the assumption that the act in progress will follow through to its logical conclusion (fig. 9.8). Such motion—one that is expected to continue—is known as **anticipated movement**.

Anticipated movement is also referred to as **implied motion**, because movement is indirectly expressed in the art or design. It is the action, gesture, or pose that imparts the motion. The pose or body language of a person walking, for example, holds less energy than that of a person crouched and running.

9.5 Trajan's Column (Rome), 116 CE.
The carved narrative frieze, once brightly painted, moves around the column in a spiral. The images are factually accurate in their representations of weapons and battle dress. The story portrayed on the column has much in common with literature in that it has a beginning, middle, and end, as the villain cuts his own throat, knowing that all is lost in the battle.

☽ new perspectives

Douglas Klauba's *Project Superpowers*

How does breaking out of the confines of the cell create a feeling of motion?

Comics, storyboards, and graphic novels have been influential in helping artists and designers produce the visual illusion of motion. The sequential images imply a narrative structure, reminiscent of storytelling. The viewer is able to follow the movement and story from one panel to another.

In his visual narratives, Douglas Klauba implements many of the elements discussed in this chapter. In his most recent work, *Project Superpowers*, he expresses the movement of his characters using a traditional comic strip convention known as **whiz** (or **motion**) **lines** (fig. 9.6). The motion lines surrounding the figure show the direction of the movement. For example, to show someone spinning around, he might draw motion lines in a semicircle surrounding the character. Using whiz lines and text as sound effects are techniques often used in comic books and graphic novels. Another convention used to create dynamic action involves allowing the figure, and other parts of the imagery, to break out of the confines of the frame, spilling out over the other panels.

Visit the online resource center to view the Contemporary Voices feature.

9.6 Douglas Klauba, PROJECT SUPERPOWERS (CHAPTER 1 #0 PAGE 3), 2008.

9.7 Martha Rich, *Snack Chat*, 2014.
There is no focal point. The nonlinear format of Rich's composition allows the viewer's eye to move around the work in any direction. There is no secondary hierarchy to direct the viewer's attention.

The design of an item or product can also generate a feeling of anticipated movement. The streamlined silhouette of an object that shows its curves and diagonal lines, such as a sports car, a running shoe, or a pair of sunglasses (fig. 9.9), can suggest the feeling of motion and high speed, even when the object is still. This could be considered motion by design.

Other contemporary paraphernalia have an aerodynamic form that conveys the feeling of motion and signifies modernity. An item such as a hairdryer, an electric drill, or any product for that matter, can have an aerodynamic form that evokes a sense of speed and energy.

Optical Illusions

Optical Art (or **Op Art**)—also known as psychedelic art—capitalizes on many of the same scientific principles as implied movement. These artworks are purely designed entities

CONCEPTUAL CONNECTIONS

How does nonlinear or nonnarrative change how a viewer might read an artwork or design? How are scale and proportion affected in this type of nonlinear arrangement?

CONCEPTUAL THINKING ACTIVITY

As you have seen, products from sunglasses to athletic shoes can be created to generate the feeling of potential motion. Find a product (other than sunglasses and athletic shoes) that demonstrates the feeling of impending or anticipated movement.

9.8 Katsushika Hokusai, *The Great Wave*, 1831. Polychrome wood-block print; ink and color on paper, 10 1/8 × 14 15/16 in.
The concept of implied or anticipated motion is not only found in Western art. Hokusai shows the wave at the height of its arc as it begins to crash down. There is no question that the movement will continue.

9.9 Proflow™ from Rudy Project.
Activeware and sports-related products, including eyewear, are meticulously crafted with the aid of biometric engineers and professional athletes to achieve perfect harmony between performance and aesthetics.

9.10 Bridget Riley, *Blaze 1*, c. 1961. Emulsion on hardboard, 43 × 43 in.
Riley's large-scale works explore optical phenomenon, which produces a disorienting physical effect on the eye. She is fascinated with the act of looking, and her work aims to engage the viewer with the actual process of observation.

9.11 Hermann Grid.
Making use of physiological and psychological principles to convey movement became the basis for many Op Art works. The same principles that operate the Hermann Grid are at the heart of many optical illusions.

with linear geometric shapes and forms derived from, or influenced by, geometric abstraction. Many of these works appear to move because they employ the illusion of movement that stems from perceptual psychology; the movement is in the viewer's mind and eye (fig. 9.10). These highly decorative works gained public acceptance and became staples of popular youth culture in the 1960s and '70s.

While many Op Art works did not actually move, artists and designers used the psychological and illusionist feeling of movement in their works. Works like the Hermann Grid (fig. 9.11) take advantage of the psychological and physiological workings of the body to create visual movement. When you look at the grid in figure 9.11, it appears as though the black dots are blinking or firing on and off, moving randomly through the intersections. Logically, you know that you're reading the printed page of a book—there can't be any kinetic action. The flashing dots are produced as the chemicals in the cones within the retina of the eye fire on and off in rapid succession.

A.

B.

9.12 Diagonals and Arcs.
A. As the incline increases, so too does the apparent velocity of the movement. The angle can show the direction of the movement, as well. B. As the arc of the curve becomes tighter, so too does the implied momentum.

9.13 Yvonne Jacquette, *Two Bridges,* 2007–08. Oil on canvas, 70 3/8 × 53 1/4 in.
Jacquette generates a sense of action by placing all of the items on diagonals. The degree of the diagonal depicts the relative speed or momentum of the object.

Using Motion

There are a number of formalist means of visually expressing motion. An artist or designer might use a compositional element that creates a narrative sequence, or choose a particular page placement. He or she might evoke anticipated motion, or use media to create a focal point.

**9.14 Michelangelo Buonarroti, *Study for the Last Judgment,*
c. 1490–1564.**
Michelangelo directs the viewer's eye so that it follows the figure's gesture by heightening some of the lines, making them heavier or darker so that they stand out on the page. Using this method, Michelangelo works out the movement and action of the figure.

The type of illusion used is directly related to the conceptual basis of the artist's or designer's work. Each method of producing the illusion of movement will alter the visual message. It is important to match the method used to depict the movement with the story or message being portrayed. Techniques that create a sense of movement feature the use of diagonals and lines of force. These can be used singly or in combination to achieve the illusion of movement.

Diagonals

One of the simplest and most elemental methods of portraying motion on a picture plane is to simply position the object on a diagonal. Placing objects on angles that oppose each other, or on angles that oppose the horizontal and vertical edges of the

CONCEPTUAL CONNECTIONS

How does using diagonal elements affect working within a grid structure? How do diagonal elements reinforce the underlying visual emphasis of an artwork or design?

page or canvas, establishes a sense of movement (fig. 9.12). The use of curved lines, or placing the object on the arc of a curve, will also create movement and motion. The more oblique the arc, the faster the movement will appear to be (fig. 9.13).

Lines of Force

Artists will place extra emphasis on some of the lines in a drawing to show the energy or power of the moment being portrayed in the image. These emphasized lines are called **lines of force**. Accentuating the value of one line over another draws the viewer's attention to that area and creates a focal point. Take Michelangelo's sketch (fig. 9.14) as an example of how an artist or designer can implement lines of force. The addition of overlapping lines produces areas of darker value, defining the form and suggesting the force of the action. Lines that are not clearly defined result in a blurred image that expresses movement in much the same manner.

Stop Motion

Closely related to anticipated motion is the use of **stop motion** photography. Also known in photography as freeze-frame, stop motion grew out of technological breakthroughs

in photography (fig. 9.15). By using strobe lights and extremely high shutter speeds, photographers are able to visually stop motion, highlighting a split second in time. This makes visible to the naked eye a droplet of water hitting a surface and generating ripples, or the aftermath of a bullet that has been fired through an object.

Motion Blur

Another effect made visible by the camera is **motion blur**. If the shutter is left open (at a slower speed), and the object moves, the image blurs in the opposite direction of the movement. The leading edge of the object remains in focus while the tail, or back, of the object develops a streak, or blur. As the object moves across the picture plane at a certain rate of speed, the image perceivable with our eyes is vague and wispy. This blur is a common visual phenomenon. The greater the blur, or length of the smear, the greater the sense of momentum created. Today, this effect can easily be achieved using blur filters in software such as Photoshop. Now any object, whether moving or at rest, can be made to look as if it were in motion (fig. 9.16).

9.16 Chad Verly, Advertisement for SONY headphones, c. 2001.
The innovative use of motion blur on the type implies the effect of the sound waves coming from the headphones. This effect allows the viewer to see and feel the music.

9.15 Harold Edgerton, Stop Motion Photograph of the Effects of a Gunshot, c. 1930–75. Photograph.
Edgerton uses high-speed photography to slow down time and reveal events that happen too fast for the human eye to perceive. Photographed in less than one-thousandth of a second, the instant the bullet penetrates the apple, and the aftermath, are shown. The force of the exit of the bullet is very dramatic.

Multiple Images

Even before the advent of the camera, artists were experimenting with multiple images as a means of representing motion. The camera made these sequenced images easier to achieve. Photographers, including Eadweard Muybridge, made studies of humans and animals in motion to capture the exact manipulations of the body (fig. 9.17). These studies were a boon to artists and designers, and volumes presenting multiple image sequences were sold. There was a time when virtually every art and design student had a book that demonstrated the figure in motion.

CONCEPTUAL THINKING ACTIVITY

A motion blur, whether produced through photography or added using software such as Photoshop, produces a sense of momentum. Find an ad or artwork that uses image blur to represent motion. How does the image blur establish rhythm in the ad or artwork?

Another way of using multiple image sequences to create the feeling of movement is to allow the image to fade out as it moves across the picture plane (fig. 9.19). As the image transitions from light to dark, it becomes clearer and sharper,

9.17 Eadweard Muybridge, *Animal locomotion*. Plate 367, c. 1887. Photographs.
Related to stop motion, high-speed and multiple image photography allows us to see each individual aspect that makes up the flow of the gesture or movement. It allows us to study, in detail, the posture and attitude of the figure in motion.

9.19 Bouncing Ball.
This illustration shows the use of "trails." The viewer follows the movement of the object as the image of the ball moves from light to dark. As the repeated or multiple images move farther away from the object, they fade out into a light gray.

Global Connections

Multiple Images and Storytelling in Amos Bad Heart Buffalo's *The Battle of Little Big Horn*

How do overlapping figures enhance the feeling of movement?

The concept of rendering motion is not purely a Western concept; many other cultures depict the concept of movement in their artworks. The Sioux used many different visual notations, including the use of repeated images. In figure 9.18, the exact same image is replicated numerous times. The technique of overlapping multiple images generates the feeling of forward movement. Not all repeated images, however, produce the feeling of motion or movement; the images must be set up in a linear fashion to generate a narrative for the eye to follow. Notice in the top left of the painting, for example, how the artist achieves a linear narrative by depicting a coherent scene—Major's Reno's army in retreat. The images in this work serve as both storytelling devices and educational illustrations. The painting's naturalistic representation is a recent convention that shows the Anglo influence on traditional Sioux imagery.

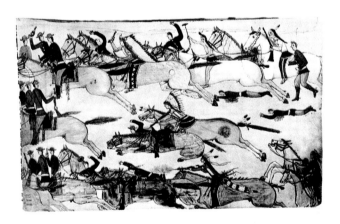

9.18 Amos Bad Heart Buffalo (Sioux), *The Battle of Little Big Horn (Retreat of Major Marcus Reno's Command)*, c. 1900.

9.20 Steff Geissbuhler, Poster for Blazer Financial Services, 1974. Geissbuhler uses the convention of multiple images, or trails, to illustrate the frantic, fast-paced movement of Blazer Financial Services. Comic books and graphic novels use this same principle to represent movement.

showing the direction of the movement as well as making the object or figure appear as though it is coming toward the viewer. This visual illusion uses the inherent concepts of atmospheric perspective; as the item moves away from the viewer, it loses its color and texture. As the image comes closer to the foreground, it will have more detail and heightened color. In the heyday of the psychedelic '60s, this method would have been called "trails," a reference to the fading segments of the images as they trail from the object into nothingness (figs. 9.19, 9.20).

Cropping and Placement

Selectively **cropping** the image and placing the subject in the proper location on the page is another method of achieving the sensation of motion. Pictures or designs that have the bulk of their images placed in the lower right portion of the page (fig. 9.21) tend to possess a greater sense of movement. This

increased sense of motion is due partly to the fact that we read a page from top left to bottom right, so it is natural for our eye to move rapidly in that direction. To heighten the effect, an artist may use an open composition, letting the object flow off the page to the lower right-hand side. This also gives the appearance that the lower right-hand side of the image is closer to the viewer.

Foreshortening

As we discussed in Chapter 8, amplified perspective is an exaggerated perspective in which the portion of a figure that is closest to the viewer appears to be dramatically larger than the portion that is farthest away. Foreshortening is the technique used to achieve this perspective. Foreshortening can be used on human, animal, or inanimate objects to achieve the same visual effect (fig. 9.22). By exaggerating this effect, a sense of movement or motion can be achieved.

9.21 Marcel Duchamp, *Nude Descending a Staircase, No. 2*, 1912. Oil on canvas, 57 7/8 × 35 1/8 in.
Duchamp's painting may have been the first to use the convention of repeated imagery to show movement. The diagonal direction of the movement toward the bottom right of the page increases the speed of the movement. In addition, the size of the figure filling the canvas creates a tight space, focusing the viewer's attention on the diagonal movement.

CONCEPTUAL CONNECTIONS

How can the page placement of the elements affect the sense of balance? How can an image be cropped to increase the feeling of movement or motion?

9.22 Joyce Kozloff, *Topkapi Pullman* (detail), 1985. Glass mosaic; glazed tile, 156 × 192 in.
Kozloff's use of extreme fore-shortening creates the impression that the train is heading directly toward the viewer.

THINK ABOUT IT

- Why do you think the Futurists were so concerned with depicting movement? How did this influence the philosophies espoused by the group?
- What techniques do graphic novelists use to convey motion? How do comics and graphic novels differ in the ways that they depict motion?

- How is the concept of kinesthetic empathy employed in artworks and designs?
- How can you use different media to depict the illusion of movement in your own artworks or designs?
- How has the development of photography influenced the way artists and designers depict motion?

IN THE STUDIO

This project requires you to demonstrate your understanding of the techniques described in this chapter by representing two distinctive sounds. We hear sound when "sound waves" emanate from the object, animal, or person making the noise. Develop a layout for two contrasting sounds, such as a butterfly and a jet, a whisper and a scream, and the like.

Graphically represent these sounds using the visual methods described in the chapter, including the use of diagonals, multiple images, stop motion, or extreme foreshortening (figs. 9.23, 9.24, 9.25). Carefully consider the character of the sound, its tempo, volume, duration, rhythm, context, and related value.

9.23 Student Work: Andrew Dettra, *Sound as Motion*, 2016.
Dettra visually contrasted two sounds: the sound of a guitar strum and the sound of gunshots. The sound of gunshots is implied by the aftermath of the marks left on the surface.

9.24 Student Work: Danielle Ortiz, *Sound as Motion*, 2016.
Ortiz developed a conceptual composition by juxtaposing images of whispers and screams and comparing the two different facial expressions.

9.25 Student Work: Taylor Dinkins, *Sound as Motion*, 2016. Dinkins contrasted the sound and motion of a feather floating to the ground and that of the speed and crashing noise of an anvil hitting the pavement.

VISUAL VOCABULARY

anticipated movement
cropping
implied motion
kinesthetic empathy

lines of force
motion
motion blur
motion lines

narrative
optical art (or Op Art)
stop motion (or freeze-frame)
whiz lines (or motion lines)

THE ASSOCIATION
ALONG COMES MARY
QUICKSILVER
MESSENGER SERVICE
GRASSROOTS
FRI SOPWITH CAMEL SAT ONLY
SAT JULY 22 23
FILLMORE
AUDITORIUM

TICKET OUTLETS

San Francisco	Berkeley	Mill Valley
City Lights Book	Discount Records	The Mod Hatter
Psychedelic Shop	Shakespeare & Co.	Sausalito
Bally Lo – Union Square		Rexall Pharmacy
Town Squire – 1318 Polk		

Three

Color

We live in a world filled with color. Of all the elements of art and design, color may be the most complex and enigmatic. Now that we have covered six art and design elements—line, shape, texture, value, space, and motion—we can delve into the finer details of color and the foundations necessary to use color successfully. Unlike most of the elements covered in Part 2, color elicits an unconscious, psychological response. Viewers immediately respond to the color of an object, even before they are fully aware of what that object might be; this is the nature and power of color.

In Chapter 10, we will explore all aspects of color, including the science behind perceiving color, the characteristics that comprise color, organizing color on the color wheel, and the biological explanations behind color interactions. It is important to understand the differences between various color schemes and how to use them effectively. We will also take a closer look at how to work with color to achieve contrast, balance, space, and meaning. The complexities of color, including visual perception, color psychology, and expression, will all be discussed.

Today, every artist or designer interacts with digital technology, and therefore, digital color. Technology adds a new dimension to working with color, and since we live in a world where *"Are you on Instagram?"* is a common question, it is essential for both artists and designers to be aware and take advantage of this development. Chapter 11 is dedicated to digital color. We will address additive color primaries and how to use them, whether you are working for print, the web, digital video, or another format. We will also explore color selection and management, as well as the use of raster- and vector-based programs. A discussion of how artists and designers can present their work using digital color will highlight the most effective ways to communicate ideas, visions, and voice through these new media.

The fields of art and design are continually progressing. Contemporary artists and designers must, therefore, be comfortable working in a wide variety of both traditional and new media.

P3.1 Wes Wilson, Poster for the Avalon Ballroom, 1967.

Art&Design
FUNDAMENTALS

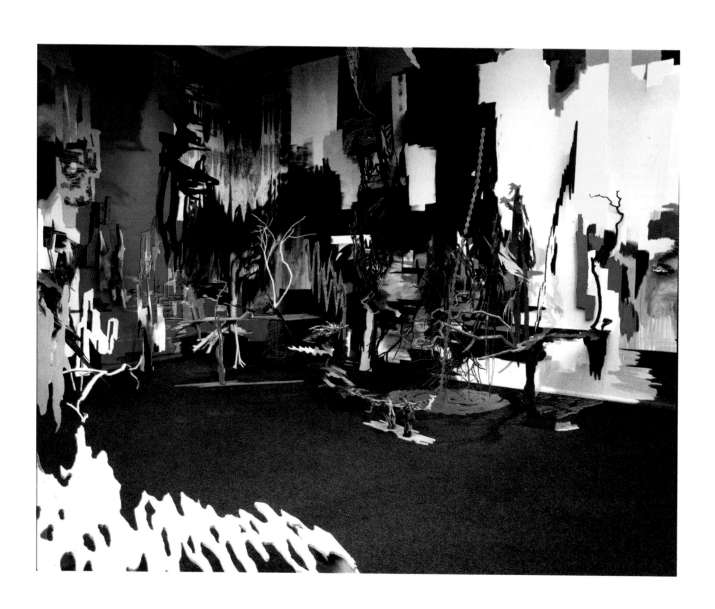

Color

- **What is color?**
- **What are the characteristics of color?**
- **What are the differences between additive color and subtractive color?**
- **What are the organizing principles behind the color wheel?**
- **What are color schemes and how are they used by artists and designers?**
- **How do colors interact with one another?**
- **How can color be effectively used in a composition?**
- **How can the use of color affect the meaning of an artwork or design?**
- **How can color express emotion?**
- **How does the use of color change from culture to culture?**

AN ARTWORK OR DESIGN MIGHT SOLELY FOCUS ON COLOR AND COLOR usage (fig. 10.1). Or, color might be a subordinate element in the work. Whether it is a dominant or subordinate element, color can dramatically affect the size, weight, flavor, and significance of a piece. Color not only adds visual interest, but it can remind the viewer of a certain time of day, or a particular season. Colors can carry emotional, historical, and cultural connotations as well, and changing an object's color can directly alter the meaning of that object. This chapter explores one of the most powerful art elements by delving into the ways in which artists and designers use color.

10.1 Judy Pfaff, *Rorschach*, 1981.
Pfaff uses a very colorful palette in her installation. The use of extreme contrasts, such as red and green, heightens each color to produce bright and dynamic visual elements.

Color Defined

Have you ever wondered whether we all see color in the same way? Or, whether objects in a room retain their color when the lights are turned off? Is color simply in the eye of the beholder? These questions have intrigued humanity since the beginning of time. Color may be the most ephemeral of all the elements of art, because it is hard to define except in its most basic scientific terms: color is light, and light is color. **Color** is light energy made visible (fig. 10.2), and so without light, there is no color. Different types of light sources, therefore, will directly affect the color we perceive. This effect is known as **metamerism**, whereby the amount and quality of a perceived color is dependent upon the character and intensity of the light source.

Hue is the proper term for color. By using a prism, white light—sunlight—can be broken down into **pure hues**. Pure hues are the component colors that, when taken together, create white light: red, orange, yellow, green, blue, indigo, and violet. Together, these seven colors make up the color **spectrum** (fig. 10.3). Not only is the spectrum composed of these hues, but in order for something to be considered a color, it must fall within this color spectrum. Therefore, black, gray, and white are not colors, because they do not fall anywhere within the color spectrum.

Characteristics of Color

A color is composed of three components: hue, value, and saturation. Every color exhibits each of these characteristics, and understanding these basic components gives artists and designers the ability to use color in dynamic or understated ways.

Hue

In addition to being the term for color, hue also designates the position of a color on the spectrum. Yellow, red, and blue are considered the **primary hues** because they cannot be broken

sun light tungsten light florescent light

10.2 Metamerism.
The amount and quality of a perceived color will vary depending on the light source. Tungsten light brings out the warmer hues while fluorescent light brings out the cooler hues of green and blue.

10.3 Pink Floyd, Album cover for *Dark Side of the Moon*, 1973.
The album cover uses the image of a prism breaking down white light into all the colors within the spectrum. The image is also reminiscent of the light shows that often accompanied Pink Floyd's live performances.

down and are the most basic building blocks of color. Green, orange, and violet are the **secondary hues**; they are produced by mixing two primary hues together. For example, blue and yellow produce green, red and blue produce violet, and yellow and red make orange. If a primary hue is mixed with a secondary hue, a **tertiary hue** (also known as an intermediate hue), is produced.

Value

As you will recall from Chapter 7, value is the relative quality of light and dark. The value of any hue can be altered by adding black, white, or gray (fig. 10.4) to make it darker or lighter. When a hue is mixed with white, it is called a **tint**. A **tone** is produced when a hue is mixed with any shade of gray, and a **shade** is produced when a hue is mixed with black (fig 10.5). Let's take orange as an example. Orange plus white produces peach, and orange plus black produces brown. In each color combination, however, the overriding hue is orange.

While the value of any given hue refers to its inherent quality of lightness or darkness, each hue has a corresponding value as well. For example, yellow corresponds with a light gray, while ultramarine blue or violet corresponds with dark gray (fig. 10.6). There is no corresponding hue for white or black, however, because there is no hue that would be

10.4 Orange Value Scale.
The pure hue is in the middle of this value scale while the tints extend to the left and the shades extend to the right. While there are only 18 steps in this particular value scale, there are an infinite set of values within one hue.

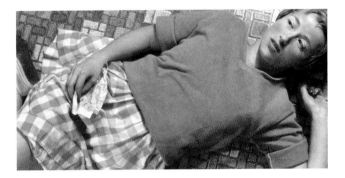

10.5 Cindy Sherman, *Untitled #96*, 1981. Chromogenic color print, 24 × 48 in.
Sherman's work could be subtitled *A Study in Orange*. All of the hues within the work are tints, tones, or shades of orange.

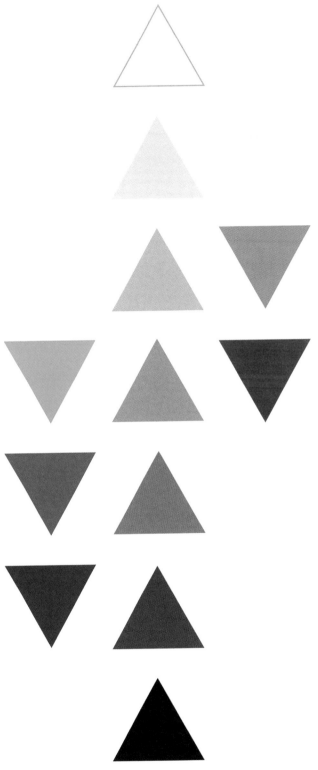

10.6 Relative Value.
As shown in this illustration, red and green both correspond to middle gray.

as light as pure white or as dark as black. Even the deepest shade of violet is relatively lighter than pure black. However, saturation and value are different and not interchangeable. The same hue in a different value may be lighter or darker than the pure hue. For example, in Figure 10.4 the tint of orange is much lighter than the pure hue, and any shade of orange would be darker.

Saturation

The terms *saturation*, *intensity*, and ***chroma*** are synonymous and refer to the purity of a given hue (fig. 10.7). A hue can range from being intensely saturated, such as an overly bright version of the hue, to being a **desaturated** hue that is nearly gray, or entirely **achromatic** (without color). Saturation can also be described as the relative brightness or dullness of a color.

10.7 Franz Gertsch, *Dominique*, 1988. Woodcut, 92 × 71 in.
Gertsch uses a desaturated palette of blue in this wood cut. The hues
are so desaturated that the work almost looks achromatic.

10.8 Additive Color.
These overlapping circles of light reveal some of the varieties of
hues that can result when red, green, and blue are added together.

10.9 Subtractive Color.
When white light hits the fire hydrant, all of the colors, except for red,
are subtracted from the light and absorbed into the object. The viewer
sees a red object, because red is the only color that is reflected back.

Types of Color

As mentioned earlier in this chapter, color and light are insepa-
rable. Light informs the manner in which we think about color
and the ways in which we work with it. There are two funda-
mental types of color, known as additive and subtractive color.

Additive Color

Additive color is composed of pure light. To produce any
given hue, light waves are combined or *added* together. Ad-
ditive color is the color you see on a computer screen. RGB,
or red, green, and blue, are the basic hues that are added to-
gether to create color for all digital entities (fig. 10.8). The
process of creating additive color, as seen on a monitor or
screen, is intangible and can result in millions of different
color combinations.

Subtractive Color

While additive color is created by emitting colored light, an-
other type of color is produced by subtracting parts of the
spectrum of light. As light waves strike a given object, many

of the rays are absorbed, or *subtracted*, and the remaining
color that is reflected back to the viewer is known as **subtrac-
tive color.** This process of light absorption/subtraction pro-
duces the red color appearing in figure 10.9. It is also the type
of color used in printing, where cyan (blue), magenta (red), and
yellow—*keyed* to black (the base color used in printing)—are
known by the acronym CMYK.

Using Color

Color is a potent design element because it can evoke an im-
mediate response from the viewer. To use color effectively,
artists and designers must understand common responses
to color and then select colors based on their relationships
and interactions with one another. This section will explore
some ways in which artists and designers can employ color
to enhance their works and elicit powerful responses from
their audiences.

The Color Wheel

For thousands of years, people have tried to understand what color is and how it can be used effectively. Color is often thought of as being circular in nature, and therefore, mapping color onto a wheel is a logical method of organizing and referencing color. The **color wheel** is a device that allows artists and designers to examine color in an orderly fashion, since each color is placed in a logical arrangement that reflects the color spectrum (fig. 10.10).

Sir Isaac Newton, who is considered the father of modern color theory, was the first to place all of the pure hues into a circular color wheel format (fig. 10.11). His 1701 treatise on color, titled *Opticks,* is the basis and foundation for all contemporary color theory. Newton discovered that, by using a prism, he could break down white light into its component colors.

In the early twentieth century, Albert Munsell developed the first modern color classification system. He devised

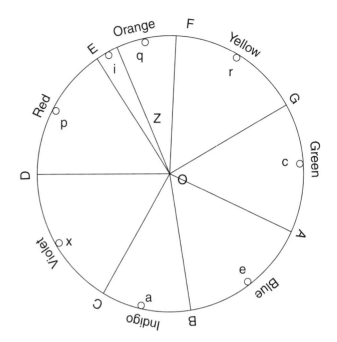

10.11 Newton's Color Wheel.
In the early eighteenth century, Sir Issac Newton arranged pure hues onto a circular color wheel.

10.10 A Basic Color Wheel.
Color wheels are always composed of an even, doubling number of hues, such as 6, 12, 24, and 48. Shown here is a basic, twelve-step color wheel that presents three primary hues, three secondary hues, and six tertiary hues.

···

CONCEPTUAL THINKING ACTIVITY

Develop a color wheel by organizing photographs of objects from your daily life. Use your smartphone to document the items. Which were the easiest and which were the most difficult hues to find? Why do you think certain hues were more or less difficult to find?

···

10.12 Munsell Color Wheel.
Each cell that makes up the color solid is numbered for precise color identification.

a color solid—a three-dimensional representation of a color model—to show color relationships (fig. 10.12). Munsell's classification system was the forerunner of today's spot color systems, such as the Pantone Color System, which will be discussed in more detail in Chapter 11. The Pantone system is still used today by graphic designers and publishing houses, because it allows for consistent color matches and mass production.

Color Schemes

It is not by mere chance that artists and designers select the right colors for their work. There are long-established methodologies for understanding color response. Some of these methodologies are based on scientific investigation and research, while others are based on visual phenomena. These predetermined color combinations are known as **color schemes**, or **color harmonies**. Together, they form the foundations of contemporary color use.

Monochromatic Colors

The term **_monochrome_** comes from the Latin _mono_, meaning one, and _chrome_, meaning color. A monochrome is the set of values for a single hue that ranges from the lightest tint to the darkest shade possible. The monochromatic range can comprise all the variations that can be achieved using one hue and mixing it with white, black, and gray (fig 10.13).

It cannot be combined with any other hue, no matter how closely related.

Analogous Colors

An **analogous color range** is composed of any three hues that are next to each other on the color wheel (fig. 10.15). Blue, blue-green, and green would be considered an analogous group on a traditional thirteen-hue color wheel. Analogous hues are usually used as pure hues and are rarely tinted or shaded (fig. 10.16).

Complements

Complements are any two hues that are opposite each other on the color wheel. They represent extreme contrast, and when used together at the same value and saturation, they play off one another to deeply intensify each other (figs. 10.17 and 10.18). Complements are usually used as pure hues in order to achieve visual vibration and intensity.

10.13 Barbara Kruger, *Face It (Cyan)*, 2007. Archival pigment print, 41 1/2 × 32 in.
Kruger uses a monochrome of blue (cyan) in her biting commentary on the commercialization of blue jeans and youth culture. Her use of type is inspired by advertising and graphic design.

Global Connections

The Artwork of Richmond Ackam

How are color harmonies used across cultures?

Color harmonies are not only a Western concept; in fact, many color harmonies, along with their connotations, are universal. The work of artist Richmond Ackam, which is inspired by the cultural heritage of his homeland, Ghana, demonstrates the universal nature of color harmonies.

One of the images from Ackam's *Ackamism Drumbeat Series* depicts a shield with an outline of an Akua Ba fertility symbol at its center (figure 10.14). To complement the subject of the piece, Ackam chooses a color scheme that is a monochrome of red. While the color red can symbolize blood in many cultures, Ackam's color scheme conveys a dual meaning as well: it represents both the blood of death and life, and the blood of new birth. Ackam also considers the color temperature, choosing warm and cool colors so that the diamond shapes seem to advance and float above the cooler half-circle, or moon-shaped, forms receding into the background. These diamond shapes, which may represent *the ladder of death* from an Ashanti proverb, are a reminder that the journey toward death is inevitable. Additionally, the diamond-like and cross-like motifs in the painting represent

10.14 **Richmond Ackam, Akua Ba Seal from the Ackamism Drumbeat Series, 2009.**

two versions of the Adinkra symbol for "Mmra Krado," or "Supreme Authority," from which the symbols were derived. Here we have the Asante Adinkra symbols providing protection for the Asante fertility doll (Ackam, 2018).

10.15 **Analogous Color Wheel.**
Any three hues next to each other on a color wheel are analogous.

10.16 **BP Logo.**
British Petroleum's logo portrays a stylized flower in an analogous range of yellow, yellow-green, and green. The decision to use bright, sunny hues in a floral design reveals the company's attempt to appear eco-friendly.

10.17 Complementary Color Wheel.
Standard pairs of complementary colors include red/green, blue/orange, and yellow/violet.

Split Complements

For a more complex color combination, a split complement can be used. A **split complement** starts with the selection of any complementary pair but then takes one of the selected colors and uses the hues on either side, as seen in the color wheel in figure 10.19. For example, the traditional complementary pair of blue and orange would become blue paired with yellow-orange and red-orange (fig. 10.20). Double split complements take two complementary colors next to one another, as demonstrated in figure 10.21.

Neutrals

A **neutral** is achieved by mixing two complementary colors together. If white is added to the neutral mix, a form of gray is produced. Depending on the quality of the neutral mix, the resulting gray can be either warm or cool. Neutrals also include gray, the mixture of black and white.

A warm and cool neutral effect can be seen in the work of Aaron Douglas (fig. 10.22). The neutralized yellow in the background has a warm feeling juxtaposed against the cool neutral violet of the central dancing figures in the foreground. Douglas was a part of what became known as the "Negro Renaissance Period" in Harlem and was a member of the Harlem Artists Guild, the African American artist's alternative to the Artists Union. His work blended his

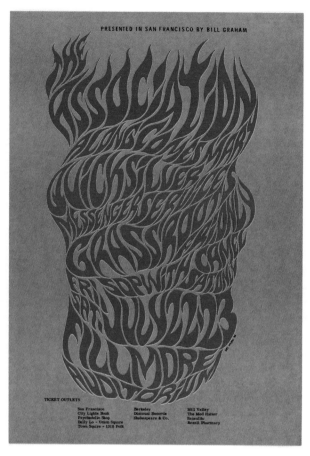

10.18 Wes Wilson, Poster for the Avalon Ballroom, 1967.
Wilson uses complementary hues of red and green. The saturated hues, which are all equal in value, further heighten the intensity and brightness of the color, adding to the psychedelic effect of the poster. Wilson painted these posters on a weekly basis for the Fillmore Auditorium and Avalon Ballroom in San Francisco.

Afro-American heritage with the new jazz revival of Harlem in the 1930s.

Chromatic Gray

We normally think about mixing white and black to make gray, but gray can also be produced by mixing two complementary hues and adding white. This combination of hues creates **chromatic gray**. The value produced tends to be either a warm or cool gray depending on the amount of each color used in the complementary mix. The Impressionists favored this method of value creation (fig. 10.23).

Triads

A **triad** is a color scheme composed of any three hues that are equidistant from one another on the color wheel. The most commonly used triads are the primary and secondary hue color groups (figs. 10.24 and 10.25); however, any three hues that are equally spaced apart from one another can be used to create a triad.

10.19 Split Complements Color Wheel.
To create a split complement color scheme, first find two complements; then, instead of using one of the complements, use its two adjacent hues instead.

10.20 Sandy Skoglund, *Revenge of the Goldfish*, 1981. Photograph, 27 1/2 × 35 in.
Skoglund uses a split complement palette of yellow-orange, red-orange, and blue in her photograph of an installation. The bright hues create a dream-like setting for the disparate elements—fish flooding the blue bedroom.

CONCEPTUAL CONNECTIONS

How can complementary color schemes create visual emphasis? How can they change the viewer's visual and conceptual perception?

10.21 Double Split Complements Color Wheel.
To create a double split complement color scheme, select two neighboring hues, along with their corresponding complements.

10.22 Aaron Douglas, *Aspects of Negro Life: Song of the Towers*, 1934. Oil on canvas.
Douglas achieves a warm and cool neutral effect by juxtaposing a warm, neutral yellow against a cool neutral violet. The figures are back-lit, creating a moody atmosphere.

10.23 Claude Monet, *Train in the Snow*, 1875. Oil on canvas, 23 1/6 × 30 3/4 in.
Monet painted the train and the winter sky using cool grays, while he predominately used warm grays for the smoke rising from the locomotive.

10.24 Triadic Color Wheel.
Any three hues that are equidistant from one another on the color wheel are considered a triad.

10.25 Wolf Kahn, *Ochre Barn Ochre Bush*, 2004. Oil on canvas, 36 × 46 in.
Using a triad of secondary hues, Kahn is able to achieve the color and feeling of a hot summer day. The warm hues seem to visually advance on the canvas. Kahn uses small amounts of a cool violet to push the background into the distance, balancing the warm hues and creating depth.

Disharmony

Color schemes are usually used to generate a harmonious, pleasing mixture; however, there are times when the artist or designer wants to create drama and jar the audience. Selecting strong contrasts and unusual hue combinations will create a disquieting feeling of **disharmony**. Disharmony can be achieved by using harsh contrasting colors, as seen in Robert Yarber's *Always Already* (fig. 10.26). The intense hues produce vibrancy, while the cooler hues suggest that there is an intense harsh contrast and lighting.

10.26 Robert Yarber, *Always Already*, 2010. Colored pencil on paper, 14 x 11 in.
Using colored pencil, Yarber chooses orange, red, green, and electric blue hues, which dominate this intensely colored scene. Viewers' eyes could almost hurt from looking at these clashing hues for any length of the time.

10.27 Josef Albers, *Homage to the Square*, 1964. Oil on Masonite, 47 1/2 × 47 1/2 in.
Albers used simple geometric shapes so that the form does not interfere with the color interactions. His work shows the purely formal aspects of color interaction. The series, *Homage to the Square*, is a result of this color experimentation. Albers's work inspired many to experiment with minimalist forms.

Color Interactions

Artist and designers do not always work with a single hue. If they did, then there would be no need to understand the interactions between two or more colors. Each time a hue is selected and placed next to another, there are myriad consequences and reactions. The ability to predict the effect of these color interactions plays a key role in all forms of art and design (fig. 10.27). Color is not experienced in a vacuum; rather, color perception is influenced and affected by its surroundings and environment.

Successive Contrast

Chemicals within the cells of our eyes allow us to see color. These cells can be overstimulated when viewing one-half of a complementary pair of hues. When a person stares at one hue for any length of time and then looks at a white or neutral color, the other half of the complement pair will appear, at times appearing as spots (fig. 10.28). This biological phenomenon is known as afterimage, or **successive contrast**.

Simultaneous Contrast

The French colorist M. E. Chevreul observed that when a particular hue is seen on, or next to, various other colors, it may

10.28 Successive Contrast Illustration.
Stare at the stop sign for at least thirty seconds, and then look at the black dot. You should see the traditional red stop sign. This is an example of afterimage.

appear to be dissimilar (fig. 10.29). He called this visual occurrence **simultaneous contrast.** A color's appearance is always subjective and relative to background and neighboring hues.

The Bezold Effect

Another color phenomenon is the **Bezold effect**. Scientist Johann Friedrich Wilhelm von Bezold was involved in the textile industry as a rug designer in the nineteenth century. While working, he noticed that if one color in a pattern or

10.29 Simultaneous Contrast.
The green hue is the same on both sides of this illustration. When the blue borders the green, the green color appears darker than when the yellow borders it. This illustration is an example of how colors are influenced by neighboring hues.

10.30 The Bezold Effect.
Notice how the visual look of the design changes dramatically if one color is replaced with another.

design was changed, it could dramatically alter the pattern's entire appearance (fig. 10.30). This concept can be applied to any composition or design.

Warm and Cool Colors

The interaction between warm and cool colors is fundamental to color theory. It is important to note, however, that no one hue is always warm or cool; rather, warm and cool classifications are relative and based on a comparison of two hues. For example, green can appear warm in relation to blue, but cool in relation to yellow. The only exception may be the color yellow; it is difficult to find a situation in which any hue is warmer than pure yellow. **Warm hues** tend to make things look larger. They also have a tendency to make elements appear to visually advance on the picture plane. **Cool hues**, however, make objects appear smaller and create the illusion of elements receding on the picture plane. You may notice that cool hues also make elements look heavier and denser, while warm hues make elements look lighter. Mary Cassatt balances warm and cool hues in *The Boating Party* (fig. 10.31). The cool hues of the water and of the boatman recede into the picture plane while the warm hues of the woman and child, the main subjects of the painting, advance and grab our attention.

Working with Color

Color evokes an immediate, unconscious response from the viewer. Viewers respond to the color of an image before they can comprehend its shape or read any text. A person reacts to the red color of the stop sign, not the octagonal form or the word *STOP*.

10.31 Mary Cassatt, *The Boating Party*, 1893–94. Oil on canvas, 35 7/16 × 46 3/16 in.
The boat's warm hues surround and frame the mother and child, who are the main subjects of the painting.

10.32 Helen Frankenthaler, *Bilbao*, 1998. Screenprint in colors on wove paper, 35 1/2 × 47 1/4 in.
Frankenthaler was interested in staining and the movement of the liquid paint across the surface. With only two lines of blue, her painting primarily presents a warm, analogous color scheme.

The colors an artist or designer selects can inform the audience of the time of year or season. When used in interiors, warm and cool hues can change the look and feel of a room, opening up the space or making a room look smaller. Colors can be selected purely for their lush, sensual qualities, which was a method preferred by the Color Field painters of the 1950s and 1960s, who poured thinned paint onto canvas to explore the fluid nature of paint (fig. 10.32). But it's not enough to know about how color is produced or its technological advances. It is also important to understand how to effectively work with color.

Color and Contrast

When working with color in design, contrast and readability are two primary concerns. If the colors used are too similar in hue, as with an analogous group, the resulting text or images may be very difficult to see (figs. 10.33 and 10.34). Using hues with a greater contrast will make the text or images stand out and improve their readability. For this reason, hues that are

10.33 Austin Cooper, London Underground Posters, 1924. Poster, 20 × 12 1/2 in.
Cooper uses warm hues, creating a wide range of contrast that makes the poster very readable. The poster informed Londoners that the underground (subway) is warmer during the winter.

10.34 Austin Cooper, London Underground Posters, 1924. Poster, 40 × 25 in.
This poster announced that the underground is cooler in the summer. While the cool hues represent the new, cooler stations, the dark color palette is an odd choice for the summer season. The colors that Cooper selected for the text are too close in value and saturation; as a result, they show little contrast and make the poster very difficult to read.

at opposite ends of the color wheel, or hues that are high in contrast, create readable text and graphics.

When hues are close in contrast, the artist or designer can place the cooler hue in the background and the warmer hue in the foreground. Since warm hues tend to advance and cool hues tend to recede, placing hues in this way will make the text or images more discernable and readable for the viewer.

Color and Balance

Color can be balanced in the same way that shapes and space are balanced on a page. The sense of visual weight can be used to balance contrasting elements, such as light and dark, warm and cool, color saturated and dull hues, and an infinite mix of hues. In the *i-D magazine cover*, hues of white and red are contrasted and balanced against dark, desaturated hues on the diamond trim of the hood (fig. 10.35). The bright white hue in the face visually advances to the foreground while the deep shadows on the hood visually recede an image which has a very shallow sense of space.

...

CONCEPTUAL CONNECTIONS

How can color balance, or the use of warm and cool colors, create a sense of depth or proximity in an artwork or design? How can color balance be used to focus the viewer's attention by creating a focal point?

...

10.36 Caspar David Friedrich, *Morning*, 1821. Oil on canvas, 8 × 12 in. Friedrich uses desaturated hues that recede in space, creating depth on a picture plane.

Color and Space

Color can also contribute to the illusion of space (fig. 10.36). As elements move away from the foreground and into the background, they gray out. This illusion occurs because there is more light near the viewer's position in the foreground; as a result, objects in the foreground appear to have more color, texture, and detail. As elements move into the background of a picture and the light diminishes, the hues must also become desaturated and gray. The gradual loss of color, texture, and detail creates the illusion of distance. As you may recall from Chapters 6 and 8, this visual phenomenon is known as atmospheric perspective. The phenomenon is both physiological and psychological.

Color and Meaning

People have long associated specific meanings with specific colors. They derive from language, emotion, expression, custom, locale, and culture. Color psychologists have found that some of these associations are innate responses and others are learned—encultured associations that develop over time. As artists and designers, it's important to be aware of the nuances of these various implications and their usage.

10.35 *i-D* **magazine cover.**
The magazine's cover effectively balances the contrast between the deep vibrant red and the stark whiteness of the model's face and background.

Innate and Learned Responses

Understanding the differences between innate responses and learned responses to color can play an important role in art and design. **Innate responses** to color are universal reactions that surpass an individual's nationality, religion, or race, while **learned responses** to color reflect taught behaviors, or reactions, and often vary from culture to culture.

One of the most universally recognizable examples of an innate response to color is the combination of yellow and black (fig. 10.37). This color combination represents danger; it is the color of bees, wasps, and many poisonous animal species. This color arrangement says, "Beware! Danger!" Our innate response to the combination of yellow and black may be the reason why road hazard signs and caution tape use this color scheme. The combination says, "Take notice and be aware; there may be danger ahead." This color combination is rarely used in advertising because its underlying message is *danger*; it could, therefore, repel more customers than it might attract.

Reactions to the color of the food we eat are also examples of innate responses to color. The color of the food (and its surroundings) affects our sense of taste. For instance, the color pink enhances the taste of sweetness; this is why most bakeries use pink boxes for their treats. The color of the box sets off triggers in the brain that tells the consumer that the product inside will be sweet, sugary, and delicious. On the other hand, blue is one color that can reduce hunger and kill the appetite. Blue has strong negative associations, reminding us of spoiled food and mold. The "blue plate special" of the Depression era in the 1930s relied on this fundamental color reaction. Diners and restaurants relied on the fact that people were not able to eat large portions and, in fact, ate less when their food was served on a blue plate. As more of the blue plate showed through, the customer's appetite diminished. On the other hand, bright warm hues will stimulate the adrenal glands, causing a customer to eat more and faster. This is why most fast food restaurants are decorated in brilliant, hot tones, such as yellow, orange, and red. Think about the color schemes of McDonald's, Burger King, or Wendy's (fig. 10.38). Under the influence of these hues, customers will order more and consume their food purchases in a hurry.

Many responses to color that we believe are innate are not; they are learned responses. For example, fashion sense is a learned behavior. One must be taught the rules of fashion, which can change from region to region as well as from country to country. More basic cultural color conditioning can be seen in our color choices for babies and young children. The old standard of blue for boys and pink for girls is a learned response and a Western tradition. Infants and toddlers do not react to soft pastels; they respond to bright primary hues. Imagine, however, the surprise of the neighbors and family if they walked into the nursery and were confronted with bright saturated hues instead of traditional, soft pastel hues.

10.37 Yellow-Banded Poison Frog (*Dendrobates leucomelas*)
The color grouping of yellow and black is universally recognized as a sign of poison and danger.

CONCEPTUAL THINKING ACTIVITY

Color and meaning are intricately linked. Find an object or product that is undeniably related to its color and explain why that is the case.

10.38 McDonald's Restaurant.
The colors used in McDonald's restaurants are not haphazardly selected. The influence of the bright, warm hues of yellow, orange, and red stimulate the adrenal glands, increasing hunger. As a result, people order more food and consume it faster.

Portia Munson's *Pink Project*

How Can Art and Design Question Learned Reponses to Color?

Conceptual artist Portia Munson emphasizes stereotypes and cultural associations through her work. In particular, she examines certain learned responses to color, such as pink for girls, blue for boys, green for nature, and so forth. The first of these works, the *Pink Project*, grew out of her mounting collection of discarded objects, all in various shades of pink (fig. 10.39). This was a collection of objects and products designed specifically for female consumers. The collection of objects may be displayed amassed on an exhibition space floor or set up in museum showcases known as vitrines. The items in the installation can vary depending upon the venue and can be edited, enlarged, or rearranged as desired, which allows her to continually update the work's conceptual content.

10.39 Portia Munson, *Pink Project: Table*, 1994.

Visit the online resource center to view the Contemporary Voices feature.

Color Psychology and Design

There are issues of color use in design. One of the most fundamental issues of color and design is readability. The greater the contrast between the typeface and the background, the greater the legibility of the design. However, this is not always the case. Earlier in the chapter, the issue of black and yellow was discussed. While this may be a great color combination because of its contrast and readability, it also sends an underlying message of danger. Instead of working with their favorite colors, designers must always be conscious of how the audience will read into the color and it use.

Each hue has its own inherent meaning and psychological associations. Take green, for example. What is the first thought or product that comes to mind when you think of the color green? Green stands for nature and fertility, and today it also stands for the green movement and ecology. Products and logos use these implied associations. British Petroleum uses two analogous hues of green in their logo (see fig. 10.16). They are trying to send the underlying message that they are an earth-friendly corporation. John Deere uses the same color in their logo for their tractors and other farming equipment. In this vein, Coca-Cola designed a green can to promote Coca-Cola Life, made with pure cane sugar and the natural sweetener stevia (fig. 10.40). But what flavor of soda most often comes in a green can? Lemon-lime sodas. Coca-Cola Life was introduced in 2013 and was discontinued in 2017 due to poor customer reception and lagging sales.

The socioeconomics of color is another important consideration regarding the psychology of color and design. Different economic groups react differently to color. As a rule, lower economic groups relate to bright, simple color schemes, while

10.40 Coca-Cola Life.
The green indicates that the product is made with pure cane sugar and stevia. The soda was discontinued due to poor reception and sales.

higher economic groups relate to dark, more complex colors. As a designer, it is important to know your client and target audience. You would design differently for a young audience than you would for an older, more established audience. For instance, think about cars. The lower-range models of automobiles, such as the Toyota Corolla, Ford Fiesta, or Honda Civic, have color choices with simple names, such as brown, silver, or white. On the other hand, luxury car models have color names such as sable, titanium, or pearl. These colors are usually more complex, and their names bring expensive items to mind.

Language and Emotion

Color is part of the language we speak and one of the ways in which we understand our emotions. While artists and designers do implement familiar associations (whether innate or learned) in their work, artistic movements in the twentieth and twenty-first centuries have taken color a step further, making it central to a message of uncertainty, discordant emotion, and intense anxiety.

Color is used in language to express emotion, intention, and desire. People speak of *being green with envy* or *seeing red*. You can be *tickled pink* or you can *turn green*, meaning you're ill and sick to your stomach. A person can be *true blue* or *have the blues*. Being *in the red* means that you are in debt, while being *in the black* signifies a profit. Yellow may refer to someone who is scared or afraid, while its complement, violet (or purple), signifies courage. When was the last time you used color when describing someone or the way you were feeling?

How can artists and designers use certain colors that have become synonymous with specific emotions? Red, for example, is associated with rage and lust, green stands for envy and greed, blue for sadness, and yellow for a bright, sunny disposition. The use of light, intense colors tends to portray happy, joyous emotions. These hues have a lively and upbeat feel to them (fig. 10.41). We associate brilliant, vivid colors with festive events and occasions. Additionally, tints share many of these same associations. Viewers associate tints with spring, new blossoms, babies, and femininity.

In contrast, no other hue is associated more closely with sadness and depression than blue. For nearly a four-year period from 1900–1904, Pablo Picasso worked predominately with the color blue. After the suicide of his best friend, Carlos Casagemas, Picasso chose this hue for his work to visually represent and express his feelings of grief and melancholia. Picasso is the first artist to develop a series of monochromatic paintings over an extended period of time. Picasso chose this hue specifically for its mood-altering, emotional feel. Not only did he paint using blue, but he also dressed almost exclusively

10.41 Natalie Harrison, *Pastel Tapestry*, 2019. Acrylic and glitter on panel, 30 × 24 in.
Harrison is drawn to the aesthetic qualities of jewelry and considers her work a tapestry of paint. She uses tints of bright primary and secondary hues, molding the paint into bead, lace, and floral forms.

in the same hue. It was as if he were living his life as one of the principal characters depicted in his paintings.

The subject matter of Picasso's paintings during this time expresses deep sentiment. The depressing themes of his work included the poor and especially those who were starving, infirm, and mentally ill (fig. 10.42). It has been said that the "Blue Period" symbolizes the artist as an outcast from society. There may be some truth to this, since at the time, Picasso was penniless, living far from his family, and not yet successful.

Expressionism

Taking color and emotion to the next level, the artists of the early twentieth century moved away from a realistic use of **local color**—the actual color of an object—and began to invent their own color schemes to suit the mood of a painting. The **Expressionist** movement included two main groups, *der Blaue Reiter* (German for **"The Blue Rider"**) and the **Fauves** (French for "wild beasts"). Both groups used color purely for its expressive qualities (fig. 10.43). This was a liberating experience for artists who had previously been tied to naturalist color representations. The new movement meant

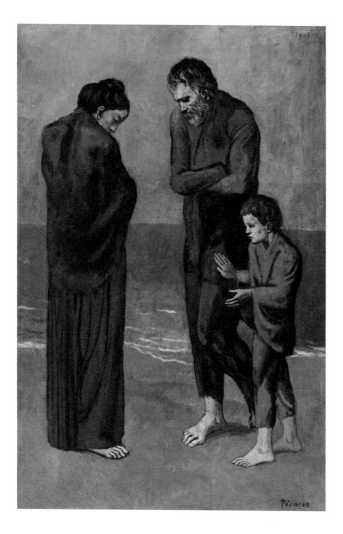

10.42 Pablo Picasso, *The Tragedy*, 1903. Oil on wood, 41 7/16 × 27 3/16 in.

While these huddled figures—presumably a family—are shoeless and in rags, it is Picasso's use of a blue color palette that heightens the sense of sadness, loss, and isolation. Since there is no trace of what disaster affected this family, the audience is left to wonder about what led to their misfortune.

CONCEPTUAL CONNECTIONS

What color, other than blue, could you use to represent sadness or depression? How would your color choice change the viewer's visual and conceptual perception?

that the artists could freely interpret color for their own subjective desire. Their work expresses the angst and upheaval in the years before the First World War.

The expressive use of color reemerged eighty years later in the Neo-expressionist movement, which began in Italy and New York City. Artists, including Sandro Chia, Francesco Clemente, and Jean-Michel Basquiat, were part of the resurgence of the use of color for its purely expressive qualities. In *Boy and Dog in a Johnnypump*, Basquiat uses warm hues to enhance the frenetic movements and push the primary visual elements to the foreground (fig. 10.44). His use of less saturated hues allows elements to recede into space, generating the feeling of depth and producing a background. As with earlier movements, local color is abandoned in favor of using color for its purely emotional effect.

Culture

Color is used symbolically in every culture and society. Color may even be a factor in cultural color selection and adaptation. In the hot, humid climates of India, Asia, and Africa, the warmer end of the color spectrum is favored for clothing and apparel (fig. 10.45). In India, for example, single women wear yellow to attract a romantic partner and keep evil spirits away, while red is the color often associated with weddings.

Color can have both personal and public, or national, associations. It appears prominently in logos, symbols, pennants, and flags. The colors used in national emblems such as flags are not selected at random. Great thought is put into color selection, as decision makers consider the underlying significance and meanings of certain colors. Color significance can be multidimensional and complex. Take, for example, the flag of Ireland (fig. 10.46). Its tricolor bands of green, orange, and white hold great significance. The green hue represents the Catholic segment of the population; this color association is evident worldwide on the celebration of Saint Patrick's Day. The orange band is emblematic of the country's Protestant population, an association derived from William of Orange who overthrew the Catholic reign of James II. The center band of white was selected to represent peaceful coexistence and tolerance between Catholics and Protestants.

This chapter emphasized Western traditions and color theory primarily, but if we analyze a single common practice across cultures, we can see the varied ways in which cultures use color. Let's take the practice of funerals as an example. In the West, black has been the customary color for funerals. In much of Asia, white is the traditional funeral color (fig. 10.47), since it is believed that white reflects the purity of the soul at death. In Ghana and other parts of West Africa, white was the conventional color of mourning. Today, black is being used there, partly due to the influence of the Catholic Church; however, the established funerary color white is still seen at children's funerals. Red is the color for mourning in still other regions of West Africa and in South Africa (fig. 10.48), while yellow is the color used in traditional Egyptian funerals.

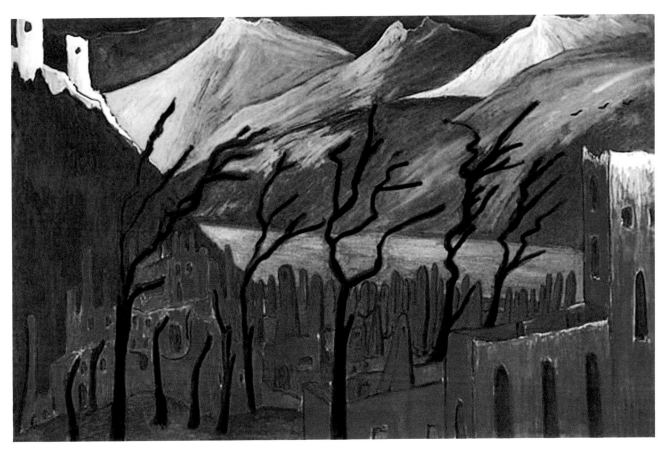

10.43 Marianne von Werefkin, *Red City*, 1909.
Von Werefkin, a member of the Fauves, used an intense application of pure hues. To maintain such concentrated color, she rarely tinted her palette.

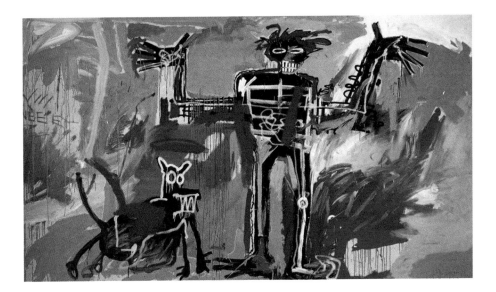

**10.44 Jean-Michel Basquiat,
Boy and Dog in a Johnnypump,
1982. Oil on canvas, 94 1/2 × 165
1/2 in.**
Integrating his earlier interest in
graffiti and tagging, Basquiat uses
text and warm hues to enhance
the frenetic, gestural strokes in his
painting. The gaze of the figure
is unfixed and vacant, adding to
the unsettling feeling the work
evokes.

The establishment of black as the traditional Western color for funerals dates back to the thirteenth century. According to Bertram Puckle's *Funeral Customs: Their Origin and Development*, black was selected for mourning by Queen Anne, widow of King Charles VIII of France, at the time of his death in 1498. Queen Anne believed that white, which had been the customary color, didn't adequately reflect the depth of her sorrow and grief. Her decision set a trend that has

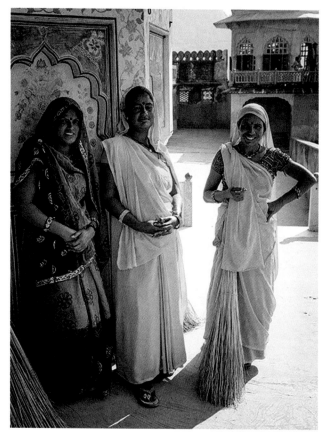

10.47 Funeral procession in Tay Ninh, Vietnam.
One man is carrying a photo of the deceased. The mourners wear traditional Vietnamese mourning white, as in other parts of Asia and the Far East.

10.48 Traditional funeral in Kumasi, Ghana.
Those officiating the service are clad in red. The color symbolizes blood and its life giving properties.

10.45 Indian Sari.
This traditional Indian garment is usually made from cotton or silk. These natural materials breathe and allow for evaporation, which cools the body. The warm hues also help to regulate temperature, as they block the absorption of the sun's rays.

10.46 The Irish Flag.
The orange and green bands represent the two main religious factions comprising the country. The flag itself could be seen as a metaphor for the country and the history of strife between these two groups.

continued in Western culture until today (fig. 10.49). Despite the choice by Mary, Queen of Scots to wear white upon the death of her second husband, Lord Darnley, the use of black continued.

There are many non-Western concepts regarding color and its use. Each country and region may have many diverse ethnic and cultural constituencies, and each of these groups may have differing views and color preferences. No matter the country or culture, color plays a major role in our lives and belief systems. It is important to be aware of non-Western cultural color associations as the internet and other new technologies bring audiences closer together.

10.49 Fleury-François Richard, *Valentine of Milan Mourning Her Husband*, 1802. Oil on canvas, 21 1/2 × 17 in.

Richard chose to paint the recently widowed woman in dark nineteenth-century mourning attire. The contrasting light from the sun streaming in through the window may represent the "light of God."

THINK ABOUT IT

- If light and color are inseparable, and you are in a dark, pitch-black room, does the color of your clothing, for example, still exist? Explain your reasoning.
- What is the difference between value and saturation?
- Envision a single hue (other than blue), or an analogous set of hues. Why do these hues elicit specific emotional feelings?
- Why are analogous hues rarely used in logos and graphics?

- What is simultaneous contrast and how can it be implemented effectively in artworks or designs?
- Why are warm and cool colors important to keep in mind when creating an artwork or design?
- How might the color of an artwork or design affect the meaning of the work?
- How are color and culture interrelated?

IN THE STUDIO

This project allows you to demonstrate an understanding of the expressive nature of color and the relationships between different colors and color values. Develop an original, non-objective composition showing the color changes in the four seasons. Do not use any standard narrative techniques or imagery, such as falling leaves, Christmas trees, snowflakes, beach scenes, and so on. Think about which shapes and forms (geometric or organic) best relate to each season before beginning.

First, divide the picture plan into four parts. Select only four colors (hues), and by varying the amount used of each, create four designs with distinctively different color "climates." You must use the same four hues in each segment of the picture (or season), but you may not mix the hues. You can only use tints and shades of the chosen pure color hues. Your color choices, along with your execution, must convey the feeling of each season. The emotional response to color is the key to this assignment. You may vary the amount of the four colors used in each panel to achieve the desired emotional response for each season (figs. 10.50, 10.51, and 10.52). The viewer should be able to tell which season is which solely by your use of color.

10.51 Student Work: Troy Kinner, *Four Seasons*, 2016.
Kinner gives each season a different visual treatment. This adds to the visual interest of the work as he tries to capture the mood of the season along with the color.

10.52 Student Work: Taylor Willis, *Four Seasons*, 2018.
Willis blends all four seasons into one continuous visual stream without an obvious break between the seasons.

10.50 Student Work: Steven Parker, *Four Seasons*, 2016.
Parker creates a design with four linear columns. Each has a slightly different treatment.

VISUAL VOCABULARY

achromatic
additive color
analogous color range
Bezold effect

chroma
chromatic gray
color
color harmonies

color schemes (or color harmonies)
color wheel
complements
cool hue

der Blaue Reiter (German for "The Blue
 Rider")
desaturate
disharmony
Expressionism
Fauves (French for "wild beasts")
hue
innate response
intensity
learned response

local color
metamerism
monochrome
neutral
primary hue
pure hue
saturation
secondary hue
shade
simultaneous contrast

spectrum
split complement
subtractive color
successive contrast
tertiary (or intermediate) hue
tint
tone
triad
warm hue

11

Digital Color

LOOKING AHEAD

- **What is digital color?**
- **What characteristics define digital color?**
- **What are RGB and CMYK color systems and how do they differ?**
- **What is digital printing and how might it increase productivity?**
- **What are vector- and raster-based programs?**
- **How do input and output devices affect digital color?**
- **How do artists and designers use digital color and its related technologies?**

FOR THE PAST THIRTY YEARS, ARTISTS AND DESIGNERS HAVE BEEN ABLE to transcend the traditional confines of the page or canvas and enter the digital domain. The widespread availability of hardware and software for creating sophisticated artworks and designs has opened up new modes of creative expression and avenues for experimentation (fig. 11.1). Computer-generated visual works may be turned into printed works or preserved for display on the screen of a smartphone or tablet. New technologies have enabled artists and designers to collaborate and share their works online, pushing the boundaries of traditional art and design. This chapter explores digital color; it will help you to understand how digital color can be manipulated to bring a digital work to life.

11.1 c a l c (Teresa Alonso and Johannes Gees), *communimage*, 1999.
Alonso and Gees create a composite out of pictures uploaded by members of a website, creating a sort of democratic collage. The site has become a platform for communication, as members develop relationships that center around their participation in the site.

Digital Color Defined

In the digital world, color is no longer a tangible element. Instead, it is a product of zeros and ones that make up binary code. This code, written in any one of a dozen or so computer software languages, such as Visual Basic, C+, or Python, forms the basis of all elements of digital creation, including not just color but also texture, form, sound, motion, and position in space.

Unlike paints and pigments that can be physically controlled by hand or with a brush, digital color can only be manipulated with hardware such as a mouse, keyboard, stylus, or touch screen. Digital creations can be viewed on a monitor, screen, or as printed hardcopy.

Characteristics of Digital Color

You may have noticed that the colors of a digital product can look very different depending on whether you are viewing it on, say, a desktop monitor or a tablet. In addition, the colors of a print copy may not accurately represent what you see on screen. For this reason artists and designers must ensure that their digital creations, including their chosen colors, are accurately and consistently conveyed to the viewer. To achieve color accuracy and consistency, they must consider the viewing medium throughout the creative process. Digital media have two defining characteristics that contribute to our understanding of their digital color capabilities and limitations: color space and color depth.

Color Space

Each medium has a certain, sometimes limited, capacity for displaying hues called **color space** (fig. 11.2). The human eye has the largest color space and is able to discern the widest array of hues. All printed matter, despite the quality of the printing process, lags behind, and the web—with its severely truncated color space of only 256 colors—takes a distant third, owing to its highly limited ability to reproduce a full color range.

Color Depth

In addition to understanding the color space available for each medium, artists and designers must be aware of the color depth that each digital medium can produce. **Color depth** relates to the complexity of the color that can be displayed. More specifically, it describes the amount of digital information needed to represent a particular color. The most basic unit of digital information is called a **bit** (or **binary digit**). It

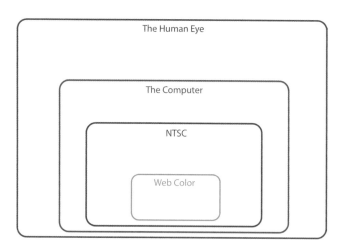

11.2 Color Space.
The human eye has the largest color space, far greater than any hardware device.

takes a number of bits to create the smallest point of light in a **pixel** (short for picture element). This number is referred to as the **bits per pixel**, or **BPP**. The higher the BPP, the greater the color depth. A medium with greater color depth will be capable of producing a broader variety of distinct colors. For instance, an 8-bit color graphic can reproduce the standard 256 variations found on the web. A 16-bit color graphic can store 65,000 color combinations, and a 24-bit color graphic can produce about two million color variations. Today, most graphics cards run in 32-bit Truecolor. **Truecolor** enables a vast number of hues; tints, shades, or tones can be displayed for high-quality photographic images or complex graphics. In Truecolor format, an image can have at least 256 shades of red, green, or blue for a total of 16,777,216 color variations, producing the most lifelike color. While color depth describes color *complexity*, another important aspect of color representation is the **gamut** (fig. 11.3), which refers to the *range* of colors that a particular piece of computer or printing hardware can display or reproduce.

Viewing Digital Color

The type of digital color used depends on where the final product will be viewed. A piece created for the Internet, for example, will likely be viewed on a computer monitor or a smartphone, although it may also be viewed on a flat-screen, high-definition TV monitor. In some cases, a viewer might print a hardcopy of the online image. Artists and designers must be aware of the fact that, similar to the way in which each medium has its own color space and color depth, each viewing medium also has its own primary color system that they must consider when creating a digital artwork or design.

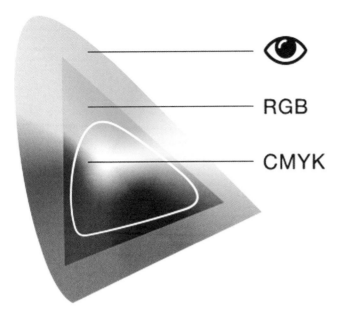

11.3 Gamut Illustration.
Color systems, such as RGB, Pantone, and CMYK, each have a color gamut. RGB has the largest color gamut, and CMYK the smallest.

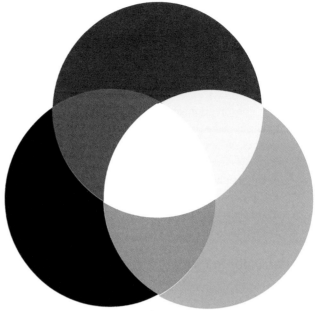

11.4 RGB Illustration.
Red and green combine to make yellow, green and blue combine to make cyan, and red and blue combine to produce magenta. When all three primaries are combined, white is produced.

CONCEPTUAL CONNECTIONS

How does digital color differ from traditional color applications, such as colored pencil or paint? How does digital color affect the gestalt of an artwork or design?

Digital Color on a Monitor

Your computer monitor is a viewing device that uses **RGB**, or red, green, and blue, as its primary color system. Digital color on a monitor works by mixing varying amounts of light energy. The colors are composed of pure light, and therefore, have no physical depth. Consequently, the color is intangible, because it is composed of light. Color composed of light rays is known as additive color (see Chapter 10). To digitally produce any given hue, light waves are combined or added together on the monitor (fig 11.4).

Hexadecimal color (HEX) is used by designers and developers in web design. A HEX color is expressed as a combination of six letters and numbers defined by its mix of red, green, and blue (RGB). The main difference between HEX and RGB color systems is that HEX colors are only used in web design while RGB has a range of uses, allowing you to add opacity to your color selection.

Computer monitors display color using the same principle as televisions, through the combination of RGB light rays. Even the latest-generation **LCD (liquid crystal displays)** and **plasma screens** use this principle. Smartphone screens also use either LCD or LCD-based LED (light-emitting diodes) screen technology. Their bright color and sharp images make LCD and LED displays ideal for watching movies, playing games, or

for use as creative tools. The newest technological advances in high-definition plasma technology add yellow to the standard RGB primary range. The typical RGB technology generates millions of colors, while this new technology and its four-color system (RGBY) can produce more than a trillion colors.

- Liquid crystal displays offer the advantages of saving space and providing a high-quality color display (fig. 11.5). The LCD monitor is backlit using a series of color cathode-ray fluorescent lamps at

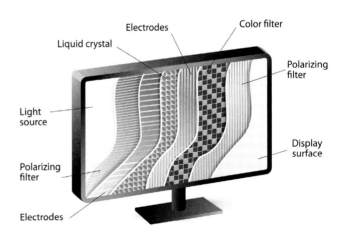

11.5 LCD Display.
When not energized, the crystals line up with the front and rear polarizers, and light travels down their spiral staircase and back up to the viewer. When energized, the polarizers are crossed, which makes the elements appear dark.

the rear of the screen. These lamps are always on. They produce darker hues and blacks by twisting, which blocks the light. They untwist for whites and bright colors.

- Light-emitting diodes are semiconductor light sources, which offer exceptional brightness, lower energy consumption, and faster on-off switching. These qualities make them ideal for handheld electronic devices. When switched on, the electrons combine with the electron holes in the device, releasing their energy as photons or elementary particles of light. In this process, known as electroluminescence, the color of the light produced corresponds to the energy of the photon.

Digital Color in Print

Digital artwork is normally intended to be viewed on a digital device, but creating print copies of digital artwork is also an option. This adds another layer of complexity to the challenge of faithfully producing color, and designers and artists should understand the basic principles on which a standard printer operates.

In 1703, Jacob Christoph Le Blon, an engraver, printer, and inventor, singled out three primary hues for printing. He concluded that all colors were some mixture of yellow, red, and blue. Le Blon's color mixing theory is still used today. From a large-scale printing press to a color printer that you might use at home, all printers use the basic primary color system **CMYK**, which stands for cyan, magenta, yellow, and key (or black). Black is considered the key color because it adds depth and value to the primary printing hues. Professional production prints are run on a press. In the four-color printing process, four screens are created that separate the colors of an artwork or design into the primary CMYK inks (sometimes called **process colors**) (fig. 11.6). Paper runs through each screen in order to generate the final print (fig. 11.7). The CMYK model recreates the work by partially or entirely masking colors on a lighter—usually white—background. The ink reduces (subtracts) the light that would otherwise be reflected (see Chapter 10).

If a color cannot be produced by mixing these four inks (cyan, magenta, yellow, and black), artists and designers may use spot colors to ensure a faithful reproduction of color. The advantage to using spot colors is that they are made from a specific formula or recipe. The inks are specially mixed for the press, and therefore the color produced is always consistent and accurate. When a spot color is used, no matter where the piece is printed, the desired color will be produced. This color consistency is extremely important in branding and product recognition. The **Pantone** brand is one of the most widely used of all spot color systems (figs. 11.8 and 11.9). Today,

11.6 Printing Primary Palette.
The color separations show how each of the four individual inks is applied to produce a full-color print. (Courtesy of Thaddeus Robinson)

there may be seven or more spot colors in some commercial printing processes.

There is always a difference between what you see on the screen and what is printed. This discrepancy is due to the fact that the digital image is created using an additive light process (with RGB as the primary color system) and then translated to a pigment-based, subtractive color process (with CMYK as the primary color system). When an image that is composed of light and developed on a computer is reproduced using inks, the color changes from a brightly backlit translucent image that is viewed on a monitor to an opaque printed piece. The color in the print will be darker in value and less saturated than the on-screen version. As an analogy, imagine the difference between a color print of a photograph and the same image as seen through a transparent slide projection. Since the slide is backlit by the projector, it will have brighter colors and a greater intensity than the photograph. Artists and designers must take this into account when they produce a final printed version of their work. They must always run a test print to check the color and make necessary adjustments.

11.7 Rosmarie Tissi, *Serenaden*, 1992.
Tissi's work is printed using the standard four-color process.

11.9 Jesse DeStasio, *Tankola*, 2009.
DeStasio uses Pantone colors for his toys and action figures so that no matter where the toy may be manufactured, the color will be accurate and consistent.

11.8 Adobe Pantone Selection Palette.
Pantone palette options, such as the one shown here, include metallic, coated, and noncoated varieties. The user can select from a variety of other spot colors, including TRUMATCH, ANPA Color, and Focoltone.

Printers have different uses and capabilities. When choosing a printer for printing a digital artwork or design, the key is matching the final visual output requirement with the budget while keeping the intended use of the print in mind.

- **Inkjet.** Most home printers are inkjet, using liquid ink to produce an image. The ink is sprayed through tiny nozzles that work like an atomizer, creating a fine mist or spray. This mist is sprayed onto the paper or canvas in the printer.

- **Laser.** Laser printers use dry-powder toner to generate an image. The powders are passed through a fuser, which heats the toner, bonding it to the paper. Laser printers tend to have a larger color space than inkjet printers.

- **Giclée (Iris).** Giclée printers are also known as iris printers. The name is derived from the French *gicler*, meaning to spray or squirt. These are high-end printers that produce quality prints. Many artists create limited-edition prints using giclée printers (fig. 11.10). The advantage to giclée printing is that the prints are archivable, meaning the image quality and color will not fade or degrade over time.

- **Dye-Sublimation.** Dye-sublimation printers use heat to penetrate the surface of the substrate or material with ink. Artificial materials, such as nylon, certain plastics, and polyester fabrics, contain polymers that, when heated, enable the bonding of ink. This type of printing produces a wide range

11.10 Jane Nodine, *Shirt*, 2004.
Nodine produces high-quality, limited-edition prints using giclée print technology. Since they are printed from a digital file, there is no difference between the first print and the last. Compare this to many other print processes, such as traditional laser prints or a home inkjet printer, where there may be some form of color change or degradation during the printing process.

of colors that are permanent because, instead of being a surface application, they are fused or embedded in the material. Images on hard surfaces will not chip, blister, or scratch, and the color printed on fabrics will not fade even after many washes.

- **UV.** UV printing is a professional production-printing method. It uses light-emitting diodes in the print head instead of a laser. The LED lamp emits energy onto specially formulated ink containing photoinitiators that cure the ink directly onto the surface of the material. It creates less pollution than conventional printers because there is little evaporation of the solvent in the inks, reducing the environmental impact.

Digital Color in 3D

Today, printing dimensional objects is becoming commonplace as software and hardware are more readily available to the average consumer. 3D printing enables artists and designers to create and produce complex functional items using less material than most traditional printing methods. 3D printing, also known as **rapid prototyping**, originally referred to a process whereby inkjet printer heads deposit a binder material onto a powder bed layer by layer. More recently, the term is being used in popular vernacular to encompass a wider range of additive manufacturing processes and techniques.

3D printing is an additive process of creating three-dimensional objects from a digital file. It is a fast method for artists, designers, and manufacturers to create scale models of their item. The object is printed by laying down successive layers of material until it is fully realized. Each layer can be thought of as a thinly sliced horizontal cross-section of the eventual object.

3D printing offers a fast way for artists, designers, and manufacturers to create prototypes or scale models of their object. Three-dimensional models are normally created using **CAD (computer-aided design)** software. There are a few

common types of file formats used in this printing process, including fused deposition modeling (FDM), fused filament fabrication (FFF), and stereolithography (STL). Before the CAD file can be sent to a digital printer, such as MakerBot, the file must go through a process known as **slicing**. This process divides the digital model into hundreds or even thousands of horizontal layers. Resolution for this method of production is described in thickness, either in DPI or in micrometers (μm). A typical thickness is around 100 micrometers. Some new machines can print layers as thin as 16 micrometers, which is comparable to a standard laser printer. Some applications have a slicing process built into the software. However, unlike traditional two-dimensional prints, the color is not controlled by the software or a color picker, but by the selection of the material used (fig. 11.11). This may change in the future as 3D printers become more advanced and specialty inks or colorants are developed.

3D printing technology becomes more affordable every day. New machines have brought the cost down to a level that many people can afford. More and more companies are

adopting this form of additive manufacturing. Digital printing technology will allow for the individual customization of products and devices while their reduced cost and timely production may increase productivity.

Using Digital Color

In his book, *Chromophobia*, artist and writer David Batchelor explains that contemporary artists no longer choose the color they want by mixing paints. He says that artists have abandoned the traditional paint tube in favor of ready-made, premixed hues from a paint can. He points to the use of color swatches used in many digital applications as the basis for his argument (fig. 11.12). To borrow Batchelor's metaphor, choosing digital color is much like going to the hardware store and selecting paint from a paint chip. This section will discuss different types of digital imaging and design software before exploring digital color selection, management, and presentation.

Vector-Based and Raster-Based Programs

There are two basic types of digital imaging and design software programs. Both use the additive process, but within each program is an algorithm that converts the additive color space to one that simulates the more traditional subtractive color space. These two categories of software programs are known as vector- and raster-based programs, and each has unique characteristics.

Vector-based programs use an underlying mathematical algorithm or formula. Every time the mouse is moved to create or modify a shape, the computer software program writes a corresponding algorithm to produce the desired effect or

11.11 Jeff Case, *01*, 2017. 3D-Printed Stereographic Projection Globe, 5 × 5 in.
When Case chooses the material for his sculpture, he also chooses the color. Until digital printing becomes more advanced, the color on the screen will not affect the printed object.

CONCEPTUAL CONNECTIONS

How does digital three-dimensional printing affect the scale and proportion of a work? How does creating a fully dimensional work differ from using a three-dimensional program to produce a movie or video game?

11.12 Adobe Swatches Palette.
Additional color swatches can be added to the palette as needed.

action. In the early days of computer graphics, the algorithm had to be written by the artist or a programmer. This laborious process lacked the spontaneity of today's design programs.

Today, vector-based programs produce images with sharp, crisp lines and linear elements (fig. 11.13). They are most often used to create graphics, logos, and illustrations, and in CAD for drafting and model making (fig. 11.14). The advantage of vector-based software is that the designs or graphics produced can be resized without losing clarity or integrity. This means that a designer can begin with a logo or design the size of a standard page and either reduce its size for use on a business card or enlarge it to fit a billboard.

Raster-based programs, including Photoshop and Painter, are used when working with continuous-tone images and photographs (fig. 11.15). Raster software applications are based on the pixel. Pixels come in different sizes, heights, and lengths. Since pixels are composed solely of light, they have no measurable depth. The pixel **resolution** is defined as the number of pixels per square inch (commonly referred to as

11.14 Gerber CAD.
CAD renderings can be in either two or three dimensions. Three-dimensional patterns can be generated from two-dimensional designs. The final output is produced two-dimensionally as a plan or three-dimensionally as a fully realized object. The simulated garment can be rotated and viewed from all angles.

11.13 Scott Stowell, *Graphic Design in the White Cube*, no date.
The use of type as a design element and the hard-edged quality of Stowell's work gives this piece a bold graphic quality. This style of work lends itself to vector-based illustration software.

11.15 April Greiman, *Fire*, c. 2009.
Greiman takes the primal element of fire and places it in a postmodern context. The continuous tone or painterly quality of raster imaging allows Greiman to produce multilayered, deconstructed imagery.

Typefaces Inspired by African Writing Systems

How can a typeface be created from traditional writing systems?

Saki Mafundikwa is a typographer who creates digital typefaces inspired by traditional African writing systems. While researching writing systems during the 1980s, Mafundikwa found that in addition to the oral traditions of the African continent, in many cases knowledge had been passed on in unique written forms. This was a revelation for Mafundikwa. He dedicated himself to the subject, and in graduate school, the sharing of knowledge through unique written forms became the topic of his thesis project.

Mafundikwa published *Afrikan Alphabets* in 2004. The book was the result of twenty years of research and a tribute to Africa's intellectual heritage (fig. 11.16). Mafundikwa's letterforms have a universal, primal appeal, and it is his hope that Africa can establish its role in the canon of graphic design. Mafundikwa says, "The

11.16 Saki Mafundikwa, *Afrikan Alphabets: The Story of Writing in Afrika*, 2004.

dream is for something to come out of Africa that is *of* Africa." To this end, he started the Zimbabwe Institute of Vigital Arts, or ZIVA. He tells his students, "You wanna break the rules? Well, you gotta LEARN the rules first. Learn to draw like your life depends on it."

DPI, dots per inch, or **PPI, pixels per inch**). A row of pixels is known as a *raster*, which gives the software category its name. The greater the resolution (i.e., the more dots per inch), the smoother the images produced. Web-based images are 72 DPI. Their small size allows them to load quickly, and they are meant to be viewed on the screen, instead of printed. The standard resolution for professional and printing production is 300 DPI. Depending on the purpose of the image, pixel resolution may be higher or lower, and raster-based programs give artists and designers the flexibility to manipulate the resolution to best suit the intended medium.

Digital Color Selection

When selecting color in a digital application, such as Photoshop or Illustrator, a device called a **color picker** is used. Each manufacturer, such as Apple or Adobe, has its own standardized interface, but all color pickers work on the same underlying principle whereby the desired hue is selected from a color solid (figs. 11.17 and 11.18). For a real-world analogy, imagine that a stick of butter represents the entire range

11.17 **Adobe Color Picker.**
The color picker has been standardized for all Adobe products, including Photoshop, Illustrator, InDesign, and Dreamweaver.

of the hues in the spectrum. By slicing through the butter at any given point, a section is made. Within that block, either a pure version of the hue or a slice that is lighter or darker, more or less vivid, can be chosen. The color picker application is very versatile, and a color can be selected by hue, saturation, or value.

Color can also be selected by RGB color or LAB color. LAB color is a machine-language or device-oriented system. The *L* stands for luminance, while *A* and *B* represent two color channels. There is also a notation for corresponding CMYK color. Another color selection tool, the eyedropper tool, is used for selecting an exact color from an existing image or design. This tool simplifies color matching within an artwork or design. Many new programs also have a toggle switch that will filter the color picker,

11.18 **Apple Color Picker.**
This color selection device is native to all Apple computers. Like the Adobe color picker, it works by using a color solid model.

11.19 Adobe Web Color Picker.
Checking the dialog box limits the number of selectable hues to the 256 that are web safe.

enabling only web-safe hues (fig. 11.19). This can be a great time saver when developing internet applications.

Digital Color Management

In order to view and work with digital color, artists and designers must use various hardware devices. Scanners, keyboards, tablets, and digital cameras are all input devices that send information to a computer and allow artists and designers to manipulate that information.

A scanner includes a light source that passes over a document or image while a **CCD (charge-coupled device)** reads the light energy that is reflected back (fig. 11.20). The CCD converts the image into binary code. The scanning software function is known as TWAIN Acquire. The acronym temporarily stood for "technology without an interesting name," but this acronym stuck after being coined as a placeholder. The scanner's light source is calibrated to 55,000 degrees Kelvin, which is equivalent to the brightness of sunlight. This light source produces the most accurate and lifelike color reproduction.

Most digital cameras use CCDs similar to those found in scanners. This chip needs plenty of light in order to produce lifelike color, and therefore most digital cameras have a built-in flash unit. This flash unit aids the CCD by ensuring that there is enough light for optimum image capture.

Image size in digital cameras and cellular telephones is measured in **megapixels (MP)**. A megapixel is a unit of measurement that equals one million pixels. The higher the number of megapixels, the greater the image resolution. The chart below shows the relation of MP to the resolution and size of a high-quality print that can be produced from a given camera.

11.20 Liz Atkin, *321 Self-portrait*, 2008.
Atkin pressed her face against the scanner glass to produce an image.

MP Size	Resolution	Print Size
2 megapixels	1600 × 1200	4″ × 6″
3 megapixels	2048 × 1536	5″ × 7″
5 megapixels	2560 × 1920	8″ × 10″
6 megapixels	2816 × 2112	11″ × 11″
8 megapixels	3264 × 2468	16″ × 20″

Whether you use a scanner, camera, or some other hardware device to capture an image, each method has its own unique features. If you are transferring digital color information from the scanner to the computer, or from the computer to a monitor, these pieces of hardware must be able to communicate with one another. Communication is achieved through the use of a color management model, or **ICC Profile** (fig. 11.21). The ICC Profile, created by the International Color Consortium (ICC), characterizes color according to a specific set of standards. The ICC is composed of government officials and industry experts. Working in collaboration, they are responsible for developing color standards to be used by all manufacturers across all hardware and software applications. These models store the data needed to maintain color acuity.

11.21 RGB, ICC Profile, Pat Herold/ColorThink Pro, 2019.
The illustration is what is commonly called the "horseshoe diagram" due to its shape. The colored background represents the total color spectrum visible to the human eye, while the triangle represents the gamut or color space profile of AdobeRGB. Color profiles for other devices may be smaller or larger and take different shapes depending on the color reproducing capabilities represented.

Each time a new document is created (whatever the software program), the file is imbedded with an ICC tag, allowing every piece of hardware to read the data.

Digital Color Presentation

Today, there are more **output devices** than ever before, including digital projectors, film recorders, smartphones, and a variety of print options. New technologies are continuously being developed that empower home computers with the same sophisticated software that professionals use in their studios. Each method of presenting a digital creation, whether it's a digital print, web entity, or animation, has its own unique features. The output capabilities of monitors and printers have already been discussed, but it is equally important for artists and designers to understand and become comfortable with these other formats as well:

- **The Internet.** When creating artwork and designs for use on the web, file size may be the single most important concern. On the internet, images must appear on screen quickly and accurately. People do not want to wait for an image or screen to load. If your screen doesn't refresh quickly, the viewer will leave the site and move on to another. The smaller the file size, the faster the image will load. Another consideration for web images is the use of warm and cool hues; when used effectively, these will help create a sense of depth and space (fig. 11.22). Using cool hues in the background will make elements appear to recede. Contrasting the background with warmer foreground colors will make the warmer elements pop and appear to advance visually, creating a more complex visual.

CONCEPTUAL CONNECTIONS

Does the device someone is using to view an artwork or design distance the viewer from the work? Is the viewer's connection more intimate or more removed because of the device used?

11.22 Mark Napier, *Empire*, 2010.
Napier uses the Internet to put a scale model of the Empire State Building into a three-dimensional environment. By merging software and architecture, he explores power in a postnational world. As a virtual monument, the work can be demolished and instantly reassembled.

- **Digital Video.** Before the digital revolution, creating and editing video was possible only for professionals with thousands of dollars of equipment. Now, most home computers can run a variety of software from iMovie to Final Cut Pro. The democratization of software for editing digital video includes such products as GarageBand for sound editing. The color produced is no longer limited, but a professional-level output. Now there are central hosts for sharing and airing homemade films. The proliferation of home-generated videos led to the birth and proliferation of sites like Vimeo, DailyMotion, and YouTube. The latter site is now so popular that many colleges and universities use it in their classes to post all manner of visuals.

- **Digital Animation.** New software advances have enabled the move into a totally digital world for film and movies with what are referred to as 3D modeling programs. The most popular are programs, and new ones are developed with each successive film produced. The first filmmaker to start blending live action and extensive computer animation was James Cameron with the film *Avatar*. Only a quarter of the movie *Avatar* used live footage; the rest of the film was digitally rendered. The characters were brought

to life using motion capture and state-of-the-art computer animation. This seamless mix of traditional motion picture filming techniques and digital animation brings the movie's Na'vi—the blue humanoids indigenous to Pandora—to life. Disney's production of *The Lion King*, directed by Jon Favreau, is another example of digital animation. Unlike *Avatar*, however, *The Lion King* is a fully animated or CG film (fig. 11.23). The animals are incredibly lifelike, thanks in part to the work of animation artists who specialize in how fur looks and moves. Artists build fur by constructing "guide hairs," setting parameters for the look of the hair: thin, thick, smooth, textured, and so forth. Finally, special software uses the data from the guide hairs, duplicating them and populating them around the animal's body.

An important part of the animation process is **rendering**, which is the method of generating an image or animation from the digital data. Rendering is used in architecture, video games, simulators, movies, and special effects, and may have acquired its name because it is analogous to an artist's rendering or drawing. The process takes the data and compiles it to produce the information in a final output format, whether that's video, film, or a CD-ROM. There are also color issues to

11.23 Jon Favreau, *The Lion King*, Walt Disney Enterprises, 2019. Film, 118 min.
Favreau used VR headsets to explore the virtual set as if it were a real filming location. Afterward, he advised the animation teams how to set up the shots to capture a particular sequence as if he were on a traditional movie set.

be addressed when rendering or compositing a digital creation to film. If the appropriate color filtering systems are not used, the color in the resulting transfer will look overly saturated. Oversaturation can produce the visual illusion that the color is flaring or blowing out from the object (fig. 11.24).

- **Smartphones.** Today, virtually all cellular phones, smartphones, and PDA (personal data assistant) devices contain digital cameras. Many of these can be used to take pictures or read data such as a QR (Quick Response) matrix code. These codes have become popular in consumer advertising, bringing the viewer directly to the information with immediacy unrivaled by most other media. The newest phones have the same color-producing ability as a standard monitor. Many artists and designers now work directly from their smartphones or create apps, as seen in the work of Lia (fig. 11.25). Lia's app allows for a collaborative art experience. As users become familiar with how their own interaction affects the design process, they are able to create more involved works, which can be shared, posted, or printed.

As new devices enter the market, artists and designers explore their functionality as art-making devices. New technologies encourage interactions between artists, designers, and their audiences. Digital media allows for the real-time production and dissemination of an artwork or design. New advances in technology will continue pushing the limits of digital color, as technological inventions are increasing the amount and depth of the color that can be produced on screen and as printed matter. Smartphones are now minicomputers

with the capability of becoming true art instruments. Additionally, combining new technologies with traditional media offers artists and designers new avenues for developing their work.

CONCEPTUAL THINKING ACTIVITY

You carry your smartphone with you every day. Without using your smartphone camera, use your smartphone as an art and design tool. How does the smartphone change your art and design practice?

11.24 NTSC.
Film has less color space than a computer. To combat distortions that can arise when transferring motion capture from one output device to another, the National Television System Committee (NTSC) developed a standardized color space format. In NTSC, thirty frames are transmitted each second and each frame is made up of 525 individual scan lines. Not only is the color space different in HD, but the total size of visual area is also greatly enhanced.

11.25 Lia, *PhiLia 01*.
Lia created an app for the smartphone that allows users to create their own artworks by using multi-touch to interact with elements on the screen. Tilting the device changes the direction of movement.

David Hockney's *Fresh Flowers*

What is digital painting?

Artists and designers continue to embrace new technology and use it to create new forms of expression. One such artist, David Hockney, has embraced the iPad. Hockney was intrigued with the direct nature of the medium and how it enables artists and designers to instantly share their creations. He began drawing on his iPhone in 2008, and moved up to the iPad upon its release in 2010. Hockney draws a new floral composition almost every morning using a touch screen, a stylus, and an app called Brushes (fig. 11.26). The app allows him to play back every stroke so that viewers can see how each line of the flower piece was drawn. Hockney maintains that dawn is about luminosity, and so is the iPhone, with its backlit touch screen. He says, "I draw flowers every day on my iPhone and send them to my friends, so they get fresh flowers every morning. And my flowers last. Not only can I draw them as if in a little sketchbook, I can also then send them to 15 or 20 people who then get them that morning when they wake up" (Gayford, 2010).

Visit the online resource center to view the Contemporary Voices feature.

11.26 David Hockney, *Untitled 780*, 2011. iPad drawing.

THINK ABOUT IT

- What are the differences between traditional color pigments and digital color?
- What is meant by color space or gamut and why is it important?
- How does the underlying manner in which a piece of software works (vector or raster) change the nature of the artwork or design that is created?

- Why are color pickers effective when selecting digital colors?
- Has digital technology changed art and design-making practices?
- How will the advent of new devices, such as smartphones, change art and design?

IN THE STUDIO

How has art and design creation changed with the invention of smartphones, tablets, and art-making applications? How can you incorporate this new technology into your artwork and designs? This activity challenges you to explore a new digital avenue. Imagine that your computer, smartphone, or tablet is your sketchbook, and choose an app through which to create an artwork or design (figs. 11.27, 11.28, and 11.29). Alternatively, if you have another idea for an art-making app, propose your idea. Afterward, draw comparisons between your digital work practices and your regular work practices.

11.27　Student Work: Emily Beekman, *iPhone Art*, 2016.
Beekman brought her iPhone into the life-drawing studio to draw the figure. She created a series of three drawings, each in a different color, to go along with the mood and concept of the pose.

11.29　Student Work: Maria Neito, *iPhone Art*, 2016.
Neito used her cell phone drawings to create a series of "fantasy tattoos." She photographed her subjects and developed virtual tattoos to reflect their personality and demeanor.

11.28　Student Work: Sara Becker, *iPhone Art*, 2016.
Becker went to the aquarium to develop a series of images based on jellyfish. The digital paintings have a liquid feel to them.

VISUAL VOCABULARY

bit (or binary digit)
bits per pixel (BPP)
CAD (computer aided design)
CCD (charge-coupled device)
CMYK (cyan, magenta, yellow, key/black)
color depth
color picker
color space
digital animation
digital video
dots per inch (DPI)

gamut
hexadecimal color (HEX)
ICC Profile
internet
LCD (liquid crystal display)
megapixel (MP)
output device
Pantone
pixel
pixels per inch (PPI)
plasma screen

process colors
rapid prototyping
raster-based programs
rendering
resolution
RGB (red, green, blue)
slicing
smartphones
Truecolor
vector-based programs

Glossary

abstract—A style of art in which the visual treatment of the form is derived from the natural world but simplified or streamlined to fit the artist's intent. [1]

abstract shape—A shape that represents a person or object that exists in the real world, but that has been altered, refined, or synthesized into a nonrealistic form by the artist or designer. [5]

achromatic—The absence of color; black, white, or gray. [10]

achromatic value—The relative lightness or darkness of a black, white, or gray surface. [7]

actual line—A line rendered by a pencil or other medium as a connected and continuous series of points. [4]

actual shape—A shape that is delineated from its surroundings by a visible boundary. [5]

actual space—The physical space that objects or areas occupy, either on a two-dimensional surface or in three dimensions. [8]

actual texture—A physical surface quality that can be felt through touch. Also known as *physical texture* or *real texture*. [6]

additive color—Color that is created by combining, or adding, light waves together. The additive primary hues are red, green, and blue (RGB). [10]

aerial (or "bird's-eye") point of view—An extreme angle that forces the viewer to look down at the main subject. [3]

aesthetic—The look of the work; related to *aesthetics*, the study of beauty. [1]

alternating rhythm—Repetition of a visual element or elements in a regular sequence, such as a-b, a-b, a-b. (See also **rhythm** and **progressive rhythm**.) [3]

amplified perspective—An exaggerated perspective in which the portion of a figure that is closest to the viewer appears to be dramatically larger than the portion that is farthest away. [8]

analogous color range—A color range composed of any three hues that are next to each other on the color wheel. [10]

anticipated movement—See **implied motion**. [9]

appropriation—Taking or borrowing something, often from popular culture or art history, to create a different context for its use. [1]

approximate symmetry—A type of balance in which the two halves of a composition are very similar but not exactly equal, allowing for greater design complexity. (See also **symmetrical**.) [3]

asymmetrical—A type of balance in which the central element takes up more than one half of the composition. [3]

atmospheric perspective—A visual phenomenon caused by the interaction between light and atmospheric particles, resulting in objects closer to the viewer appearing brighter and in greater detail compared to objects farther away. [6]

balance—The perceived equilibrium among the various components of an artwork or design. (See also **symmetrical**, **asymmetrical**, **radial**, and **crystallographic**.) [3]

Bauhaus—A German art movement founded in 1919 by Walter Gropius that combined the aesthetic of crafts and fine art using radically simplified forms that stressed the functionality of the object. [1]

Bezold effect—Named for Johann Friedrich Wilhelm von Bezold, this effect refers to the way in which a color may appear drastically different depending on its relation to adjacent colors. [10]

bilateral symmetry—A type of balance in which the elements on two sides of a composition are mirror images of each other. (See also **symmetrical**.) [3]

bit (or binary digit)—The most basic unit of digital information, often referred to as bits per pixel, or BPP. [11]

bits per pixel (BPP)—See **bit**.

brainstorming—A process of working with a group to generate and develop ideas through free association. [2]

CAD (computer-aided design)—The use of computers in drafting and model making that is especially useful in creating three-dimensional designs. [11]

calligraphic line—A lyrical, flowing, decorative line that expresses a sense of the fluid, graceful, rhythmic motion of the artist's hand. [4]

calligraphy—The art of beautiful writing. [4]

cast shadow—A shadow that falls on a surface or object near the object that is casting the shadow. [7]

casting—See **substitution method**.

CCD (charge-coupled device)—A device found inside a scanner that reads light energy and converts the image into binary code. [11]

character—An aspect of a line derived from the media the line is created with, such that the material bestows a given line with a unique feel or emotional content. [4]

chiaroscuro—The technique in painting of producing dramatic lighting that frames the main subject against a very dark background to create an explicit focal point. [3, 7]

chroma—The perceived intensity, or saturation, of a color. [10]

chromatic gray—A color that is produced by adding two complementary hues and white. [10]

chromatic value—The relative lightness or darkness of a colored surface. [7]

closed composition—A framing arrangement in which all of the elements fit within the edges of the work's frame; this approach is often used to distance the viewer from the work. [3]

closed-value composition—Compositions in which areas of value are clearly separate from one another, establishing distinct boundaries between shapes or regions. [7]

CMYK (cyan, magenta, yellow, key/black)—The primary color system for printing. [11]

collage—An art form in which various materials such as paper, cloth, wood, or aluminum foil are pasted together on a surface. [6]

color—1. Light energy made visible; an element of design that can be used to produce an area of visual importance or elicit an emotional response. 2. In three-dimensional design, an artist or designer can choose to work with the natural color of a material or apply color to cover the natural color. [10]

color depth—The number of bits used to represent the color of a single pixel. [11]

color harmonies—See **color schemes**.

color picker—A tool found in software, such as Photoshop, that selects digital color. [11]

color schemes—(or **color harmonies**) Predetermined color combinations that can be used in creating artworks and designs. [10]

color space—The range of hues available for a particular medium. [11]

color wheel—A device that allows artists and designers to look at hues in an orderly fashion by placing them in a logical order that reflects the spectrum. [10]

comp or comprehensive—A highly detailed drawing that could be considered the final drawing stage. [2]

complements—Any two hues that are opposite each other on the color wheel. [10]

composition—The way the parts of an artwork or design are assembled to make a unified whole. [3]

conceptual perception—A deeper awareness that follows an initial visual perception and involves the imagination and/or an emotional response to the image or object. [3]

conceptual thinking—A means of thinking that involves taking a broad look at a situation and making unconventional connections, leading to new perspectives and ideas. [1]

content—The subject matter, meaning, and message of an artwork or design. [1]

context—The conditions that surround a project or a concept and inform its meaning. [2]

continuous contour line—A line created when the drawing instrument is not lifted from the page once the first mark is made until the drawing is finished. [4]

continuous values—Encompass the use of the entire range of values along a value scale. [7]

contour—The border or perimeter that defines the edges of a shape, distinguishing the shape from its surroundings. [5]

contour line—The defining or outermost edge of a form rendered on a two-dimensional surface. [4]

contrast—Difference created through the juxtaposition of two or more values, colors, textures, or other elements within a composition. [3, 7]

cool hue—A color, usually variations of green, blue, and violet, that makes objects appear smaller, heavier, and denser, creating the illusion of elements receding on the picture plane. [10]

creative thinking—Approaching a problem, project, or assignment by opening up your mind to limitless possibilities. [1]

criteria—The rules or specifications of a project. Also refers to a standard for judging something, like an artwork or a design. [2]

critical thinking—Delving deep into the heart of the problem and examining the issue from all sides. [1]

critique—An analysis of the formal and conceptual aspects of an artwork or a design. [2]

cropping—A method of achieving the sensation of motion by selectively moving pieces of the image, or placing a subject in the proper location on the page. [9]

cross-hatching—A drawing technique in which intersecting sets of parallel lines are used to generate areas of value. [4]

crystallographic—A type of balance in which elements of similar shape and size are repeated across the composition, without creating any one dominant focus. [3]

Cubism—A style of art developed in the early twentieth century in which objects are depicted from multiple angles at once through combinations of nonrealistic angular shapes. [5]

curvilinear—A type of shape that is made up of circles or curves. [5]

decorative line—A type of line used purely for embellishment. [4]

decorative shape—A shape used purely for ornamentation. [5]

decorative space—Designed or invented space that is ornamental in nature. [8]

deculturization—Shifting the focus away from concepts of high or low culture to create a democratization of cultural status. [1]

depth—In two-dimensional art, the sense of distance or three-dimensionality created when objects on the picture plane seem to be closer or further away from the viewer. [7]

***der Blaue Reiter* (German for "The Blue Rider")**—A German-based Expressionist group of painters who used color purely for its expressive qualities. [10]

desaturate—To remove chroma, or color intensity, from a given hue. [10]

design—(n.) The concept or message that provides the underlying aesthetic of a work; the look of the work and the manner in which visual elements are used to communicate a message. (v.) To express in a visual language the concept or message that provides the underlying aesthetic of an artwork or design. [1]

design language—A style or scheme developed by artists or designers that, when followed, gives a consistent look or feel to a collection of pieces. [2]

design process—The method of thinking, planning, and executing an artwork or a design. [2]

digital animation—The process of using computer graphics to generate moving imagery. [11]

digital color—Color information that is written in binary code and interpreted through an additive color process using light. [11]

digital video—The successor to analog videotape that uses digital media to store its visual information. [11]

direction—The path of the linear movement. Horizontal and vertical lines produce strong structural elements but tend to be static, while curved and diagonal lines depict movement. [4]

disharmony—The effect created when hues that tend to clash are employed in a color scheme. [10]

dots per inch (DPI)—See **resolution**.

elements of design—The fundamental components that fill the space of any artwork or design, in particular line, shape, texture, value, space, and color. [Part 2]

emphasis—Special prominence given to a specific area of visual importance that draws the viewer's attention to that area. [3]

execution—The production or construction of the final artwork or design. [2]

Expressionism—An early twentieth-century movement whereby painters, including the Fauves and *der Blaue Reiter*, freely interpreted color and used it purely for its expressive qualities. [10]

eye-level point of view—A view where the eye of the subject is on the same level as the eye of the viewer, creating a sense of intimacy with the viewer. [3]

eye-level vantage point—The position from which an observer sees an object or a scene when looking straight ahead. [8]

Fauves—(French for **"wild beasts"**) A France-based group of Expressionist painters. [10]

figure—The positive shapes in a composition. [5]

figure-ground reversal—A composition in which the positive and negative shapes are so fully integrated that the viewer cannot identify which are positive and which are negative. [5]

focal point—The area of greatest visual emphasis or interest in an artwork or a design. [3]

foreshortening—The distortion of a figure's proportions such that the figure appears to have less depth than it actually does. [8]

form—The overall shape and appearance of a work, or the makeup, structure, and collective elements that combine to create a work. A work's form includes the formal elements (e.g., the materials, shapes, patterns, and colors) of which it consists. [1, 5]

form follows function—The Bauhaus concept that an object's form and design should relate to the use and function of that object. [1]

fragmentation—Showing elements in bits and pieces rather than portraying the entire image. [1]

free association—A psychoanalytical process that involves saying or writing down the first things that come into your mind, allowing you to explore new avenues of thought and unlock your subconscious mind. Also known as *stream of consciousness*. [2]

frottage—A drawing created by placing a sheet of paper over a dimensional surface and then rubbing a soft material such as pencil lead or charcoal over the paper. [6]

gamut—The actual range of color that a piece of hardware can display or reproduce. [11]

geometric—A type of shape that has a mathematical formula or algorithm underlying its construction. [5]

gestalt—A whole that is perceived as a totality greater than the sum of its parts. [3]

gestural line—A line that gives the viewer a sense of the movement of the artist's hand and conveys a feeling of weight and movement of an object or figure. [4]

golden mean—An aesthetically pleasing proportion, which can be found by dividing a line into two parts, in such a way that the ratio of the shorter part to the longer part is the same as the ratio of the longer part to the entire line. Mathematically, the golden mean is approximately 1:1.618. [3]

grid—A geometric structure of intersecting horizontal and vertical lines that can be a visible or transparent framework for a composition. [3]

ground—The negative shapes in a composition. [5]

grouping—The placement of visual components near enough to one another that they look like they belong together. [3]

hatching—A drawing technique in which parallel lines are used to generate areas of value. [4]

hexadecimal color (HEX)—Color that is expressed as a combination of six letters and numbers defined by its mix of red, green, and blue (RGB). [11]

high-key values—A value range that spans from the very lightest values to the midpoint along a value scale. [7]

highlight—An area on a surface where the intensity of the light is the strongest, resulting in a value lighter than the surface's local value. [7]

horizon line—An imaginary horizontal line, usually placed at the observer's eye level, along which elements seem to disappear from sight. [8]

hue—The proper name for a given color. [10]

human-made textures—Smooth, even textures that are characteristic of mass-produced consumer products. [6]

hybridity—The result of mixing two different or incongruent elements together. This is often achieved through combining various disparate media or materials. [1]

ICC profile—Created by the International Color Consortium (ICC), it characterizes color according to a specific set of standards. [11]

icon—An image or work that has become so familiar that everyone recognizes it and understands it as a pictorial shorthand representation of a particular concept. [1]

iconography—The visual symbols and icons used in a work of art. Also, the study of the cultural usage and meaning of those symbols and icons. [1]

idealism—A style of art in which the goal is to make the object appear better than it may actually be in life, showing the person or object not as it is, but as the artist thinks it should be. [1]

illusionistic space—The illusion of three-dimensional space on a two-dimensional surface, in particular through the use of perspective. [8]

impasto—A technique in which paint is applied to a flat surface in thick, heavy layers, either with a brush or a palette knife, creating an actual texture that reveals each individual brush or knife stroke. [6]

implied (or psychic) line—An invisible line that leads the viewer's eye in the direction the artist or designer desires. [4]

implied motion—A psychological phenomenon whereby the viewer believes that the act that is in progress will follow through to its natural conclusion. [9]

implied shape—A shape that lacks a visible border but is suggested by perceived relationships among marks on a picture plane. [5]

infinite space—A space that appears to be limitless, as suggested when we look off into the horizon. [8]

innate response—A universal, ingrained response to color that surpasses nationality, race, religion, or gender. [10]

inspiration—The initial germ or concept behind a creative or innovative idea. [1]

intensity—1. See **chroma** and **saturation**. 2. in time design, the level of liveliness or vigor in a work. Together, tempo and intensity generate the underlying rhythm. [10]

Internet—A global system of interconnected computer networks. [11]

invented texture—A visual representation of an imagined surface quality, which is often used to add variety or interest. [6]

isolation—The separation of one visual component from the others such that it will stand out and grab the viewer's attention. [3]

isometric perspective—An approach to creating perspective that is based on mathematical systems for representing space. [8]

juxtaposition—Placing contradictory words, images, or concepts close together to show a contrast. [1]

kinesthetic empathy—The experience of feeling movement, as a memory from your own physical experience. [9]

landscape format—A horizontal arrangement that eliminates unused space above and below a figure, so named because it is traditionally used for landscapes. [3]

lateral thinking—A means of thinking that moves from accepted ideas to innovative ideas in nonlinear ways. [1]

layering—The physical act of combining many items or elements on top of one another, including the expression of levels of meaning. [1]

LCD (liquid crystal display)—A visual display that uses energized polarizers, which are subpixel cells that are straightened or twisted to produce a full range of color. Also known as *flat screen monitors*. [11]

learned response—A taught behavior, response, or reaction, such as the color blue for boys and the color pink for girls. [10]

line—An infinite series of points, or the shortest distance between two points. [4]

line quality—The combined emotional feel and physical characteristics of a line. [4]

linear perspective—An approach to creating perspective that is based on a structure of parallel lines that converge at one or more vanishing points. [8]

lines of force—Accentuated lines that emphasize the energy or power of the momentum of the action. [9]

local color—The actual, realistic color of an object. [10]

local value—The intrinsic lightness or darkness of a surface, without regard to the amount of light that falls on it. [7]

logo—An easily readable and identifiable design that consists of one or more shapes and/or text, and that is used as a means of identifying or branding an organization or company and its products or services. Originally an abbreviation of *logotype*. [5]

low-angle (or "worm's eye") point of view—An extreme angle that forces the viewer to look up at the main subject. [3]

low-key values—A value range that spans from the very darkest value to the midpoint along a value scale. [7]

mass—The physical weight of a three-dimensional object, or the illusion of weight in a two-dimensional representation of a three-dimensional object. [5]

measure—The physical aspects of a line that can be measured, including its length, height, and width. [4]

megapixel (MP)—A unit of measurement used to measure the resolution of digital cameras; one megapixel equals one million pixels. [11]

metamerism—The perceived matching of colors, whereby two colors that are not the same appear to be the same when viewed under particular lighting conditions. [10]

mind map—A word-based diagram that highlights connections between related words and ideas, all of which stem from a central word located in the middle of the map. [2]

model—A three-dimensional miniature scale realization of an object. Also known as a *maquette*. [2]

monochrome—(from the Latin *mono* meaning one and chrome meaning color) The set of values for a single hue, ranging from the lightest possible tint to the darkest shade. [10]

motif—The original visual element or group of visual elements that is repeated to create a pattern. [3]

motion—The act or process of moving, or the way in which somebody or something moves; involving an action or gesture. [9]

motion blur—An effect whereby the action or movement of a figure flows in the opposite direction of the force of the action or movement. [9]

motion lines—See **whiz lines**. [9]

multiple perspectives—A perspective that combines multiple vantage points within a single composition, such that different objects seem to be viewed from different vantage points. [8]

narrative—A story, or an account, that has a beginning, middle, and end. [9, 16]

natural textures—Rough, uneven textures that are commonly found in natural objects and substances. [6]

naturalism—A style of art characterized by a realistic or factual rendering of a person or object. Naturalistic shapes can also be thought of as an accurate visual portrayal of a person or object. [1]

naturalistic shape—A shape that renders a person or object in a realistic or factual way, created from direct observation. [5]

negative shape—A shape that surrounds the main objects within a composition; sometimes referred to as *negative space*. [5]

neutral—A mixture of two complementary colors. [10]

nonlinearity—The result of creating elements of a narrative that move in an unpredictable fashion. [1]

non-objective—A style of art in which the imagery has no relation to the natural world. [1]

nonrepresentational shape—A shape with very little or no relationship to the natural world; also referred to as a *non-objective shape*. [5]

objective—Unembellished and straightforward; not influenced by personal feelings or opinions. [1]

one-point perspective—A linear perspective that uses one vanishing point located on the horizon line. [8]

open composition—A framing arrangement in which some of the elements expand outside the work's frame; this approach is often used to bring the viewer into the work. [3]

open-value composition—Compositions in which areas of value blend into one another, blurring across imagined boundaries between shapes or regions. [7]

Optical Art (or Op Art)—Artwork derived from, or influenced by, geometric abstraction that employs many psychological and physiological principles. Also known as *psychedelic art*. [9]

organic (or biomorphic)—A type of shape derived from nature, composed of fluid, free-flowing lines. They may also be referred to as *free forms*. [5]

output device—A device, such as a monitor, that allows for the display of digital data. [11]

Pantone—A proprietary color selection system that affords designers a consistent and broader range of color for printing. The Pantone brand is the most widely used of all spot colors. [11]

papier collé—A type of collage in which papers with different qualities are pasted together. [6]

pattern—Discernable groups of visual elements that repeat in a regular and predictable arrangement. [3]

perspective—A learned system of using angular and other conventions to represent three-dimensional space on a two-dimensional surface. [8]

photorealism—An artistic style in which artists use paint, pencils, charcoal, or other media to create near-photographic depictions of their subject. [6]

pictogram—A symbolic shape that represents a specific word or thing, often taking the shape of a simplified silhouette of the thing it represents. [5]

picture frame—The edge of the page, canvas, or other two-dimensional surface. [3]

picture plane—The two-dimensional surface of the canvas or other physical material onto which the media is applied. [3]

pixel—A small, two-dimensional square of light. [11]

pixels per inch (PPI)—See **resolution.**

placement—The location of an element, object, or image, which can establish it as the primary focus of a composition. [3]

plasma screen—A visual display that uses an inert mixture of noble gases that are electronically turned into a plasma that excites phosphors to emit light. [11]

point of view—The vantage point from which the content of a work is being depicted (e.g., an aerial, eye-level, or worm's eye point of view). [3]

portrait format—A vertical orientation that eliminates unused space on either side of the figure, so named because it is traditionally used for portraits. [3]

positive shape—A shape that represents the main objects within a composition; sometimes referred to as *positive space*. [5]

postmodern—A style that developed in the late twentieth century in reaction to modernism. Its hallmarks include appropriation, hybridity, layering, nonlinearity, recontextualization, and juxtaposition. [1]

primary hue—A color that cannot be further broken down or reduced into component colors; primary hues are the most basic building blocks of color. [10]

principles of design—The fundamental concepts that guide the assemblage of the parts of an artwork or design into a unified whole. (Sometimes referred to as the "principles of composition.") [3]

process colors—Colors used in the four-color printing process. The standard colors are cyan, magenta, yellow, and key (or black). [11]

progressive rhythm—Repetition of a visual element or elements that gradually change in a uniform way as they recur. (See also **alternating rhythm.**) [3]

proportion—The size of the parts of a form or image relative to its whole. [3]

prototype—An original full-scale model after which the final work is copied or patterned. [2]

proximity—The physical distance between objects, forms, textures, and so forth, whereby the visual elements appear related or unrelated. (See also **grouping** and **isolation**). [3]

psychological space—The space of the mind and of dreams, populated with nonrealistic images and landscapes. [8]

pure hue—A component color—either red, orange, yellow, green, blue, indigo, or violet—that when taken together with other pure hues, creates white light. [10]

radial—A type of balance in which the composition is created with a common center or axis from which visual elements radiate. [3]

rapid prototyping—A printing process that deposits a binder material onto a powder bed layer by layer; more recently, the term encompasses a wider variety of additive manufacturing processes and techniques. [11]

raster-based programs—Pixel-based software programs designed for working with continuous tone images and photographs. [11]

recontextualization—Placing familiar words, images, or concepts in new or unexpected contexts. [1]

rectilinear—A type of shape that is composed of straight lines. [5]

relative value—The value of a surface in comparison to the values of surrounding surfaces, with values appearing lighter in close proximity to darker values and darker in close proximity to lighter values. [7]

rendering—The method of generating an image or animation from digital data. [11]

repetition—The sustained recurrence of a visual element or group of visual elements in regular intervals that creates a visual rhythm or pattern. [3]

representational shape—A shape that looks like the real-world object it is intended to represent; also referred to as an *objective shape*. [5]

resolution—The number of pixels per square inch, commonly referred to as DPI (dots per inch) or sometimes PPI (pixels per inch). [11]

reverse value drawing—A drawing in which a light medium is used to create marks on a dark background. [4]

RGB (red, green, blue)—The additive primary color system through which red, green, and blue are added together to produce a broad range of colors. [11]

rhythm—The underlying repetition of a visual element (e.g., a color, shape, or texture) that creates a sense of flow and unity within an artwork or design. (See also **repetition**, **alternating rhythm**, and **progressive rhythm**.) [3]

rough—A quick, rough drawing that may or may not be to scale. [2]

saturation—The purity of a given hue. [10]

scale—The size relationship between a form as it is depicted in an artwork or design and a similar form that exists in the real world. [3]

scumbling—A drawing technique akin to scribbling in which loosely drawn, sometimes choppy lines with variable spacing are used to generate areas of value. [4]

secondary hue—A mixture of two primary hues. [10]

semiotics—The study of the underlying or intrinsic meaning or message of a symbol or sign. [1]

shade—A color produced by mixing a hue with black. [10]

shading—The use of light and dark values to generate a sense of mass and volume in the two-dimensional representation of a three-dimensional object. [5]

shadow—An area on a surface where the least amount of light penetrates, resulting in a value darker than the surface's local value. [7]

shape—A two-dimensional form created by a line that encloses itself or by a distinct border that clearly separates the form from the surrounding areas. [5]

signified—The object or concept that a sign or symbol represents. [1]

signifier—The visual form of a sign or symbol. [1]

silhouette—An outline or contour of an object or form that is solidly filled in, usually in black. [5]

simulated texture—A visual representation of an actual surface quality, which creates the illusion of an actual surface as precisely as possible. Also known as *visual texture*. [6]

simultaneous contrast—A visual occurrence whereby a particular hue may appear to be dissimilar when viewed on, or next to, various other colors. [10]

slicing—Dividing a digital model into hundreds or even thousands of horizontal layers before sending the model to a digital printer. [11]

smartphones—Mobile phones with more advanced computing capability and connectivity than the standard cellular mobile telephone. [11]

space—The distance between objects as well as the area those objects occupy. [8]

spectacle—The grand, glorious, and monumental. [1]

spectrum—A range, or rainbow, of colors achieved when white light is refracted in a prism or through natural occurrences. [10]

split complement—A color combination that includes a color and the two colors on either side of its complement on the color wheel. [10]

stippling—A drawing technique in which tiny dots are used to generate areas of value. [7]

stop-motion (or freeze-frame) photography—Ultra-high-speed photography. [9]

subjective—Filtered through personal experience and emotion. [1]

subtractive color—The remaining color that is reflected back to the viewer as light waves strike a given object and the rays are absorbed, or subtracted. [10]

successive contrast—A biological phenomenon whereby an image continues to appear in one's vision after the exposure to the original has ceased, usually in contrasting color to the original. [10]

symbol—A shape or other visual representation that is commonly understood to stand in for something else. [1]

symbolic meaning—A message communicated through lines, shapes, or objects that stand in for something else. [4]

symbolic shape—A shape that is widely understood to convey a particular meaning. [5]

symmetrical—A type of balance in which both halves of a composition are completely equal or mirror images. (See also **bilateral symmetry**.) [3]

tenebrism—A style of painting characterized by an exaggerated use of high contract or chiaroscuro to achieve a dramatic effect. [7]

tertiary (or intermediate) hue— A combination of a primary hue mixed with a secondary hue. [10]

texture—The tactile surface quality of an object or a substance. [6]

three-point perspective—A linear perspective that uses three vanishing points—two on the horizon line and a third either above or below the horizon line. [8]

thumbnail—A small, quick sketch or visual notation that is made in proportion to the end product or final piece. [2]

tint—A color produced by mixing a hue with white. [10]

tone—A color produced by mixing a hue with gray. [10]

triad—A color scheme based on three hues that are equidistant from each other on the color wheel. [10]

trompe l'oeil—An artistic style in which artists try to mimic nature so closely as to fool the viewer into mistaking their depictions for actual forms. [6]

truecolor—The rendition of an object's natural color using 24-bit color depth to display an RGB. [11]

truth in materials—A concept developed by Constantin Brancusi that asserts the material used should display its inherent qualities (e.g., wood should look like wood). [2]

two-point perspective—A linear perspective that uses two vanishing points located on the horizon line. [8]

unity—Agreement among the various visual elements in a composition; each item or element must, in some manner, relate to the others for there to be a visual cohesion. [3]

universal design—Design concept that takes accessibility or functionality of the end user into account as a part of the design process. [3]

value—The relative lightness or darkness of a surface. [7]

value scale—An arrangement of various shades of gray or a single color in a sequential order from lightest to darkest or from darkest to lightest. [7]

vanishing point—A spot on the horizon line at which a set of parallel lines appears to meet and then vanish. [8]

variety—Provides visual interest. To keep the visual elements from becoming a confusing array of disparate items, however, the varied elements must still have a common thread, such as geometric form, biomorphic form, linear elements, color, or texture. [3]

vector-based programs—Software applications that use an underlying mathematical algorithm or formula. [11]

verisimilitude—The quality of appearing to be true or real. [6]

vertical location—The position of an object on the picture plane relative to the top or bottom of the frame. [8]

virtual reality (VR)—A computer-generated environment that simulates three-dimensional reality. [8]

virtual space—A space that exists only inside a computer or other electronic device. [8]

visual ideation—The process of forming ideas or concepts through visual means (e.g., sketching or making diagrams). [2]

visual orientation—The two basic methods of orienting the page: landscape and portrait which should be dictated by the subject matter. [3]

visual perception—How the elements of a composition are grouped together. [3]

volume—The amount of physical space a three-dimensional object occupies, or the illusion of this space in a two-dimensional representation of a three-dimensional object. [5]

warm hue—A color, usually variations of yellow, orange, and red, that makes objects appear larger and lighter, creating the illusion of elements advancing on the picture plane. [10]

wash—A transparent effect created by applying overlapping layers of a thinned liquid medium to produce complex areas of light and dark value, color, or form. [6]

whiz lines (or motion lines)—Lines that emanate from a figure, depicting the direction of the movement. [9]

References

Ackam, Richard. Personal interview, 2018.

Batchelor, David. *Chromophobia*. London: Reaktion Books, 2000.

Bleicher, Steven. *Contemporary Color: Theory and Use*, 2nd ed. New York: Cengage Learning, 2012.

Cole, Willie. Personal website. n.d. https://www.williecole.com/background.

Davies, Char. Ephémère. 1998. http://www.immersence.com/ephemere/.

Gayford, Martin. "David Hockney's iPad Art." *The Telegraph*. 2010. https://www.telegraph.co.uk/culture/art/art-features/8066839/David-Hockneys-iPad-art.html.

"Head of an Oba." The Metropolitan Museum of Art. Accessed 2019. https://www.metmuseum.org/toah/works-of-art/1979.206.86/.

Hendricks, Jochem. "Eye Drawings." 1993. http://www.medienkunstnetz.de/works/augenzeichnungen/images/2/.

Kretz, Kate. "Hair Embroidery." Kate Kretz. Accessed 2019. http://www.katekretz.com/work-by-series/#/hair-embroidery-pillows/.

Lowry, Camille. "Saki Mafundikwa." AIGA. 2008. https://www.aiga.org/design-journeys-saki-mafundikwa.

"Mark Napier Empire: Interactive Landscapes [Press release]." bitforms gallery. 2005. http://www.marknapier.com.

Puckle, Bertram S. *Funeral Customs: Their Origin and Development*. Detroit: Singing Tree Press, 1926.

Tension. In *Oxford Living Dictionaries*. Accessed 2019. https://en.oxforddictionaries.com/definition/tension.

Weitman, Wendy. *New Concepts in Printmaking 2, Willie Cole*. New York: Museum of Modern Art, Department of Prints and Illustrated Books, 1998. http://docplayer.net/62120648-Moma-cole-willie-the-museum-of-modern-art-department-of-prints-and-illustrated-books-author.html.

Yoo, Alice. "Tibetan Monks Painstakingly Create Incredible Mandalas Using Millions of Grains of Sand." My Modern MeT. 2014. https://mymodernmet.com/tibetan-buddhist-monks-sand-art/.

Credits

Introduction

Fig I.1 Richard Levine/Alamy Stock Photo; Fig I.2 Courtesy of the artist; Fig I.3 Courtesy of the artist; Fig I.4 Courtesy of Louis Berger; Fig I.5 Courtesy of Philippe Starck; Fig I.6 © 2021 Julian Schnabel/Artists Rights Society (ARS), New York; Fig I.7 Courtesy of Deborah Rockman; Fig I.8 Courtesy of Ljubograg Andric; Fig I.9 Courtesy the artist; Fig I.10 Courtesy Fred David and P1IMAGING.com

Chapter 1

P1.1 Courtesy Paula Scher; Fig 1.1 Art Directors & TRIP/Alamy Stock Photo; Fig 1.2 iCreateMagazine/Future/Getty Images. iMac G4 Desktop Computer. Ca. 2001. Designer: Jonathan Ive, Apple Industrial Design Group. Manufacturer: Apple, Inc. Polycarbonate, chromed sheet-metal and plastic: .a (monitor and hard drive): 20 x 15 x 10 1/4" (50.8 x 38.1 x 26 cm) .b (keyboard): 1 1/4 x 18 x 6" (3.2 x 45.7 x 15.2 cm) .c (mouse): 1 1/2 x 2 1/2 x 4 1/2" (3.8 x 6.4 x 11.4 cm). Given anonymously. Location: The Museum of Modern Art, New York, NY, U.S.A. Photo Credit: Digital Image © The Museum of Modern Art/Licensed by SCALA/Art Resource, NY, Image Reference: ART584169, pierre da/Alamy Stock Photo; Fig 1.3 classicpaintings/Alamy Stock Photo; Fig 1.4 Krzysztof Wodiczko, Tijuana Projection, 2004; Fig 1.5 Courtesy of Rosanne Gibel; Fig 1.6 Courtesy of Brett Baker; Fig 1.7 Whitney Museum of American Art, New York City, USA (Gift of Melva Bucksbaum and Raymond Learsy), Photo: André Grossmann, © 2003 Christo, © 2021 Artists Rights Society (ARS), New York/ADAGP, Paris; Fig 1.8 Courtesy the artist; Fig 1.10 Ken Howard/Alamy Stock Photo, © 2020 Georgia O'Keeffe Museum/Artists Rights Society (ARS), New York; Fig 1.11 © Jonathan Green, 2013; Fig 1.12 Imagined iPod ad, 2015, for Worth1000 via DesignCrowd.com; Fig 1.13 Courtesy of Gary Tepper; Fig 1.14 The Picture Art Collection/Alamy Stock Photo; Fig 1.15 agefotostock/Alamy Stock Photo, © 2021 Estate of Pablo Picasso/Artists Rights Society (ARS), New York; Fig 1.16 Susan Meiselas, Magnum Photos; Fig 1.17 Photo by Bill Eppridge/The LIFE Picture Collection via Getty Images); Fig 1.18 © 2021 C. Herscovici/Artists Rights Society (ARS), New York; Fig 1.19 Edvard Munch, 1893, *The Scream,* oil, tempera and pastel on cardboard, 91 x 73 cm, National Gallery of Norway; Fig 1.20 Jonathan Knowles/Getty Images; Fig 1.21 Morten Løfberg, Cover for Journalist Magazine, 2017; Fig 1.22 Kadir Nelson, The New Yorker © Conde Nast; Fig 1.23 ©Panos Karas/Shutterstock; Fig 1.24 Used with permission; Fig 1.25 World History Archive/Alamy Stock Photo, © 2021 The Pollock-Krasner Foundation/Artists Rights Society (ARS), New York; Fig 1.26 The Michael C. Rockefeller Memorial Collection, Bequest of Nelson A. Rockefeller, 1979, The Metropoloitan Museum of Art, 1979.206.86; Fig 1.27 The Louise and Walter Arensberg Collection, 1950 Philadelphia Museum of Art, © 2020 Salvador Dalí, Fundació Gala-Salvador Dalí, Artists Rights Society; Fig 1.28 Courtesy of Neef Louis Design Amsterdam, © 2021 Artists Rights Society (ARS), New York/c/o Pictoright Amsterdam; Fig 1.29 Courtesy of Sharon Paz; Fig 1.30 Courtesy of Sharon Paz; Fig 1.31 Courtesy of Skylar Delaney; Fig 1.32 Courtesy of Emily Beekman; Fig 1.33 Courtesy of Morgan Hedgecock

Chapter 2

Fig 2.2 Courtesy of Anita Fields; Fig 2.3 © 2020 Adobe. All rights reserved. Adobe and Creative Cloud are either registered trademarks or trademarks of Adobe in the United States and other countries; Fig 2.4 Courtesy of Andrea Moon; Fig 2.5 Digital image © Whitney Museum of American Art/Licensed by Scala/Art Resource, NY; Fig 2.6 ®Melanie Lemahieu/Shutterstock; Fig 2.7 Image copyright © The Metropolitan Museum of Art. Image source: Art Resource, NYImage, © 2021 The Pollock-Krasner Foundation/Artists Rights Society (ARS), New York; Fig 2.8 Generated by author; Fig 2.9 Courtesy of Ursula Hockman; Fig 2.10 Courtesy of the artist; Fig 2.11 Stocktrek Images, Inc./Alamy Stock Photo; Fig 2.12 *Guest House Drawing* 16683. Mary Colter drawing of proposed Indian garden guest house. 2-story Pueblo style. GRCA 28344B circa 1916; Fig 2.14 ® 1000 Words Photos/Shutterstock; Fig 2.15 Courtesy of the artist; Fig 2.16 © 2020 Estate of Louise Nevelson/Artists Rights Society (ARS), New York; Fig 2.17 ® Gorodenkoff/Shutterstock; Fig 2.18 With permission of Marcia R. Cohen; Fig 2.19 Courtesy of the artist; Fig 2.21 Parrish Art Museum, Water Mill, New York, Gift of Louis K. and Susan P. Meisel, 2016.20; Fig 2.22 Photograph by Don Tuttle, ©2009 Linda Gasswww.lindagass.com; Fig 2.23 *America* ©Susan Stockwell 2009 recycled computer components. Photo ©Hall Puckett; Fig 2.24 © Dennis Oppenheim Estate; Fig 2.25 ® DavidNNP/Shutterstock; Fig 2.26 Courtesy of Jessica Myers; Fig 2.27 Courtesy of Sarah Navin; Fig 2.28 Courtesy of Kara Hackett

Chapter 3

Fig 3.2 Courtesy of the artist and i8 Gallery; Fig 3.3 Generated by author; Fig 3.4 Founders Society Purchase, Henry Ford II Fund/Bridgeman Images, Detroit Institute of Art, © Estate of Joan Mitchell; Fig 3.5 Collection Center for

Creative Photography, The University of Arizona © The Ansel Adams Publishing Rights Trust; Fig 3.6 Digital Image © The Museum of Modern Art/Licensed by Scala/Art Resource, NY; Fig 3.7 Digital Image © The Museum of Modern Art/Licensed by Scala/Art Resource, NY; Fig 3.9 Collection of Phoenix Art Museum, Gift of an anonymous donor, 1960.20. © Phoenix Art Museum. All rights reserved. © 2020 Banco de México Diego Rivera Friday Kahlo Museums Trust, Mexico, D.F./Artists Rights Society (ARS), New York; Fig 3.10 Reproduced with permisison of Teri Marvullo; Fig 3.11 Robert Rauschenberg, American, 1925-2008, *Retroactive I*, 1964, Oil and silkscreen ink on canvas, 84 x 60 in. (213.4 x 152.4 cm), Wadsworth Atheneum Museum of Art, Hartford, CT, Gift of Susan Morse Hilles, 1964.30; Fig 3.12 Seth K. Sweetser Fund/Bridgeman Images; Fig 3.13 "BMW leads you on the road of great music," Advertising Campaign Print: BMW/Teatro alla Scala di Milano; Italy Agency: D'Adda, Lorenzini, Vigorelli, BBDO; Advertiser: BMW; Creative Director: Luca Scotto Di Carlo/Giuseppe Mastromatteo; Deputy Creative Direction: Serena di Bruno/Francesco Poletti; Art Director: Domenico Montemurro; Copywriter: Stefano Consiglio; Fig 3.14 Used with permission; Fig 3.15 Courtesy the artist and Cranbrook Art Museum; Fig 3.16 1995.32.9, Yale University Art Gallery, Gift of Richard Brown Baker, B.A. 1935; Fig 3.17 Stunt Dummies copyright 2003 Kathleen Ruiz. For more information about the project please see: https://homepages.hass.rpi.edu/ruiz/stunt/dummies.html; Fig 3.18 Digital photograph: Photo © Tate; Fig 3.20 Courtesy of Dreprung Gomang Monastery; Fig 3.21 JakeWalk/Alamy Stock Photo; Fig 3.22 Sasho Bogoev/Alamy Stock Photo109; Fig 3.23 © Leandro Erlich, Courtesy: the artist and Sean Kelly, New York; Fig 3.25 Museo del Prado, Madrid; Fig 3.26 © Fiona Banner; Fig 3.28 Katharina Grosse, Installation view, Katharina Grosse. Photo: Tony Walsh. © Contemporary Arts Center, Cincinnati, OH, 2006; Fig 3.30 Spoerri, Daniel (1930–) AM1992-112 Photo: Philippe Migeat, © 2021 Artists Rights Society (ARS), New York/ProLitteris, Zurich; Fig 3.31 Purchased with funds contributed by Mr. and Mrs. Donald Jonas, 1981, The Solomon R. Guggenheim Foundation/Art Resource, NY; Fig 3.32 Purchase, with funds from Gertrude Vanderbilt Whitney. Inv. N: 31.426, Digital image © Whitney Museum of American Art/Licensed by Scala/Art Resource, NY, © 2021 Heirs of Josephine N. Hopper/Licensed by Artists Rights Society (ARS), NY; Fig 3.33 Rythme coloré, Paris, 1939, huile sur toile, 158 x 154 cm, signé daté bas droite. F. 1076. en dépôt au Musée des Beaux Arts de Lille, © Pracusa 20200821; Fig 3.34 Ian Dagnall/Alamy Stock Photo; Fig 3.35 Paula Scher; Fig 3.36 © 2021 Judy Chicago/Artists Rights Society (ARS), New York; Fig 3.37 Courtesy of Jason Bilous; Fig 3.38 Courtesy of Kara Hackett; Fig 3.39 Courtesy of Jessica Myers

Chapter 4

P2.1 Private Collection, © Estate of Charmion von Wiegand; Courtesy of Michael Rosenfeld Gallery LLC, New York, NY; Fig 4.1 © London Symphony Orchestra, Logo designed by The Partners/Superunion; Fig 4.2 Gift of The Georgia O'Keeffe Foundation, National Gallery of Art, Washington 1995.4.1; Fig 4.3 Hemis/Alamy Stock Photo; Fig 4.5 © The Keith Haring Foundation, Photo © Muna Tseng Dance Projects, Inc.; Fig 4.7 Used with permission; Fig 4.11 Brooklyn Museum, Gift of Carl Zigrosser, 38.183. © artist or artist's estate (Photo: Brooklyn Museum, 38.183_PS2.jpg); Fig 4.12 Used with permission; Fig 4.14 Used with permission; Fig 4.15 Artokoloro/Alamy Stock Photo Fig 4.16 Courtesy of Sarah Buddelmyer; Fig 4.18 Collection of the Taubman Museum of Art, Gift of the Estate of Peggy Macdowell Thomas. 2002.011; Fig 4.19 Jochem Hendricks wearing the eye tracker, 1991; Fig 4.20 Portait, 1991, Ink on paper, 24.02 x 16.93 in.; Fig 4.22 Van Gogh Museum, Amsterdam (Vincent van Gogh Foundation); Fig 4.23 Digital Image © The Museum of Modern Art/Licensed by Scala/Art Resource, NY, Gift of Mr. and Mrs. John A. Pope in honor of Paul J. Sachs. (244.1962), © The Henry Moore Foundation. All Rights Reserved, DACS 2021/www.henry-moore.org; Fig 4.25 National Gallery of Art, Print Purchase Fund (Rosenwald Collection) 1968.5.1, © The Trustees of the British Museum; Fig 4.27 Courtesy of Sarah Navin; Fig 4.28 Courtesy of Jessica Myers; Fig 4.29 Courtesy of Julie Crowe

Chapter 5

Fig 5.1 M.C. Escher's "Plane Filling I" © 2020 The M.C. Escher Company-The Netherlands. All rights reserved. www.mcescher.com; Fig 5.3 © Ela-Elena/Shutterstock; Fig 5.4 Courtesy of the Walker Art Center, Minneapolis; Fig 5.5 Walker, Kara (b. 1969) © Copyright, African/American. 1998. Linoleum cut. Composition: 36 5/8 x 42" (93 x 106.7 cm) (irreg.); sheet: 46 1/4 x 60 1/2" (117.5 x 153.7 cm). Publisher: Landfall Press, Inc., Chicago. Printer: Landfall Press, Inc., Chicago. Edition: 40. Ralph E. Shikes, Fund. Location: The Museum of Modern Art, New York, NY, U.S.A. Digital Image © The Museum of Modern Art/Licensed by Scala/Art Resource, NY, Artwork © Kara Walker, courtesy of Sikkema Jenkins & Co., New York; Fig 5.6 Used with permission; Fig 5.7 Heritage Image Partnership Ltd/Alamy Stock Photo; Fig 5.8 Courtesy Charles Clary; Fig 5.9 Courtesy Dina Brodsky; Fig 5.10 © Meg Kaplan-Noach, 2009; Fig. 5.12 © 2021 Artists Rights Society (ARS), New York/ADAGP, Paris; Fig 5.13 Tal Revivo/Alamy Stock Vector; Fig 5.14 ©1988 Nancy Stahl; Fig. 5.15 © 2021 Estate of Miriam Schapiro/Artists Rights Society (ARS), New York Fig 5.18 Private Collection, © Estate of Charmion von Wiegand; Courtesy of Michael Rosenfeld Gallery LLC, New York, NY Fig 5.19

Roni Tresnawan/Alamy Stock Vector; Fig 5.21 United States Postal Service; Fig 5.23 imageBROKER/Alamy Stock Photo; Fig 5.24 Gift of Ken Friedman, 1997-19-136. Photo: Matt Flynn. Cooper Hewitt, Smithsonian Design Museum, New York, NY, U.S.A. Photo Credit: Cooper Hewitt, Smithsonian Design Museum/Art Resource, NY; Fig 5.25 Alistair Laming/Alamy Stock Photo; Fig 5.26 Courtesy of Katrina Eckert; Fig 5.27 Courtesy of Steven Parker; Fig 5.28 Courtesy of Tyra Gillard

Chapter 6

Fig 6.2 Digital Image © The Museum of Modern Art/Licensed by SCALA/Art Resource, NY, © 2021 Center for Creative Photography, Arizona Board of Regents/Artists Rights Society (ARS), New York; Fig 6.3 Courtesy of Luce Plan; Fig 6.5 Digital Image © The Museum of Modern Art/Licensed by SCALA/Art Resource, NY, © 2021 C. Herscovici/Artists Rights Society (ARS), New York; Fig 6.7 Elder Bequest Fund/Bridgeman Images, © Copyright Agency. Licensed by Artists Rights Society (ARS), New York, 2021; Fig 6.8 Used with permission; Fig 6.9 Margaret Fisher Endowment, The Art Institute of Chicago/Art Resource, NY; Fig 6.10 Courtesy Jason Mercier; Fig 6.11 Used with permission; Fig 6.12 Courtesy of Pat Rosenstein; Fig 6.13 Generated by author; Fig 6.14 Copyright Estate of Robert Arneson/Licensed by VAGA at Artists Rights Society (ARS), New York, NY; Fig 6.15 Dorling Kindersley ltd/Alamy Stock Photo; Fig 6.16 Image courtesy of the artist and Alexander and Bonin, New York; Fig 6.17 Used with permission; Fig 6.18 ©Vija Celmins, Courtesy Matthew Marks Gallery; Fig 6.20 Acquired 1989. The Dr. and Mrs. John J. Mayers Collection, Boca Raton Museum of Art; Fig 6.22 Used with permission; Fig 6.23 Courtesy of Taylor Pellegrino; Fig 6.24 Courtesy of Erica Pallen; Fig 6.25 Courtesy of Collin Riebe

Chapter 7

Fig 7.5 Foto: Skagens Kunstmuseer; Fig 7.7 Courtesy of the National Museum of Women in the Arts, Washington, D.C. Gift of Wallace and Wilhelmina Holladay; Photograph by Lee Stalsworth; Fig 7.10 Courtesy of the artist and Pilar Corrias, London, Private collection; Fig 7.11 © ALP, Inc; Fig 7.12 Used with permission; Fig 7.14 Collection Scottish National Gallery; Fig 7.15 Courtesy of the artist, pablojuadoruiz.com; Fig 7.18 © Chuck Close, courtesy Pace Gallery; Fig 7.19 Denver Art Museum: Gift of the Eleanor and Henry Hitchcock Foundation 2011.265, Photography corrtesy Denver Art Museum; Fig 7.20 Courtesy of Desirae Jones; Fig 7.21 Courtesy of Joya Blackwell; Fig 7.22 Courtesy of Erica Patton

Chapter 8

Fig 8.1 Used with permission; Fig 8.2 Courtesy of the artist; Fig 8.4 Courtesy the artist and Peter Freeman, Inc.; Fig 8.6 Digital Image © The Museum of Modern Art/Licensed by SCALA/Art Resource, NY; Fig 8.12 © 2021 Artists Rights Society (ARS), New York/DACS, London; Fig 8.14 Used with permission; Fig. 8.15 © 2021 Remedios Varo, Artists Rights Society (ARS), New York/VEGAP, Madrid; Fig 8.16 The State Hermitage Museum, St. Petersburg Photograph © The State Hermitage Museum /photo by Vladimir Terebenin; Fig 8.17 Char Davies. *Autumn Flux, Ephémère* (1998). Digital still captured in real-time through HMD (head-mounted display) during live performance of the immersive virtual environment Ephémère; Fig 8.18 Generated by author; Fig 8.19 Artepics/Alamy Stock Photo; Fig 8.20 Used with permission; Fig 8.21 Used with permission; Fig 8.22 Philadelphia Museum of Art, Gift of Miss Ettie Stettheimer, 1951; Fig 8.23 Valery Voennyy/Alamy Stock Photo; Fig 8.24 Courtesy of the author; Fig 8.25 Courtesy of Julie Crowe; Fig 8.26 Courtesy of Jessica Harris; Fig 8.27 Courtesy of Ke'shoan Johnson

Chapter 9

Fig 9.1 Used with permission; Fig 9.2 Used with permission; Fig 9.3 Peter Horree/Alamy Stock Photo; Fig 9.5 Photo by DeAgostini/Getty Images; Fig 9.6 Courtesy Juan Collado; Fig 9.7 Courtesy of the artist; Fig 9.8 The Howard Mansfield Collection, Purchase, Rogers Fund, 1963, The Metropolitan Museum of Art; Fig 9.9 Used with permission; Fig 9.10 Used with permission; Fig 9.12 Generated by author; Fig 9.13 Courtesy of the artist and DC Moore Gallery, New York; Fig 9.14 Alinari Archives, Florence/Bridgeman Images; Fig 9.15 Photograph. © The Harold & Esther Edgerton Foundation, 2008, courtesy of Bridgeman Images; Fig 9.16 Used by permission of Sony Electronics Inc. All Rights Reserved; Fig 9.17 Boston Public Library, Rare Books Department; Fig 9.18 Photo 12/Alamy Stock Photo; Fig 9.20 Used with permission; Fig 9.21 Philadelphia Museum of Art: The Louise and Walter Arensberg Collection, 1950, 1950-134-182. © Artists Rights Society (ARS), New York/ADAGP, Paris/Succession Marcel Duchamp; Fig 9.22 tk; Fig 9.23 Courtesy of Andrew De; Fig 9.24 Courtesy of Danielle Ortiz; Fig 9.25 Courtesy of Taylor Dinkins

Chapter 10

Fig 10.1 Courtesy of Judy Pfaff Studio, 2020; Fig 10.2 Generated by author; Fig 10.3 Photo by Michael Ochs Archives/Getty Images; Fig 10.4 Generated by author; Fig 10.5 Courtesy of the artist and Metro Pictures, New York; Fig 10.7 Franz Gertsch, Dominique, 1988, Nr. 8/18, colour: spring green, woodcut (1 plate), print on hand-made Japanese paper from Heizaburo Ivano, Museum Franz Gertsch in Burgdorf/

Switzerland, © by Franz Gertsch; Fig 10.8 Simnoe Brandt/ Getty Images; Fig 10.12 Science & Society Picture Library/ Contributor; Fig 10.13 Edition of 30, Courtesy the artist and Sprüth Magers; Fig 10.16 Peter Probst/Alamy Stock Photo; Fig 10.20 Used with permission; Fig 10.22 Public Works of Art Project (U.S.) (Sponsor). Painting and Sculpture Collection Aaron Douglas; Fig 10.23 Icom Images/Alamy Stock Photo; Fig 10.25 © 2021 Wolf Kahn/Licensed by VAGA at Artists Rights Society (ARS), NY; Fig 10.26 Courtesy the artist; Fig 10.27 Used with permission; Fig 10.31 Chester Dale Collection, National Gallery of Art 1963.10.94; Fig 10.32 Phillips Editions Department; © 2021 Helen Frankenthaler Foundation, Inc./Artists Rights Society (ARS), New York/Art of This Century, New York; Fig 10.33 Used with permission; Fig 10.34 Used with permission; Fig 10.35 Retro AdArchives/ Alamy Stock Photo; Fig 10.36 Heritage Image Partnership Ltd/Alamy Stock Photo; Fig 10.37 ©Dan Olsen/Shutterstock; Fig 10.38 Used with permission; Fig 10.39 Courtesy of the artist; Fig 10.40 © Sheila Fitzgerald/Shutterstock; Fig 10.41 Courtesy Natalie Harrison; Fig 10.42 Chester Dale Collection, National Gallery of Art, Washington 1963.10.196 © 2012 Estate of Pablo Picasso/Artists Rights Society (ARS), New York; Fig 10.43 Art Collection 3/Alamy Stock Photo; Fig 10.44 Archivart/Alamy Stock Photo; Fig 10.45 Inge Johnsson/Alamy Stock Photo; Fig 10.46 ©Semmick Photo/Shutterstock; Fig 10.47 Pawel Bienkowski/Alamy Stock Photo; Fig 10.48 agefotostock/Alamy Stock Photo; Fig 10.49 The Picture Art Collection/Alamy Stock Photo; Fig 10.50 Courtesy Steven Parker; Fig 10.51 Courtesy Troy Kinner; Fig 10.52 Couresty Taylor Willis

Chapter 11

Fig 11.2 Generated by author; Fig 11.3 Tekimageon/Alamy Stock Photo; Fig 11.4 Generated by author; Fig 11.5 © Designua | Dreamstime.com; Fig 11.6 Courtesy of Thaddeus Robinson; Fig 11.7 Used with permission; Fig 11.9 Courtesy of Jesse DeStasio; Fig 11.10 Courtesy of Jane Nodine; Fig 11.11 Courtesy of Jeff Case; Fig 11.15 Used with permission; Fig 11.21 Courtesy of Pat Herold; Fig 11.22 Courtesy the artist; Fig 11.23 PictureLux/The Hollywood Archive/ Alamy Stock Photo; Fig 11.24 Generated by author; Fig 11.25 Courtesy of Lia; Fig 11.26 Used with permission; Fig 11.27 Courtesy Emily Beekman; Fig 11.28 Courtesy Sara Becker; Fig 11.29 Courtesy Maria Neito

Index

breaking the frame, 132
Brodsky, Dina, 87
Buddelmeyer, Sarah, 75
Burmese Democracy Movement flag, 93
burning for texture, 104

C

Cabbage Leaf (Weston), 98
Caboose Sundial (Marvullo), 49
calligraphic lines, 74
cameras, digital, 186, 189
Cameron, James, 188
Campbell, Joseph, xxviii
Canto Five/Union of Opposites
 (Fenster), 49
Caravaggio, 114
Career Junction advertisement (TBWA/
 RAAD), 119
Carson, David, 37
Casagemas, Carlos, 169
Case, Jeff, 183
Cassatt, Mary, 164
cast shadow, 117
CBS Records poster (Scher), 60
Celmins, Vija, 105
Chair (Cohn), 34
character characteristic of line, 69–70
charge-coupled device (CCD), 186
Charles VIII of France, 171
Chevreul, M. E., 163
Chia, Sandro, 170
chiaroscuro, 56, 114, 116
Chicago, Judy, 61
Chilkat blanket, 54
Chirico, Giorgio de, 126–127
Christo, 9
chroma, 155
chromatic gray, 160
Chromophobia (Batchelor), 183
Cincy (Grosse), 58
Clary, Charles, 64–65, 87
Clemente, Francesco, 170
Close, Chuck, 120
closed composition, 48–49
closed-value compositions, 115–116
CMYK magazine cover (Astrelli), 34
Cobweb Castle Still Life (Benedict), 132
Cohen, Marcia, 35
Cohn, Helaine L., 34
Cole, Willie, 104
collage, 101
color. *See also* digital colors
 characteristics of, 154–155
 defined, 154
 digitally generated, 113
 effective use of, 156
 effects of, 153
 of food, 167
 function of, 18
 hexadecimal (HEX), 179

introduction, 151
 meanings conveyed with, 159, 166–173
 viewer responses to, 164–165, 167,
 168–169
color, types of
 additive color, 155, 179
 analogous color, 158
 perceived color, 154
 subtractive color, 155
color balance, 166
color characteristics
 hue, 154
 saturation, 155
 value, 154–155
color classification system, 157
color complexity, 178
color depth, 178
Color Field painters, 165
color harmonies, 157, 159
color interactions, 163–164. *See also*
 contrast
color mixing theory, 180
color picker, 185
color psychology, 168–169
color schemes
 analogous colors, 158
 chromatic gray, 160
 complements, 158
 defined, 157
 disharmony, 162
 monochromatic colors, 158
 neutrals, 160
 split complements, 160–161
 triads, 160
color space, 178
color spectrum, 154
color temperature, 159, 164
color theory, 157, 164
the color wheel, 157, 159–162
Colter, Mary, 32, 33
comic books, 140
communication, 5–6
communimage (Alonso & Gees), 177–178
comparative analysis in critique, 39–40
complements in color, 158
composition
 concept, 50
 defined, 48
 to establish connection, 45
 how viewers read a page, 49–50
 open and closed, 48–49
 point of view in, 50
 visual orientation in, 48
Composition with Boiled Beans (Dalí),
 19, 21
comps (comprehensives), 33
computational art and design, 131
computer-aided design (CAD) software,
 35, 182–183, 184
conceptual perception, 47–48

conceptual thinking, 9, 10
connections, creativity and, 7
content
 elements contributing to, 17–20
 as message and meaning, 19–20
 subject and, 21–22
context, 28
continuous contour lines, 72
Continuous Profile of Mussolini
 (Bertelli), 138
contour in shapes, 84
contour lines, 71–72
contrast
 color and, 165–166
 function of, 111, 113
 high and low, 113–114
 principle of, 56
 simultaneous, 163
 successive, 163
Cook, Roger, 93
cool colors, 159, 164
Cooper, Austin, 165
copying, inspiration vs., 10–11
Cranbook graduate program poster
 (McCoy), 2–3, 52
Creation of the Birds (Varo), 130
creative process, beginning the
 audience, determine the, 28
 evaluate the context, 28
 identity the criteria, 27
 investigate the person, object, or topic,
 27–28
 media and materials, 28–30
 purpose, define the, 28
 tone, 30
creative process, defined, 27
creative thinking
 approaches to, 8–10
 example of, 6
 principles of, 6–7
 questioning assumptions in, 10
 requirements for, 9
 tools of, 7
creativity, cultivating, 7
criteria, defined, 27
critical thinking
 components of, 17
 form and content in, 17–20
 form and function in, 20
 subject and content in, 21
critique in the design process
 accountability and, 40–41
 approaches to, 37
 comparative analysis, 39–40
 descriptive analysis, 37–38
 formal analysis, 38
 group, groundrules for, 36–37
 main value, 37
 positive and constructive, 37
 successful, factors in, 37